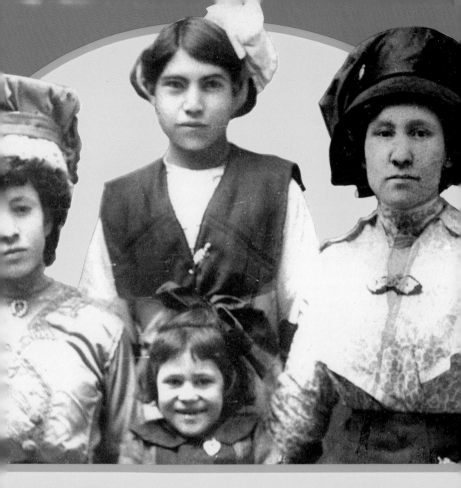

Comadres

HISPANIC WOMEN OF
THE RIO PUERCO VALLEY

Collected & Edited by Nasario García

Comadres
Hispanic Women of the Río Puerco Valley

Comadres
Hispanic Women of the Río Puerco Valley

Collected and Edited by
Nasario García

University of New Mexico Press
Albuquerque

Library of Congress Cataloging-in-Publication Data
Comadres : Hispanic women of the Rio Puerco Valley / collected and
 edited by Nasario Garcia. — 1st ed.
 p. cm.
 Includes index.
 ISBN 0–8263–1757–X (pa)
 1. Hispanic American women—Puerto River Valley (N.M. and Ariz.)
 2. Puerco River Valley (N.M. and Ariz.)—Social life and customs.
 I. Garcia, Nasario.
 F802.P83C66 1997
 979.1'37—dc20 96-9936
 CIP

Chapter opening drawings by Lloyd Lózes Goff, from *New Mexico
Village Arts* by Roland Dickey, © 1990 by U.N.M. Press.

Dedicated To

Emilia Padilla-García, Lucinda López-Atencio, Agapita López-García,
Doris Dowe-Smith, Janice M. Smith-García, Michele C. García,
and Raquel L. García

Contents

Acknowledgments

Comadres: Hispanic Women of the Río Puerco Valley, like my previous publications on oral literature of the Río Puerco valley, is a compendium of people's experiences, reflecting their daily lives in the rural New Mexico of yesteryear. The present work is distinguished by one notable difference: It comprises the vivid words, thoughts, and viewpoints of Hispanic women describing the trials and tribulations of struggling for survival in a hostile environment. To each one of them I owe a debt of gratitude for having in their sunset years laid bare the heart and soul of their younger days.

I would also like to express my sincere appreciation to Martha Liebert, Sandoval County Historical Society, for sharing with me old Río Puerco photographs in the society's archival collection, and to Robert Himmerich y Valencia, editor of the *New Mexico Historical Review*, for bringing to my attention a number of scholarly articles written about women in New Mexico. A special note of thanks is due Nedra Westwater, whose excellent editorial suggestions added a special sparkle to the manuscript.

No work, however large or small or whatever the subject, ever escapes the watchful eye of a good critical editor, whose natural talents sometimes can be taken for granted. Accordingly I wish to thank Barbara Guth, editor at the University of New Mexico Press, for her unflinching support and guidance, and to thank her staff for their assistance in helping to bring this work to fruition.

Preface

Like others of my generation, I have often feared that when my grandmother dies, all her stories, except the ones I have recorded, will die with her. But after reading *Comadres: Hispanic Women of the Río Puerco Valley*, I see that I am only partly right. As Nasario García makes vividly clear, each person's story is part of a community of stories, with each account, like a hologram, revealing a vision of the whole.

And what we behold in these pages is amazing. The women who look back on their lives are possessed of strength, creativity, humor, and a knowledge of land and language that allowed them to forge a unique culture; with this book it is handed down to us.

The women recall their lives in imagery uncorrupted by the often clinical and abstract psychobabble that dominates so much of today's discourse. Tossing pinto beans in the air to remove chaff, wallpapering with Montgomery Ward catalogues, eating lamb for forty days after giving birth—practicality and beauty often crossed paths, giving rise to days that read like poems and move like rituals.

Imagine sewing sheets out of tobacco sacks, burning tumbleweeds to help clean an acequia, or taking frozen clothing off the line. Picture whitewashing walls with gypsum you helped haul, roast, break up, and mix with flour. On any other day, you might fry *chicharrones* in a great pot outdoors, tear up mattresses in order to wash the wool, and cut the birthcord of an infant.

Each hour, each day of the week, and each season dictated which tasks would be accomplished. This "sanctification" of time made it possible for the families of the Río Puerco valley to carve out a place on earth in what were often exceedingly difficult circumstances.

I am amazed at how each autumn, my grandmother speaks of wanting to buy sacks of green chile to roast, use in stew, and freeze for the winter. Raised on a ranch and now living in Albuquerque, she speaks as if she were still preparing meals for eight brothers. Yet it is not nostalgia I detect in her voice. What I hear is a practical wisdom, a holism that links time of year with the fruits of the earth, health, pleasure, and tradition.

This same wisdom comes through in these narratives, as women recall their labors both inside and outside houses that were, appropriately, built from the earth itself. Regional usages of Spanish add yet another dimension to the telling; the women's words, like adobe, take us to the heart of what it means to be a New Mexican.

From his journey back in time, Nasario García has returned with unforgettable photographs. He has rescued still more of our past. As a result, we are more able to be ourselves in the present. In these stories of the lives that our foremothers made, we learn to observe the lives we ourselves are making, the history that we, too, will pass on. Reading these words, we gaze across time and space and know that we are not alone.

Demetria Martínez

Introduction

The Río Puerco valley enjoyed two settlement periods: The first began in the 1760s, after Governor Tomás Vélez Cachupín approved several grazing grants; the second one began some one hundred years later, following the birth of the Navajo Reservation. At that time people from the Río Grande valley, namely Albuquerque and surrounding communities such as Atrisco and Alameda, as well as others from more remote places such as Algodones, Antón Chico, Bernalillo, Corrales, and Pecos, started to venture west in search of a better life where they did not feel "crowded." Many of them, like my paternal grandparents, homesteaded in the Río Puerco valley during the 1880s and 1890s, where they eked out a living until abandoning it in the 1950s. The demise of the villages, precipitated by economic change, began slowly after World War I, continued during the Great Depression, and gained momentum with the advent of World War II, when many unskilled farmers/ranchers were able to get jobs at places such as the Santa Fe Shops in Albuquerque. The last village to lock its gates behind its departing residents was Guadalupe; it did so in the late 1950s, after Sandoval County school officials refused to provide a school teacher for the mere dozen students belonging to the last two remaining families.

Today the Río Puerco valley lies dormant, except for curiosity seekers who venture to the villages on weekends to explore and often to vandalize private property. Many former residents, including my father, while advancing in age, still cling to their property. Some children and great-grandchildren have begun to return on weekends or holidays to their parents' and grandparents' villages in an attempt to shore up the old adobe homes. Others have returned to live in Cabezón, like Benjamín ("Benny") and Pina Lucero, following his retirement a few years ago. A group of concerned people with roots in the village have even banded together, raised funds, and restored the local church; mass was celebrated there in 1994 to commemorate the occasion. Guadalupe and Casa Salazar unfortunately have not fared so well. The adobe church in Casa Salazar has melted into the ground with few visible signs that it

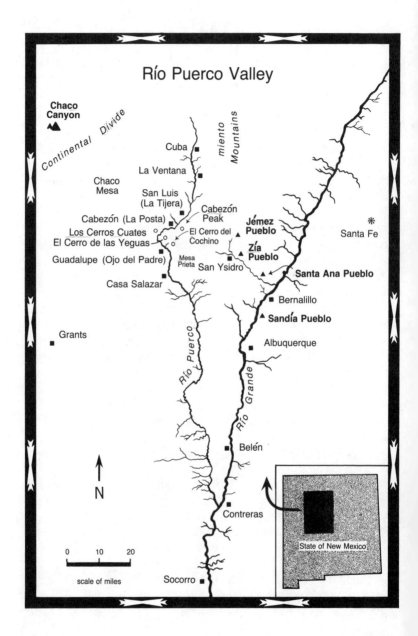

Río Puerco Valley

Chaco
Canyon

Continental Divide

Cuba

La Ventana

Chaco
Mesa

San Luis
(La Tijera)

miento Mountains

Cabezón (La Posta)

Cabezón
Peak

El Cerro del
Cochino

Jémez
Pueblo

Santa Fe

Los Cerros Cuates

El Cerro de las Yeguas

Zía
Pueblo

Guadalupe (Ojo del Padre)

Mesa
Prieta

San Ysidro

Santa Ana Pueblo

Casa Salazar

Bernalillo

Sandía Pueblo

Grants

Río Puerco

Albuquerque

Río Grande

N

Belén

Contreras

0 10 20

State of New Mexico

scale of miles

Socorro

Introduction

ever existed, while the church in Guadalupe is evidently destined for the same fate.

San Luis, on the other hand, closer to State Highway 44, has begun to generate more activity than the other villages. Today two or three families make their permanent home in the community, where electricity has been installed. Sandoval County has even paved the dirt road that stretches from the highway to the village itself. Not long ago a man living in San Luis remarked, "Now we have less dust but more traffic. I'm not sure which is worse." During the last several years, the people of San Luis have returned year after year to celebrate the reenactment at the local *morada* of Christ's crucifixion. The flurry of activity has prompted a few old-timers to proclaim that a rebirth of their former village looms on the horizon. Judging by the growth of Albuquerque and surrounding communities, an exodus similar to that of the 1860s and 1870s may yet come to pass in our lifetime.

The Río Puerco valley lies about 40 miles northwest of Albuquerque, but by car one must travel approximately 60 miles on State Highway 44 en route to Cuba to reach San Luis, the first of the four villages. The headwaters of the Río Puerco (whose name means "dirty" or "muddy" river) rise in the Nacimiento Mountains slightly north of Cuba, in Sandoval County. It meanders past San Luis, Cabezón, Guadalupe, and Casa Salazar, crosses Interstate 40 west of Albuquerque, and eventually empties into the Río Grande between Belén and Socorro.

The topography of the Río Puerco valley is one of contrasts, ranging from the austere to the lyrically beautiful. The terrain from San Luis in the north to Casa Salazar in the south, a distance of about 20 miles, consists of buttes, deep-gutted arroyos, and lava-capped mesas, including *cañadas*, broken sandstone, and *cerros*, or volcanic peaks or plugs (see map 1). Cabezón Peak, the most famous of these plugs, Los Cerros Cuates, and El Cerro del Cochino, to name but a few, dot the Río Puerco valley and provide it with a certain grandeur unique to this area.

A varied vegetation also enhances the panorama. Piñón, juniper (*sabino*), sagebrush (*chamiso*) and shortgrass (*sacate*) can be seen throughout the area. One can also find *escoba de la víbora*, or broom snakeweed, which was boiled and used by former residents of the valley to cure snake bites and to alleviate rheumatism. *Quelite del burro*, silvery donkey spinach, and cocklebur (*cadillo*), both highly toxic, also form part of the local flora. A

variety of cacti, such as the prickly pear and cholla, and wild flowers, such as yucca and desert sunflowers, add to the unique character of the region.

Wildlife includes prairie dogs (*tuzas*), lizards (*lagartos*), rattlesnakes, and coyotes. Even a couple of lobos are seen from time to time and, on occasion, cottontail rabbits and jackrabbits (*liebres*). Crows, roadrunners, and even hawks, along with a variety of smaller birds, such as quail and doves, can also be spotted. But the bird population is sparse today compared to fifty years ago, when people inhabited the area. Ironically swallows now build their mud houses on the side of buttes along the Río Puerco, where humans dwelt decades ago.

The Río Puerco valley is desertlike and semiarid; temperatures and precipitation within the 20-mile stretch that encompasses the four villages do not fluctuate dramatically. Rainfall averages from 8 to 9 inches per year, with most of it falling in the monsoon season of July, August, and September. While the weather patterns have changed over the years, according to old-timers, it is not unusual for the rainy season to begin as early as June and end in October. The dry months run from October to June, but an average of half an inch or so of snow per month adds to the valley's moisture.

Temperatures are also relatively constant. Summer months are cool at night, with temperatures often dropping down to freezing, while the thermometer rises to the 80s and 90s during the day in July and August, the hottest months. The winter months are not without sunshine, which sends the temperatures climbing above freezing; on the other hand, high winds tend to lower the effective temperature due to the wind-chill factor in the valley.

The women who appear in *Comadres* had to contend with these conditions year-round, while providing for the material and spiritual well-being of their families. This work, then, is a tribute to them in this harsh and isolated region. The word *comadre*, or co-mother, is very special because it conveys a sense of camaraderie between comadres. The term is used especially by the godparents and the mother of the godchild (*ahijado/a*) when the child is baptized. The child, boy or girl, is taught when growing up to call his godparents *padrino* or *madrina* using their first name. Both sets of parents, unless related, henceforth refer to each

other as comadre and compadre (co-father) for the rest of their lives. The *compadrazgo* relationship can also occur when a daughter (bride) or a son (groom) gets married. Similarly, the bride or groom generally do not employ padrino or madrina if the godparents are relatives and members of the immediate family. As in the case of baptism, the parents on both sides only address each other as compadre or comadre when all parties are not family related.

The women's legacy in the Río Puerco—and not all of them were comadres per se—is embodied in her day-to-day experiences, dating from approximately 1912, the year New Mexico became a state, to 1958, when the last village met its demise. The senior contributor to this work, born in 1906, is now deceased; the youngest was born in 1927. Today the oldest of these women are in their eighties; the youngest is seventy years old. The stories of the twelve women whose words appear in this collection represent a faithful reflection of the toils and tribulations of life in the villages of Cabezón (La Posta), Casa Salazar, Guadalupe (Ojo del Padre), and San Luis (La Tijera).

The women who shared their lives to create this book were interviewed between 1989 and 1992. Their remembrances are a kaleidoscope of experiences marked by a breadth of information and resourcefulness. Our attempt in *Comadres* is to bring to light the rural Hispanas' world with all of its trappings, in their own words.

In examining nineteenth century census records on the Río Puerco valley, it is worth noting that women were treated differently from men. For example, in the 1880 census, under "occupation," "keeping house" was entered for women (principally wives, not daughters) in virtually every case. The classification for men, on the other hand, was much more varied, ranging from laborer, sheep raiser, servant, carpenter, and merchant, to blacksmith or justice of the peace. Both sons and daughters were categorized as being "at home" or "at school," regardless of their gender.

By the 1900 census, women in Casa Salazar, Cabezón, Guadalupe, and San Luis had become almost anonymous. The space under "occupation, trade, or profession" was now left blank by the census taker. Men's work, however, continued to be recorded under a variety of labels: farmer, sheepherder, cowherder, day laborer, farm laborer, mail carrier,

store salesman, storekeeper, washer, capitalist, and stockraiser. From time to time, a daughter was listed as a "servant," or "at school," implying a certain privilege, while other school-age sisters stayed home.

In the 1910 census, the forms for gathering data had become more sophisticated. Under "occupation" we now find two separate columns. One reads "trade or profession of, or particular kind of work done by this person, as *spinner*, *salesman*, *laborer*, etc." The second column is headed "general nature of industry, business, or establishment in which this person works, as *cotton mill*, *dry goods store*, or *farm*, etc." The complex nature of the census forms continues to depict the male as more versatile and industrious, and his occupation may now be listed in much more detail.

While both columns favor the man more than the woman, for the first time there is a place on the census form that recognizes the woman as someone other than a wife or homemaker. We now have some adult women who, as heads of households, are duly acknowledged as a washerwoman working in a house, "dressmaker/house," "seamstress/at home," "surgeon/working," or holding "odd jobs at home"; when nothing is listed at all, a son or grandson was responsible for supporting the family. In rare instances, an unmarried daughter was permitted to do seamstress work at home. In at least two other instances, based on the 1910 census for the Salazar Precinct, which appears to have included the villages of Casa Salazar and Guadalupe, a woman whose husband owned a store is listed as "clerk/store owner," while the daughter held the position of "postmaster/assistant." In another case a wife is listed as a "surgeon/working out," "surgeon" in this case meaning a *curandera*, or folkhealer.

The "occupation" section of the 1920 census records is identical to that of the 1910 census forms. The census data for Guadalupe and Casa Salazar, which are combined, show that of the 327 total inhabitants, 7 women are listed as having an occupation. Of these, 5 are listed as heads of households: 2 washerwomen, 2 seamstresses, 1 teacher, and 2 as farmers who own their own farms. It is important to note that women are now recorded as property owners.

Cabezón, enumerated under La Ventana Precinct #4 in the 1920 census, had a population of 200 people. Of this number, 8 women are listed

as heads of a household: 5 as washerwomen, 1 as a farmer (who owns her farm), 1 as a schoolteacher, and 1 with occupation listed as "none."

San Luis, the last of the four villages in the Río Puerco valley, numbered approximately 200 inhabitants in 1920, 7 of whom are listed in the census of that year as women who head households. Of these women, 2 are washerwomen, 2 run the farms they themselves own, 1 is a schoolteacher, and no occupation is listed for the last 2, 1 of whom is categorized as a blind beggar. One woman recorded as a farmer is a grandmother taking care of 10 grandchildren—5 girls and 5 boys.

While the census data are important regarding women and their role in the community, such information barely scrapes the surface regarding their activities. It does not tell us anything about women who were, among other things, *parteras* (midwives), *sobadoras* (folk chiropractors), *mayordomas* (stewards of the local church), nor does it tell us who were good *empacadoras* (canners), *sembradoras* (planters), *enjarradoras* (mud plasterers), or *rezadoras* (known for praying at *velorios*, or wakes).

Women in the West, especially Native Americans and Hispanics, have comprised an integral part of New Mexico's historical landscape since time immemorial, but a genuine effort to confirm their importance in history has only been initiated in the last several years. According to Tey Diana Rebolledo in *Nuestras Mujeres: Hispanas of New Mexico—Their Images and Their Lives, 1582–1992*, published in 1992 by El Norte Publications/Academia, the Hispana herself made her first appearance in New Mexico in 1582, during the Espejo expedition. Sixteen years later, in 1598, several Hispanic women and children accompanied Juan de Oñate's entourage on his trip from Zacatecas to colonize New Mexico. Succeeding ventures from Mexico into this territory, from the colonial period up to and including today's immigration, have involved women.

It is fair to say that across the centuries, the social roles and contributions of rural Hispanas in New Mexico have received less attention than those of other female groups. The paucity of archival information available for the sixteenth and seventeenth centuries has not helped the situation, leaving us with a very murky picture of the Hispana of that time. Archival data for the eighteenth and nineteenth centuries still remain to be ferreted out.

Nevertheless, Hispanics now find it easier to talk about women like

Casilda de Amaya, who accompanied her husband and their three sons in the Espejo expedition of 1582, or about Refugio Gurriola, "La Cautiva," captured by the Yaqui Indians in the nineteenth century, thanks to scholars like Tey Diana Rebolledo. Or one can discuss personalities such as Gertrudes Barceló (1800–54), known as Doña Tules, renowned in Santa Fe more for her soirees than her good deeds, or those who have distinguished themselves in this century, such as Fabiola Cabeza de Baca (1894–1991) and Nina Otero Warren (1881–1965).

One New Mexican scholar who has done much to wrest women from a historical closet is Joan Jensen, who in 1991 published *Promise to the Land*, a collection of essays on rural women, including an account of "New Mexico Farm Women, 1900–1940." This article contains fascinating new information on rural Hispanic women and the fundamental role they played in their communities' survival. As Jensen remarks, "rural women are now an essential part of women's history, not because of my work but because a number of people, for totally different reasons, were coming to a similar conclusion: that the lives of rural women were central to American history . . . " The importance of rural women, including the Hispana, is further exemplified in Marta Weigle's edited work *Women of New Mexico: Depression Era Images*, which appeared in 1993. This is a collection of Farm Security Administration photographs and excerpts from the WPA New Mexico Federal Writers' Project manuscripts that visually and pictorially depicts women in a rural environment engaged in an array of homemaking activities. Joan Jensen put it best in *Promise to the Land*, when she said that "Rural women now have a past."

Of late, scholars, mostly female, have attempted to bring women from the shadows of obscurity into the light of respectability. Among these are Chicana historians, sociologists, anthropologists, literary critics, and creative writers such as Patricia Preciado Martín who, in 1992, published *Songs My Mother Sang to Me*. Her work contains a series of oral interviews with Mexican American women about their pasts in Arizona and Mexico.

An earlier but similar work is *Las mujeres: Conversations from a Hispanic Community*, published in 1980 by Nan Elsasser, Kyle MacKenzie, and Yvonne Tixier y Vigil. It contains life stories covering four generations of Hispanic women in New Mexico. Of major importance is *Nuestras Mu-*

8

jeres: Hispanas of New Mexico—Their Images and Their Lives, 1582–1992, under the editorship of Tey Diana Rebolledo, which combines empirical research with oral history and biographical sketches of Hispanic women and the role they have played since setting foot on New Mexico soil in the sixteenth century.

Hispanas of the Río Puerco valley, like countless others throughout the history of New Mexico, kept no diaries or written accounts of their daily activities; but what they share with us in *Comadres* is oral chronicles of a past marked by both joyful and sorrowful events. These voices of a bygone era also mirror the countless life experiences of mothers, grandmothers, and great-grandmothers before them.

The inspiration for this book comes from two special women: my maternal grandmother, Lucinda López-Atencio, who spent many years in Cuba, New Mexico, and my mother, Agapita López-García, born in tiny San Miguel southeast of Cuba—today just a dot on the map. These pages are a tribute to them as well as to the Hispana of the Río Puerco valley.

As a small child, I spent the summers with my maternal grandmother. Over the course of time, she taught me numerous things that to this day remain indelible in my mind. I learned, for example, how to build a fire in the wood stove, make coffee, crack and fry an egg, cook *caldito* (broth made with stew meat and potatoes), and bake *galletas* (biscuits); mending my socks using an empty bottle was one of my favorite pastimes. Emptying chamber pots (*bacines*) every morning, however, was not a chore I looked forward to. From these experiences, however, was born an unforgettable lesson in human empathy—my great-grandmother, who was totally blind and lived with my grandmother, at times needed my assistance in lighting a cigarette or pouring coffee so she would not burn herself.

These episodes constitute a vivid and central part of my early childhood, but there are others. One in particular that stands out is my grandmother's recitation of folklore. To this day I recall a litany of stories (*historias*), jokes (*chistes*), riddles (*adivinanzas*), folk sayings (*dichos*), and ditties such as "Sana, sana, colita de rana. Si no sanas hoy, sanarás mañana" (a comforting nonsense rhyme for a sick or injured child). When I reached adulthood, she was thrilled to find out that I was still able to recite riddles and folk sayings I had learned from her as a child.

Introduction

But my grandmother was also a curandera, a folkhealer, who specialized in ailments affecting men, women, and children. Among my chores were fetching medicinal herbs (*remedios*) from her pantry, heating water, and preparing some concoction for medicinal purposes; but she forbade me to stay in the house when she tended to her patients. On Saturdays the flow of women patients seemed endless, which I as a child found annoying. When I was about five years old, one time, distraught and crying, I was summoned by my grandmother, and she asked me what was wrong. I said, in a mournful sort of way, "¡Aquí no vienen más que mujeres!" ("Only women come here!"), whereupon she responded, "Hijito, bendito seas entre todas las mujeres" ("My son, blessed art thou amongst all the women").

My best friend while I was growing up in the tiny village of Guadalupe was my mother. She epitomized in my world of innocence the flawless Mother. Her tortillas were always round; her sopaipillas fluffy, not flat. The gentle touch of her hands on my forehead as she applied sliced potatoes dipped in vinegar to alleviate the fever from a cold or the flu, is a treasure in my bank of childhood memories.

Being the first child in the family, I spent many days and nights alone with my mother in Guadalupe while my father was away during the week, working for the Soil Conservation Service (SCS). Every Friday afternoon, in anticipation of his return home for the weekend, one or two small animals had to be killed. First came a chicken, for my mother's *arroz con pollo* (chicken with rice), sometimes followed by a rabbit. Killing rabbits was especially painful, since I raised them; but I learned to appreciate that slaughtering or butchering animals was necessary for one's survival. Besides, seeing my father happy brought my mother joy as he reveled in home-cooked meals away from the job.

As I now look across time and space, many reminiscences on the ranch are inextricably linked to my mother's farm experiences. We shared our grief and endured our hardships, but I also relished the good times with her. She, like most women of the Río Puerco valley, did virtually everything—from cooking, whitewashing walls, washing, and ironing, to milking cows, chopping wood, planting beans or corn, and, yes, raising children. Her responsibilities, like those of her *comadres*, seemed endless.

My close relationship with my mother (who passed away in 1972) and

with my maternal grandmother and great-grandmother led to the unique experiences that enabled me early on to appreciate and respect women for their virtues, while also recognizing their shortcomings. In retrospect, my grandmother's words, "blessed art thou amongst all the women," made perfect sense. She no doubt perceived the innocent nature of her five-year-old grandson's emerging chauvinism, so she proceeded to rescue me, unknowingly perhaps, from becoming cavalier in my attitude toward women.

The women whose voices echo throughout *Comadres* possessed many striking qualities. They were tough but gentle, demanding but considerate. A woman was just as capable of cleaning horse stables as she was of embroidering a dish towel. She could be exacting in cleaning house, yet she was flexible and patient if a son or daughter was a novice at the task.

This book is presented in a bilingual, Spanish/English format for two reasons: to encourage students of Hispanic culture in New Mexico and elsewhere to enjoy the stories in the regional dialect typical of the Río Puerco valley and northern New Mexico; and to reach out to those who speak English but not Spanish, with similar cultural and linguistic interests and curiosities.

Each chapter, headed by a short introduction, centers around clusters of themes that reflect women's duties at home and away from it. The stories themselves have been meticulously transcribed to maintain the integrity of the language of the interviewees. It is important that these voices should speak from the past in their own dialect, one that has formed part of our linguistic fabric in New Mexico for several centuries. Thus, words like *mesmo* (standard *mismo*), *abuja* (*aguja*), *fierro* (*hierro*), *babitos* (*niños*), and *jita* (*hijita*)—whether archaisms, regionalisms, or Anglicisms—appear in the narratives as spoken by the contributors.

In order to enhance the readability of the stories, however, the accounts at times required some editing to avoid repetition, cacophony, and non sequiturs. That same spirit was invoked in translating the stories, so that while a sincere effort was made not to alter unduly the meaning of words, phrases, or sentences, some revision was necessary. The ultimate aim was to be as loyal as possible to the local Spanish dialect without disrupting the true essence of the narratives. At times a "free" rather than a literal translation assumed priority. Such an approach is not unusual when culturally charged terms such as *vergüenza* are

involved, because a literal translation (in this case "shame") does not convey the true essence of the word.

A glossary is also provided with both standard and regional terms presented together. In this way the reader can discern the difference in pronunciation or connotation between local terminology and that found in Spain and the rest of the Spanish-speaking world.

A list of interviewees with their birth dates and places of birth, as well as interview dates and locations, is also provided. The accounts of these twelve remarkable women are a treasury of real life images and vibrant episodes drawn from the Hispanic woman's farm and ranch experiences. As Fernán Caballero (1796–1877), the Spanish female novelist, once said: "La novela no se inventa, se observa" ("The novel is not invented, it is observed"). The recollections found in *Comadres: Hispanic Women of the Río Puerco Valley* were not invented, they were observed—and lived.

1

Beyond the Kitchen

Inesita Márez-Tafoya set the tone for this chapter, and perhaps for the entire book, when she said during our interview, "The mother out did herself in everything" ("La mamá se fregaba pa todo"). The daily routine of the Hispana was packed with an assortment of chores year-round. For example, planting the fields came in spring; harvesting took place in late summer and early fall. Monday was the typical wash day. Other duties were more constant: looking after the children, making beds, cooking, churning butter, scrubbing floors and dishes, and chopping wood. Mud plastering, whitewashing, or laying mud floors occurred less frequently.

As Pina Lucero puts it, "La mamá se quedaba en cargo de todo" ("The Mother Took Full Charge"), especially if men were not around ("si no había hombres"). Many times the husband was away from home working for the government, or as a cow handler, sheepherder, or farmhand, so the wife's daily rounds also included feeding and watering animals, gathering eggs from the chicken coop, hobbling horses, cleaning stables and troughs, sanitizing the outhouse, and fetching water and wood for domestic use. Men, of course, worked in order to earn money to purchase staples such as sugar and coffee or clothing and other household necessities. If not, a family could only count on extra income (provided they owned cattle) once a year, in late October or November, when they sold their calves. If the mother became ill and the husband was home,

he assumed many of the household jobs. The children always helped the mother.

From sunup to sundown, and often late into the night, the house-farmwife discharged her obligations. These involved milking cows before breakfast, as reported in Macedonia Molina's "Yo en la mañana me iba ordeñar las vacas" ("In the Morning I'd Go Milk the Cows"). The milk was used at breakfast time, normally with oatmeal, and the foam was skimmed off the top and used for coffee, our version of cappuccino. Milk was also used for making yogurt (*cuajada*) and home-made cheese (*requesón*).

Cheese was made with milk, and the stomach lining of a calf, called *cuajo* (rennet) was used for curdling the milk. Once the milk was boiled and allowed to simmer, the whey (*suero*) would rise to the top and be disposed of. To ensure that all of the whey drained properly, the cheese, rolled into a ball, was wrapped up in a clean dish towel and hung on the clothesline. Any excess whey then dripped to the ground and soon the cheese was ready to slice and to eat.

Women even did carpentry, according to Frances Lovato in "Hacían sus roperos ellas" ("Women Made Their Own Closets"), a task not considered unfeminine. There were times when they had to cut out a window from an adobe wall, using barbed wire as a saw. A strand of wire was pushed through the wall between adobes and then pulled back and forth—one woman inside the home and her comadre on the outside. A window was often made to keep watch for coyotes or foxes that sought to kill and eat the chickens, or for hawks that enjoyed scooping up small hens or baby chicks.

But the Hispanas' chores did not all involve the house; an awareness of the importance of livestock for human survival began at a young age. The mother taught the children early on, for example, how to grind corn on a metate or in a food grinder in order to feed the chickens and baby chicks as part of the fattening process.

Children learned that animals on the farm were not only an integral part of the land but an extension of it. Horses, cows, goats, chickens, rabbits, hogs, and sheep confirmed the harmony and coexistence among land, animals, and people. The horse was the most important of all farm animals. Everyone depended on it to accomplish much of the work, from rounding up cattle to plowing and raking the fields.

Pina Lucero, in "Me iba a cuidar las cabras" ("I'd Go Take Care of the Goats") provides the reader with a different dimension on the care of animals. She shares with us the farm child's seemingly lonely life of herding goats in the countryside. Taking care of animals such as goats was common, although not always on a routine basis.

Often women harnessed and hitched up the horses, loaded the empty fifty-gallon barrels, and traveled from 3 to 7 miles to the local *placita* by wagon to fetch water at the *ojito*, or spring. On other occasions women, with the help of children, headed for the mountains (*monte* or *sierra*), several miles away, for a load of wood, usually *sabino* (juniper), by putting *andamios* (sideboards) on the wagon. This was an all-day trip, so they would pack a lunch of beans, tortillas, jerky, water, coffee, and bizcochitos.

Women did not always bring home wood by wagon; at times they did it on foot. "Ibanos a las mesas a trae leña" ("We'd Go to the Mountains to Fetch Wood"), narrated by Adelita Gonzales, gives an eloquent description of this venture. It was not a glamorous undertaking. The work was hard and sweaty, but it was something that had to be done. She, like other women, did not rely on the man whenever necessity and obligation demanded attention to matters that affected the entire family's well-being.

Pina Lucero's message of the woman taking charge comes across loud and clear. Women of the Río Puerco did not stand on ceremony. They were self-reliant, resourceful, and indomitable. They literally rolled up their sleeves and did more than just their own domestic chores because, as Inesita Márez-Tafoya said, "Tenía uno que entrale" ("You had to get on with it").

When things had to get done in the home or on the farm while the husband was away, the wife took the initiative. That was her calling; she did not shirk her duties. Without her contribution, neither the animals nor the people would have been able to survive.

La mamá se quedaba en cargo de todo

Pina Lucero

[Si salía el marido], pus la mamá se quedaba en cargo de todo. A lo menos que si nosotros en la casa, nos mandaba mi mamá a trae leña, nos mandaba a trae agua, nos mandaba a trae todo. Partir la leña, meter la leña pa dentro. La mujer partía la leña contoy nosotros. Los hijos la ayudábanos.

Mi mamá llegó ir a trae leña en carro de bestias. Ella y sus cuñadas, y llegó a ir a trae agua, tamién. Muy lejos. Con las lagunas muy lejos llegó a trae agua en carro de bestias. Echaban los barriles y iban y traiban agua. Todo, todo lo hacían ellas solas. En el invierno como el verano.

¡Ah sí! Todas casi [enjarraban]. Todos los veranos. Ése era el costumbre de enjarrar, todo con zoquete. Se juntaban todas y las vecinas asina se ayudaban unas a las otras. Hay veces que había hombres, pero si no había lo hacían ellas. ¡Solas! Estaan más fuertes que qué.

Mi agüelita [bisabuela] tavía asina cuando estaba ciega, mi mamá le ponía zoquete y sabes que se ponía a enjarrar abajo y estaba ciega. Con la pura mano. Yo no conocí a mi, *my grandparents.* A mis bisagüelitas nomás conocí. [Enjarraban] casi, casi al año o dos años, cuando había agua, pero tenían que jalala. Ora está muy fácil pa garrar l'agua. Antes no.

Tamién, año por año pa las fiestas, un mes antes de las fiestas, ya todas andábanos echando suelos. Hacíanos el zoquete, y loo lo metíanos pa dentro, y loo lo echábanos y lo íbanos emparejando. Al cabo que le echábanos como dos pulgadas de alto, de grueso, a que durara. Tenía que secarse y dejalo secarse y loo lo golvía uno alisar otra vez. Agarraba otra vez la tierra *muy* finita y loo lo golvíanos a dar otro aliso arriba pa que quedara muy bonito. [Si se cuarteaba] tamién teníanos que golver a echale otro alís. Le dijían alís de zoquete, muy delgadito. En veces que estaba muy descalabrao que le dijían, y lo quitaban, y loo lo golvían a echar otra vez otro suelo.

The Mother Took Full Charge

Pina Lucero

If the husband left home, well, the mother took full charge. At least if we were home, my mom would ask us to go after firewood, she would ask us to go after water, she would ask us to do everything. We had to chop wood and take it inside the house. Mother chopped wood alongside us. We children helped her.

My mom ended up going after firewood many times in the horse wagon. She and her sisters-in-law would go after water also. Very far away. Being that the lakes were far away she would haul water by horse wagon. They'd load up the barrels and they'd go and haul water. They did everything, everything by themselves, in the summer as well as in winter.

Oh yes! Almost all of the women mud-plastered. Every summer. That was the ritual, plastering, all done with mud. All the women who were neighbors would get together and thus help one another. At times men helped, but if they weren't around, the women did the plastering themselves. By themselves! They were stronger than all get-out.

My grandma [great-grandmother], even though she was blind, my mom would put mud in front of her and you know, she'd plaster the lower part of the house. Just by hand. I never knew my grandparents. I only knew my great-grandmothers. Women mud-plastered almost every year or two when there was water, but they had to haul it. Now it's easy to haul water. Not back then.

Also, year after year for the fiestas, a month before the fiestas, all of us women would be laying mud floors. We'd mix the mud, haul it inside, and then we'd pour it and spread it. Finally the mud would be about two inches high, thick, so that it would last. It had to dry and be left to dry, and then you smoothed it again. You'd get very fine dirt (mud) once more and then you smoothed it out again so that it'd be very pretty. If the mud cracked we had to smooth it again. They called it smoothing with mud; it was a very thin layer. At times it ended up

Yo me acuerdo que llegué hacer adobes. Oh, había veces que ponían hombres, porque era muy duro tamién pa munchas mujeres, pero si no había más, ellas lo hacían. Yo llegué a ver a mis tías hacer adobes. Tenía una tía yo que ella acarriaba los adobes en la carreta o si no podía, en brazos. Llevaba de a uno, de a uno hasta que estaban haciendo la casa. Muy duro. Muy duro.

La mamá se quedaba en cargo de todo

"injured," as they used to say, and so we would remove it entirely and lay another floor all over again.

I remember making adobes. Oh, at times men got involved because it was very hard for many women, but if there was no other recourse, women did the work. I saw my aunts making adobes. I had an aunt who carried the adobes in a wheelbarrow, and if she couldn't do it in a wheelbarrow, she carried them in her arms. She carried them one by one until they finished making the house. Very hard. Very hard.

Macedonia Molina, 1990.

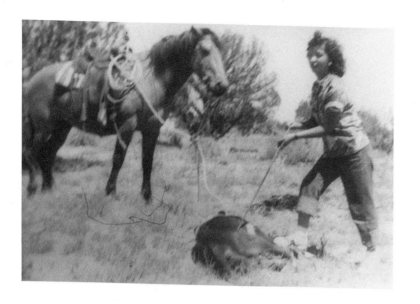

Adelina Valdez-Baca, branding calf, 1952. Courtesy of Adelina Valdez-Baca.

Yo en la mañana me iba ordeñar las vacas

Macedonia Molina

Yo me crié güérfana, muy aparte de mis gentes. Me jui pa Bernalillo a la escuela, y luego cuando él [su papá] me trajo patrás [para Guadalupe], ya él casi no me duró más de como un medio año ya vivo y lo[o] se murió.

Yo estaba muy mediana, pero yo ayudaba a mi papá hacer todo—a mi agüelito—porque ya no me tenía más que a mí. Él crió a todas sus nietas, porque todas sus hijas se murieron y se quedaron las nietas. Él comenzó a criarme. La más chiquita de las nietas jui yo. Después de que él me sacó de Bernalillo, me quedé con él.

Yo tendría como unos trece, catorce años por ai. Bueno, pues, en la mañana me levantaba yo en la mañana y me iba ordeñar las vacas. Eran trece vacas que tenía que ordeñar, encerrar los becerros, y echar las vacas del corral y lo[o] volver pa la casa, colar la leche, y destenderla. Él [su abuelo] tenía un soterrano abajo de la casa y ai, [en] bandejones tendíanos la leche pa desnatala pa hacer mantequilla. Y todo eso hacía yo en la mañana.

Y luego de ai después de esto, la almuerzo. Y luego después del almuerzo ayudarle en las siembras porque él estaba muy viejito; ya casi no vía. [Yo] iba a prender los caballos.

In the Morning I'd Go Milk the Cows

Macedonia Molina

I was raised an orphan, very much separated from my relatives. I went to school in Bernalillo, and then when he [her father] took me back to Guadalupe, he was barely with me for half a year before he died.

I was very small, but I used to help my father—I mean my grandpa—do everything, because I was the only one he had left. He raised all of his granddaughters, because all of his daughters died, and he was left with his granddaughters. He started to raise me. I was the youngest of the granddaughters. After he took me out of school in Bernalillo, I went to stay with him.

I must have been about thirteen, fourteen years old, thereabouts. Well, okay then, in the morning I'd get up and I would go milk the cows. There were thirteen cows that I had to milk, plus lock up the calves, and let the cows out from the corral and return home, strain the milk, and spread it [in pans]. My grandpa had a basement and in huge pans we'd spread the milk so as to skim the cream off the top to make butter. I did all of that in the morning.

And afterwards came breakfast. And after breakfast I had to help him in the fields, because he was quite old; he could hardly see. I was the one who would go and hitch up the horses.

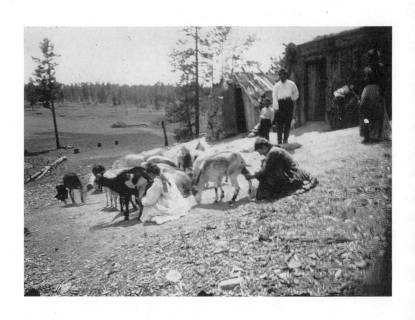

Girls milking goats, ca. 1885. James N. Furlong, courtesy of Museum of New Mexico, neg. no. 138858.

Me iba a cuidar las cabras
Pina Lucero

Andaba a pie. Iba y las traiba. Sí llegué. Tenía una tía que vivía ai en San Luis, cuando tenía yo como, oh, pueda que unos ocho, nueve años. Me iba con esta tía a cuidar las cabras aá en la orilla del río [el Río Puerco].

Una vez estáanos allá en el río y vimos que venían unas nubes muy fuertes y se soltó cayendo agua. Pus, aquí vamos. Traiba ella delantar y me llevaba mi tía Beatriz tapada, pus yo estaba mediana. Me llevaba con el delantar tapada porque estaba cayendo granizo tamién.

Pues ora verás. De ai onde mero estaba la cantina en San Luis, era un

I'd Go Take Care of the Goats
Pina Lucero

I'd go on foot. I'd go and bring them home. Yes, I managed. I had an aunt who lived there in San Luis, when I was about, oh, maybe about eight, nine years old. I'd go with this aunt to take care of the goats along the Río Puerco.

One time we were over by the river, and we saw some very thick clouds headed our way, and it started to rain. Well, we took off. My Aunt Beatriz was wearing an apron, and she covered me. I was still very small. She had me covered with the apron, because it was also hailing.

Well, let me tell you. Right there where the bar is in San Luis, there

arroyo muy fuerte. Pues, aquí vamos pa la casa y soltó las cabras ella. Ella me llevaba a mí. Pos como a las dos horas cuando bajó el agua—era una creciente bárbara que iba en ese arroyo—aquí viene mi papá y mi mamá en carro de bestias porque pensaron que nos habíanos hogao en el arroyo. Y dice mi tía Beatriz, "Mira hijita," me dice, "allá viene tu mamá y tu papá. Vamos a salir pallá pa que nos miren parriba de la loma," y salimos parriba de la lomita de onde estaba la cantina asina parriba. Salimos y les hacíanos la seña con el delantar y con la tualla de los trastes pa que no pasaron ellos el arroyo. Pus ya los [nos] vieron que estábanos ai y se jueron patrás. Platicaba mi mamá, "Yo pensé que se habían hogao," porque esa vez corrieron esas cañadas de orilla a orilla.

Me iba a cuidar las cabras

was a deep arroyo. Well, we took off running, headed for home, and so she turned the goats loose. She had me with her. About two hours later, when the floodwaters went down—the flood in that arroyo was terrible—here come my dad and my mom in the horse wagon, because they thought that we had drowned in the arroyo. And my Aunt Beatriz says to me, "Listen dear," she says to me, "there come your mom and dad. Let's go up ahead so they'll see us on top of the hill," and so we climbed up on top of the little hill from where the bar was, on up a ways. We climbed, and we were trying to catch their attention, waving the apron and the dish towel, so they wouldn't cross the arroyo. Well, they finally saw where we were, and they turned back. My mom used to say, "I thought that you had drowned," because that one time the dry riverbeds were full from bank to bank.

Ibanos a las mesas a trae leña
Adelita Gonzales

Partíanos leña, sí partíanos leña. Güeno, como a la edá cuando estaba yo joven. Yo me crié con mi agüelita. Nojotros no teníanos carro. Nojotros no teníanos modo de ir a trae leña. Yo y mi mamá nos íbanos a las mesas y de aá carriábanos la leña. Mi mamá tenía su casa y ella traiba leña par ella y pa mi agüelita porque yo me crié con mi agüelita. Pues íbanos a las mesas a trae leña pa tener aquí pa la casa.

¡Pues la cargábanos en brazos! En brazos. Mi mamá hacía unos, les dicían que eran guayabes. Les dicía a estas cosas. Los ponían asina estos guayabes y aquí se ponía ella en la cabeza; la tráibanos la leña. Partíanos allá, y mi mamá la ponía en boquesitos y loo se ponía la leña ella aquí [en la cabeza] y aquí traiba ella de malas . . . y tráibanos la leña de ai de las mesas. Y ai bajábanos despacito con ella hasta que llegábanos a la casa. El dijunto Modesto, él y yo íbanos. El dijunto Modesto llevaba un carro, y yo llevaba otro carro. Y loo los muchachos como era Abel y Eduardito, con ésos íbanos a trae leña en carros de bestias. Al monte. Y allá el dijunto Modesto cortaba la leña y nojotros, los muchachos, la echábanos en el carro.

Puede que tendría yo diez y seis, diez y siete años tendría cuando todo eso hacía yo. Eso es lo que hacía yo. Cuando ya la tráibanos aquí [a casa] la partíanos.

We'd Go to the Mountains to Fetch Wood

Adelita Gonzales

We chopped wood. Yes, we used to chop wood. Well, I was very young when I did that. I was raised with my grandma. We didn't have a horse wagon. We didn't have a way of going after firewood. My mom and I went to the mountains, and we hauled firewood from there. My mom had her own house, and so she brought wood for herself and for my grandma, because I grew up with my grandma. Well, we went to the mountains to fetch wood so we'd have it for our own use.

Why, we used to carry it in our arms! By the armload. My mom used to make what were called *guayabes*. That's what she called them. She used to put them like this, folded, on top of her head, where she put the wood. That's how she carried it. She'd chop up the wood and line it up in small bunches, and she'd put it on top of her had. She carried more or less . . . and we'd bring it down from the hills. We would climb down slowly with it until we got home.

The late Modesto, he and I used to go also. He would take a wagon, and I'd take another one. And then the boys like Abel and Eduardito, we used to go with them to fetch wood in horse wagons, to the mountains. And that's where the late Modesto would cut the wood and we, the kids, we'd load it into the wagon.

I must have been about sixteen, seventeen years old when I did that. That's what I used to do. After we got the wood home, we'd chopped it.

Hacían sus roperos ellas
Frances Lovato

Pus como en papá se mantenía allá en el rancho, en la borrega, pus casi estaba [yo] más con la mamá.

Si se ofrecía abrir una ventana o una puerta, ellas [la mamá y las hijas] las hacían porque mi *daddy* se mantenía en el rancho. Agarraban unos alambres, *barbwire*, que le dicen, de pulla, y empezaban a rajar y hasta que rajaban la ventana [en la pared], y lo hacían todas las señoras, las mamases. Pus se pasaba el papá en el campo. Pus ellas las hacían.

Hacían los roperos, de una puerta. Hacían sus roperos ellas. Los hacían ellas. Mi mamá hizo dos roperos que yo me acuerde, pero dicen que ya los quitaron. Mi madrina, la mamá de él [su marido] dice que existe lo que ella hizo. Un ropero que hizo en las paderes, allí están. Cuando vayas [a San Luis] dile a Melaquías que te enseñe, en la casa donde vive él.

Ella hizo eso y hizo las vía cruces del oratorio. Las vía cruces, *the Stations of the Cross*. A Mel pregúntale que te enseñe lo que hizo mi madrina. Tiene hasta el lavamanos, que se lavaba las manos. Allí está.

Porque cuando se ofrecía algo y mi *daddy* no estaba allí, ella [su mamá] prendía los caballos y ella agarraba el carro y nos íbanos. Ella sabía prender los caballos.

Women Made Their Own Closets

Frances Lovato

Well, since my father stayed out at the ranch, sheepherding, I was almost always with my mother.

If it was necessary to cut open a window in the wall, the mother and the daughters would do it, because my daddy was out at the ranch. They'd get some wire, barbed wire, as it's called, and they'd start by cutting until they were able to cut out the window in the adobe wall. All the women, the mothers used to do it, since the father was away. They used to cut out the windows or the doors.

They also made closets from doors. They used to make their own closets. They made them. My mom made two closets, near as I can recall, but I understand they've been removed. My godmother [her second husband's mother] says that what she built is still around. It's a closet that she made in the walls; it's still there in San Luis. When you go there, tell Melaquías to show it to you, there where he lives.

She made it and even made the crosses in the oratory, the Stations of the Cross. Have Mel show you what my godmother made. The closet even has the washstand where you washed your hands. It's there.

Also, whenever something was needed and my daddy wasn't home, my mother would hitch up the horses and get the wagon, and we'd take off. She knew how to hitch up the horses.

2

Happiness Comes from a Full Stomach

There was an old folk saying that was popular in the Río Puerco valley: "Panza llena, corazón contento" ("Happiness comes from a full stomach"). Hispano cuisine has changed little for old-timers from this region now living in Albuquerque and surrounding communities. Today, as in the past, they still cling to most traditional foods, meal customs, and recipes.

The woman's kitchen and dining area were combined; it was nothing luxurious. There would be a wood-burning stove, a box for firewood and one for kindling, a home-made wooden table and chairs, and a *trastero* (china cabinet). As time went on, better-off families had bins for flour, sugar, coffee, and so on. A pantry (*la dispensa*) was used for perishables and canned foods, after pressure cookers came to the Río Puerco in the 1930s. When families began to buy commercial canned goods, these also went into the pantry. It was made from adobes or sometimes dug out of a hill (cavelike) close to the house to keep food cool, because there was no refrigeration.

Most of the food people ate on the farm, such as pinto beans, corn, squash, peas, cucumbers, chile, garlic, onions, lentils, lima beans (*habas*), pumpkins, cantaloupes, watermelons, *chilescayotes* (resembling watermelons and used for making jelly), and wheat was home-grown. It was

not unusual during the summer for women and children to gather wild spinach and *verdolagas* (purslane) for part of their daily diet. Orchards did not exist, but an occasional fruit tree could be found in someone's yard. Apples, peaches, apricots, and grapes came from fruit venders called "Arabs," who ventured to the Río Puerco from Albuquerque. During harvest season, families traveled by wagon to Jémez Pueblo—a trip that took two to three days coming and going—to trade their crops for fruit and sometimes chile, all of which were dried and stored for the winter. Families also hauled sacks of others' wheat or corn for grinding at the mill, as part of their bartering.

Foods not raised on the farm were purchased in Albuquerque or at the Bernalillo Mercantile, in Bernalillo. My paternal grandfather made periodic trips to Albuquerque (La Plaza, or El Río) to purchase *provisiones* (groceries). These consisted of sugar, coffee, baking powder, rice, raisins, salt, pepper, and oatmeal. Later—during the '30s, '40s, and '50s—Río Puerco residents began to rely more on commercial products, such as Karo Syrup (dark, medium dark, and light), Log Cabin Syrup, Rex Jelly, Derby's Corned Beef, Hormel's Pig's Feet, Morrell's lard, salt pork (cooked with pinto beans), Vienna sausages, sardines, Spam, potted meat, and Del Monte's or Libby's canned fruits and vegetables.

Susanita Ramírez de Armijo presents us with an overview of the three daily meals in "Las tortillas sí nunca faltaban" ("We Always Had Tortillas"). Breakfast was considered the most important. Tortillas, eggs, chile, beans, potatoes, oatmeal, milk (cow's or goat's milk), and coffee were popular. In homes such as that of Adelita Gonzales, a breakfast novelty was pancakes (*panqueques*); she ran a country store in Guadalupe and was thus able to introduce new foods to the community. Susanita Ramírez de Armijo herself alludes to "corn flakes" as a new cereal. This phenomenon occurred in other villages as well.

Lunch was deemed the principal meal of the day; it involved at least two and at times three separate courses. These included soup (salads were unheard of until more recent times) and the main dish of meat, potatoes, canned or fresh homegrown vegetables, red chile, beans, and tortillas. Rounding out lunch was dessert: anything from rice pudding, boiled strips of dried pumpkin (*tasajos*) with sugar sprinkled on top, to dried slices of apples and peaches. Nothing rivaled the bizcochito, how-

ever. This anise-flavored cookie was made with flour, baking powder, sugar, salt, lard, and water. The bizcochito was popular for dunking in coffee; everyone did it.

As far as drinks were concerned, adults drank coffee and kids had water. During the last few years before the demise of the Río Puerco villages in the 1950s, lemonade was introduced. We children enjoyed it, because we no longer had to yearn for something different, novel, or unknown.

For holidays such as Lent and Christmas, or for baptisms, weddings, and saints' days, mothers and grandmothers prepared special foods. These included *molletes* (sweet rolls), *panocha* (pudding made from sprouting wheat and prepared during Holy Week), *natillas* (similar to custard), fruit pies, and sweet egg fritters (*torrejas*) dipped in a cinnamon broth (*melao*) and raisins. At Christmas time, *empanaditas* (turnovers) were served. They were made with fruit (mostly peaches or apricots) or ground boiled beef tongue mixed with cinnamon and raisins. Chiles rellenos— with no resemblance to those served in restaurants today—were popular. Some were sweet, others salty, but the ingredients were almost identical: dough (regular or sweet), green chiles, raisins, and machine-ground beef (not hamburger), rolled in egg-yolk batter and deep-fat fried. They could also be dipped in a cinnamon broth and raisins, like egg fritters.

One single food that stood above all others was bread baked in the *horno* (detached beehive oven). Macedonia Molina's words, "Dios permitía el pan en ese tiempo" ("God showered us with baked bread in those days"), voice this feeling. After the dough—prepared with *levadura* (yeast)—rose, a fire using juniper wood was built in the horno and the entrance was closed until the wood burned. Once the ashes (*la ceniza*) cooled down, they were taken out and the horno's floor cleaned with a wet gunny sack. To test whether the horno was the right temperature, a small piece of wool was tested on a wooden shovel (*pala de tabla*) used especially for baking bread. If it turned black, the oven was too hot; the wool had to have a light brown color to it. Then the dough (*la masa*) was put into the horno, the entrance was sealed, and the bread cooked until it was light brown on top. It was then ready to retrieve with the wooden shovel, to be taken inside the house and laid on a clean dish towel on the table.

Baking bread literally separated the women from the men, but both collaborated in tasks such as producing syrup, as we learn from Macedonia Molina in her rendition of "Hacíanos miel" ("We Used to Make Syrup"). Another partnership that brought both genders together was the *matanza*, or slaughtering of a hog. This was a family affair that involved adults and children alike. Sons and daughters performed a number of minor chores, such as washing pots and pans. Cutting and frying the *chicharrones* (pieces of fat with bits of meat on them) was divided between men and women, as we see in Eremita García-Griego de Lucero's account, "El día de la matanza" ("Butchering Day").

Certain aspects of the matanza were reserved for men, others for women. For example, the males were responsible for killing the hog, removing its hairs, and quartering it, while women prepared *chile caribe* (red chile kneaded with their bare hands) for marinating the pork (to make *carne adobada*). They also had the unenviable task of scrubbing and cleaning the hog's smelly intestines; women did the same thing when a cow, steer, calf, or *cabrito* (young goat) was slaughtered.

Goat intestines were rolled up into braidlike *chonguitos* and roasted in the stove. Hog intestines were cleaned and used for *morcillas* (blood sausage) before women cooked them in the stove. Morcillas were made of blood, chopped onions, red chile seeds, and other spices.

Regardless of whether it was a hog, a cow, a sheep, or a young goat, virtually the entire animal was eventually consumed. At Christmastime, for instance, a hog's head was retrieved from the pantry and roasted in the stove; the meat was used for tamales. Beef tongue, considered a delicacy, was reserved for making *empanaditas*. Pigs' feet and dried tripe (*cueritos*) were kept to make posole—a dish that also included hominy, red chile pods, and pork—prepared for people to eat after midnight mass on Christmas Eve, or Misa del Gallo.

No one looked forward to festive days more than children. While adults certainly enjoyed such occasions, they showed little outward emotion. Women derived their satisfaction not only from having prepared an array of foods, but from the fact that everyone—from the men to the children—always left their plates whistle clean, using small pieces of tortillas in the process.

Not all women were great cooks, however; in fact some were awful. There was, for example, a woman in our local placita who had a propen-

sity for burning the beans. The smell of burned beans was overpowering; it sometimes permeated the entire area surrounding her house. This used to prompt my grandmother to tell me kiddingly, "When you grow up and decide to get married, don't go marry a girl who burns the beans" ("Cuando crezcas y quieras casarte, no te vayas a casar con una muchacha que queme los frijoles"). There were also people who were so poor that often all they had to eat was *migas*, dried bread crumbs; these were browned in lard and mixed with white gravy and red-chile seeds. A*tole* (blue corn gruel) was sometimes served with their meager meals.

Men were not in the habit of complaining about the food; they appreciated having someone to cook for them. If anyone grumbled, it was the children (*la plebe*), who got tired of eating pinto beans and potatoes and drinking water.

Cocíanos frijoles, guisábanos chile y hacíanos galletas
Adelita Gonzales

Güeno, pues en la mañana los [nos] levantábanos. Si había tiempo les hacíanos [a los hijos] panqueques pal almorzar. Y güevos fritos. Esto es lo que almorzaban en las mañanas. Güeno, se jueron a la escuela. Echábanos los lonches a los muchachos; se iban a su escuela. Pues llevaban algunos *scrambled eggs*. Eso llevaban ellos. O llevaban *potted meat*. Eso llevaban. En tortilla. Sí, en tortilla. Y yo, nojotros los [nos] quedábanos barriendo, acabando de alzar, y proponiendo la comida pa mediodía.

We Cooked Beans, Prepared Chile, and Made Biscuits
Adelita Gonzales

Well, in the morning we would get up. If there was time we would make pancakes for breakfast for the children. And fried eggs. This is what we ate in the mornings. Then the children would go off to school. We'd fix lunches for them and they'd be off to school. Some of them took scrambled eggs. That's what they took. Or they carried potted meat. That's what they took. Folded in a tortilla. Yes, in a tortilla. And I, we would stay home sweeping, tidying things up, and planning the noon meal.

Güeno, cocíanos frijoles, cocíanos carne, guisábanos chile, guisábanos macarrones y hacíanos tortillas. Hacíanos pan de maiz o galletas. Hacíanos arroz con dulce, arroz con sal, arroz con durazno, arroz con cirgüela. Todo eso hacíanos pa la mediodía.

Pa la cena no sé; casi lo que quedaba de la mediodía. Pues lo que había hecho uno pa la mediodía. Pues ya pa la cena, eso venían y comían—lo que quedaba. Lo que quedaba.

Pues allá [para las fiestas] en [Guadalupe] mataban un torkey y hacían torkey, y luego echábanos pan [en el horno]. Hacíanos bizcochitos, molletes, pastelitos de durazno. Todo eso hacíanos pa una fiesta. Torrejas. Las hacíanos pal tiempo de fiestas. Lo que cocinábanos, lo que hacíanos más era chile con carne cocida. Frijoles, macarrones. Era lo que hacíanos más pa una fiesta.

Pues [a las hijas], ai les dicía uno, "Pela esta papa," les decíanos. "Haz los macarrones tú," les dicía uno. Las hijas haciendo todo eso.

Well, we cooked beans, cooked meat, chile, macaroni, and we made tortillas. We made corn bread or biscuits. We prepared rice pudding, regular rice, rice with peaches, and rice and prunes. We made all of that for noon meals.

For supper, well I don't recall exactly, just about whatever was left over from lunch, whatever one had prepared for the noon meal. For supper, that's what they came and ate—whatever was left over. Whatever was left over.

In Guadalupe for the fiestas they would kill a turkey and prepare it, and then we baked bread in the horno. We made bizcochitos, sweet rolls, and small peach pies. We made all of that for the fiestas. Egg fritters. We made them when we celebrated the fiestas. What we cooked more of was chile and boiled meat. Beans and macaroni. That's what we fixed most of for the fiestas.

"Peel this potato," we'd say to the daughters. "Do this, do that. And you, prepare the macaroni." The daughters did all that.

Susanita Ramírez de Armijo, 1989.

Las tortillas sí nunca faltaban
Susanita Ramírez de Armijo

Güeno, en la mañana nos daban blanquillos pa almorzar, porque no teníamos, como ora que tienen que tener jamón y *sausage* y todo eso. Nojotros a lo pobre. Mi mamá nos fríía güevos y tenía frijoles. Los refriía aquellos frijoles, calentaba chile o lo que tenía y de eso almorzábamos. Nos hacía ella de vez en cuando pan de levadura; en veces hacía galletas como hace uno ora con espauda, o tortillas. Las tortillas sí nunca faltaban. Ésas siempre estaban todos los días, porque era lo más fácil quizás pa hacelo.

Oh, ya después cuando mi *daddy* comenzó a ir a trabajar con los

We Always Had Tortillas
Susanita Ramírez de Armijo

What we ate for breakfast. Well, in the morning they fed us eggs for breakfast, because we didn't have ham and sausage and all that like now. We were very poor. My mom would fry us eggs, plus she had pinto beans. She would refry them and heat up the chile or whatever and that's what we'd eat for breakfast. Every once in a while she baked us bread made with yeast; at times she made biscuits using baking powder, or tortillas. We always had tortillas. They were there every day, because that was perhaps the easiest thing to do.

Oh, sometime later when my daddy began working with the

árabes estos de allí en Seboyeta, ai comencé yo a conocer *corn flakes*. Nos llevaba jarros de leche, y decía, "Miren, esto es pa almorzar," pos nos daba y eso comíamos, pero nojotros, diré que nojotros no teníanos cosas como ora. Si unos no quieren almorzar güevos, pus ya almuerzan su *cereal*, lo que sea, con la leche. Nojotros no. Tenía mi *daddy* o unos de mis hermanos ir a ordeñar la cabra o lo que teníamos, pa tener leche en la casa.

Loo mi mamá, que ordeñaban, tenía una dispensita. Le hizo mi *daddy* unas mesas largas. Tenía munchas charolitas mi mamá, yo me acuerdo, y allí ponía la leche. Tú sabes aquella nata que se criaba arriba. Todos los días la juntaba mi mamá en una bandeja hasta que ya tenía bastante pa hacer la mantequilla y nos enseñaba cómo la hacía pa comer. Ya después sabíamos lo que era comer mantequilla y todo eso.

Güeno, pal lonche nos cocía en veces mi mamá frijoles, ya jueran frijoles con carne o nos tenía chile colorao con carne. O si tenían carne como si mataban un cabrito, una borrega o lo que juera, pus nos asaba pedazos de carne y nos hacía papas como hacen ora, *mashed potatoes*. Todo eso nos hacía.

Pa la cena si teníamos carne, como si mataba mi *daddy* un animal, y tenía un costillar de carne, mi mamá lo cortaba y lo echaba adentro de la estufa y hacía sus galletas frescas y su mantequilla. Nos tenía y hacía chile que le dicían en greña, nomás seco así. Y nos hacía esa carne asada, y nos hacía una olla de, ¿tú conoces la harina esa de maiz molido no? Pus nos hacía una olla de ésas, de atole, y cocía una de leche y ésa era la cena que cenábamos.

Las tortillas sí nunca faltaban

"Arabs" from Seboyeta, that's when I became acquainted with corn flakes. He would bring us canned milk, and he'd say: "Look, this is for breakfast," and he'd give us some and that's what we ate, but I'll say one thing, we didn't have things like nowadays. If some people don't want to eat eggs for breakfast, then they eat their cereal or what have you with milk. Not us. My daddy or one of my brothers had to go milk the goat or whatever we had in order to have milk at home.

Then my mom, when they did the milking, had a small dispensary. My daddy made her some long tables. My mom had a bunch of small pans, I remember that, and that's where she'd put the milk. You know that layer that formed on top, my mom saved it in a pan every day until she had enough to make butter, and she showed us how to make it for eating. Later on we knew what it was like to eat [store-bought] butter and all that.

Now, as for lunch, my mom at times cooked beans for us, whether it was beans with meat or she had red chile with meat. Or if they had meat after having killed a young goat, a sheep, or what have you, why then she'd roast us a piece of meat; and she'd fix mashed potatoes like nowadays. She fixed all of that for us.

For supper if we had meat, for example, if my daddy killed an animal and he had some ribs, my mother would cut them up and throw them in the oven, and she'd make her fresh biscuits and butter. She made chile for us called "hurried" chile, which was nothing more than dry chile. And she'd make us that roasted meat and a pan of—you know that flour that's ground from corn? Well, she'd make us one of those pans of *atole* [blue-corn gruel] and another one of boiled milk, and that's what we ate for supper.

Comadres *cooking*, 1958. *Courtesy of* Adelina Valdez-Baca.

En cuaresma no nos dejaban comer carne
Susanita Ramírez de Armijo

Como ora pa Semana Santa, tenía mi mamá regla como era la Semana Santa, que ya son Miércoles Santo, Jueves Santo, ella nos hacía panocha. Hacía panocha pal Viernes Santo. Y mi *daddy* llevaba trigo [de Jémez]; lo lavaba bien mi mamá y todo y lo enraizaba y mi mamá tenía una maquinita y ai nos hacía molelo, y loo cuando eran estos días sagraos de Semana Santa, nos hacía una olla de esta torta pa comer todos estos días. Ésa era, y nos hacía torta como hacemos. Yo no sé tu mamá si la hará o no, o tu *grandma*.

We Couldn't Eat Meat During Lent
Susanita Ramírez de Armijo

Like now for Holy Week, my mom as a rule, that is, Ash Wednesday and Holy Thursday, she made us panocha [sprouted-wheat pudding]. She made panocha for Good Friday. My dad brought home the wheat from Jémez Pueblo. My mom washed it well and let it sprout. My mom had a little machine, and that's where she made us grind it special for panocha, and then when Holy Week rolled around, she also made us a pan of that *torta* (egg-yolk batter) to eat for all those days. That's what it was, and she made us torta like we make today. I don't know if your mom makes it, or your grandma.

Con chile [la torta] y lego que si no había fideos, mi mamá con tiempo antes de que se llegara la cuaresma, ella hacía los fideos. Hacía la masa y con de este safrán y yo no sé qué otra cosa. Güevo, safrán y harina y no me acuerdo qué otras *spices*. No sé qué *spices* le pondría y nos hacía hacelos como los hacen ora largos. Los secaba y los tenía listos pa cuando juera la Semana Santa. Y luego nos hacía sopa de pan pal medio día; nos hacía *spaghetti*, como le digo, con tomate. Luego pa la cena no nos dejaban comer torta en la tarde en la Semana Santa porque dicía que era [como] carne. Pero lo que tenían costumbre mi mamá y mi *daddy*, cuando ya comenzaba el Miércoles de Ceniza hasta que se acababa el Sábado de Gloria, nojotros no comíamos carne los miércoles, ni jueves, ni viernes. Si no teníamos más que frijoles, eso comíamos. Eso era lo que comíamos. En estos tiempos de cuaresma no nos dejaban comer carne.

She fixed it with red chile and then if there were no fideos [noodles], my mom, long before Lent rolled around, she made us fideos. She made the dough and put in some of this saffron and I don't know what else. Eggs, saffron, and flour, and I don't know what other spices. I don't know what other spices she'd put in, and she'd have us make them long, like they make them now. She'd dry them and have them ready for Holy Week. Then she'd make us bread pudding for the noon meal; and she'd make us spaghetti, as I call it, with tomatoes. Then for supper she wouldn't let us eat torta during Holy Week, because she claimed that it was like meat. But one tradition that my mom and daddy had, when Ash Wednesday began until Holy Saturday, we didn't eat meat on Wednesday, Thursday, or Friday. If all we had was beans, that's what we ate. We couldn't eat meat during Lent.

Chicos, tasajos, y rueditas

Pina Lucero

Lo que hacía uno, rayaba uno más el maiz; rayaba muncho el maiz y lo secábanos. Lo ponía uno en unas sábanas y lo secaba ahí, y logo lo echaba en un saco. Loo cuando quería uno hacer [algo], medio lo mojabas, ves, y loo lo agarrabas. Lo friías y lo guisabas con la comida. Tiernito, sí.

Y loo hacía chicos. Los hacía uno munchos chicos. Los cocía; los echaban en el horno. Uno los mojaba, le quitaba poca hoja al maiz, y loo los echaban en el horno y ai se cocían. Loo ya cuando estaban listos los sacaba uno en la mañana y los colgaba, tú sabes, hasta que se secaban y loo le quitaba uno el maiz. [Munchas veces] ai almorzábanos en un lao del horno. (Risas).

[Tamién secábanos] los tasajos de calabaza, tasajos de melón. Güeno, en esos años más de calabaza. Le[s] dijía uno rueditas. Hacía tasajos y los colgaba. Y luego tamién los echaba en un saco y loo después cuando algunos ya estaban listos medio los hacía *soak* poco lo mesmo que chile verde, y loo los friía uno con carne. Casi pal Tiempo Santo usaba uno muncho los tasajos porque como no comía uno carne, ¿ves?

[En el verano] les ponían, eh, cortinas, cortinas de ésas que están ralitas [para las moscas]. Los tapaban. Les ponía uno *clothespins* aquí abajo.

Dried Corn, Pumpkin Twists, and Round Dried Slices of Fruit

Pina Lucero

What you did was to strip fresh corn from the cob; you stripped fresh corn from the cob and you dried it. You would put it on some bedsheets and there you dried it, and then you'd throw it in a sack. Then whenever you wanted to prepare something, you'd sort of wet the corn, you see, and then you'd help yourself to some. You would fry it and cook it with the other food. It was really tender, yes.

Then you also made *chicos* [dried corn on the cob]. You made a lot of chicos. They were cooked; they were thrown in the horno. You would dampen them, peeling away a little bit of the husk, and then you'd throw them in the horno and that's where they cooked. Then when they were ready, you took them out in the morning and you hung them, you see, until they were dry, and then you stripped the corn away. Often we'd even eat chicos for breakfast right there next to the horno. (Laughter).

We also dried strips of pumpkin, strips of cantaloupe. Well, back then we dried pumpkin more than anything else. You called them twists. I used to make pumpkin twists and hang them up. Then I'd throw them in a sack, and then when some of them were somewhat ready, I'd soak them a little like green chile, then I'd fry them with meat. By Holy Week you almost always used pumpkin twists, because you didn't eat meat at the time, you see.

During the summer you covered them, ah, with cheese cloth, cheese cloth, which is very fine, used to keep flies away. You covered them. You'd put clothespins underneath.

Pelaban el durazno
María Catalina Griego y Sánchez

Se juntaban vecinas, doña Adelita y otras gentes que vinían del otro lao del río. Lavaban la fruta y la echaban en l'agua caliente y pronto la sacaban. Pelaban el durazno. La manzana era diferente. Ésa la pelaba uno con una navajita y tenían maquinitas que le quitaba lo de adentro de la manzana—*to core the apple*. Y asina era tamién como hacían los tasajos; se secaban. Los hacían como en un cordón largo y los amarraba uno en la percha y ai se secaban. O los destendía uno en los *screen* de la puertas y los ponían allá juera en una mesita y ai se secaban con el sol. Y todo eso guardaban, especialmente pal invierno. Era cuando hacían pasteles de estos tasajos, que eran las frutas secas. Antonces era tamién cuando secaba uno chile verde.

Y pa enpacar, enpacaba uno el maiz, en el elote en los frascos. Y me acuerdo que usaban unas ollas muy retegrandes con agua jirbiendo y ponían los frascos cuando ya echaban la fruta en l'agua y pronto la sacaban y loo la secaban y en veces le dejaban el hueso; en veces le quitaban el hueso al durazno. Y lo enpacaban con clavo y canela y azúcar y echaban los frascos estos en l'agua que estaba jirbiendo por no sé cuánto tiempo. Ellas sabían. Mi agüelita sabía por cuánto tiempo los ponían en l'agua caliente, jirbiendo, y los sacaban y los ponían en la mesa de tuallas. Loo al rato iban y le afíjaban más los frascos. Y asina es como hacían.

Mi mamá Trinidá llegó a enpacar carne y salía muy güena. [Tamién] cuando abría uno el frasco de chile verde con tomates hasta del frasco se lo comía uno. Quizás no había peligro de *botulism* que le dicen ora y no sé qué, que se envenena uno. Ya por eso yo no enpaco muncho chile. Me da pena que me vaya a envenenar.

Güeno, tamién enpacaban carne de marrano, pero la mayor era de res. Secaban la carne de res cuando mataban una ternera. Muy güena; muy güena. Me acuerdo que nos enseñaban hacer las cecinas.

Y nos enseñaban desde muy chiquitas a echar tortillas. Yo cuando comencé a echar tortillas, ponía una ojelata, una tapa de algún bote.

Women Peeled Peaches
María Catalina Griego y Sánchez

Neighbors got together, like Doña Adelita y other ladies who came from across the river. They would wash the fruit and put it in hot water and quickly take it out. Women peeled peaches. The apple was done differently. You peeled it with a little pocket knife, and they had little machines to take out the core of the apple. The strips of fruit were also done in a similar way, with a knife; you'd dry them. You would cut them like into a long string, and you'd tie them to the clothesline, and that's where they dried. Or you would spread them on like door screens outside on top of a little table, and that's where they'd dry when the sun hit them. People stored all of that sort of fruit, especially for winter. That's when you'd make pies from these dried strips of fruit. That's when you also dried green chile.

And for canning, you would can corn, corn on the cob, using jars. I remember using very large pans of boiling water and they'd put the fruit in the water and take it out quickly to dry with a towel. At times the pits were left in the peaches; other times they were pitted. Peaches were canned using cloves, cinnamon, and sugar. Then the jars of peaches were put into the boiling water for I don't know how long a period of time. They knew how long. My grandma knew how long they put them in the hot, boiling water, and then they'd take them out and put them on a table lined with towels. A short while later they would go and tighten the lids on the jars. And that's how they did it.

My mother Trinidad would can meat, and it came out really good. Also, when you opened up a jar of chile with tomatoes, why you'd even eat them right out of the jar. I guess there was no fear of getting botulism, as it's called now, because you can get poisoned. That's why I don't even can chile anymore. I'm afraid I might get poisoned.

Well, they also canned pork, but most of it was beef. They'd make jerky whenever they butchered a calf. The meat was very good; very good. I remember being taught how to make jerky.

And from the time we were very small, they taught us how to make

Cortaba la tortilla con el cuchillo y me pescaban haciéndolo. Y me dijían, "No. Vas a aprender a echar tortillas y échalas como la gente." Tenían que salir redondas. Oh, al principio salían como la mapa de los Estados Unidos, con Flórida en un lao y asina, pero no, ya al último salían bien. (Risas).

Pelaban el durazno

tortillas. When I started making tortillas, I used the lid of a tin can. I'd cut around it for the tortilla to turn out round, and I'd get caught. They'd say to me: "No. You're going to learn how to make tortillas like everybody else." They had to turn out round. Oh, at first they would turn out like the map of the United States, with Florida to one side and so forth, but, no, later on they turned out all right. (Laughter).

Hacíanos miel

Macedonia Molina

Hacíanos miel. El *granpa* sembraba muncha caña. Ésa de castilla, que le llaman. Lo[o] él tenía una máquina que le dicíanos el trapiches. Quizás así se llamaba y lo[o] prendía un caballo con una lanza y andaba el caballo arededor y nosotros le sampábanos la caña a ésa, la maquina, pa dentro en un—yo no sé cómo llamale, ai le metíanos la máquina y poníanos los botes abajo. Ai estaba caindo l'agua de la caña, pero estaba muy jugosa.

Y lo[o] a un ladito tenían unas cosas de adobes asina medias caidas, levantadas. No sé cómo dicirle. Usted sabe, caida pa levantada de aquí poquita y lo[o] tenían como una charola grandota de ojelata. Ojelata maciza que lo[o] tenían unas minuditas así levantada la ojelata y echaban la miel, la de la caña. La echaban ai y le prendía abajo como un horno. Le echaban lumbre y comenzaba a jirvir muy despacito. Y lo[o] acá en la orilla tenía como igual que riega uno, tenía como unas ojelatitas. Las levantaba uno muy poquito onde pasaran nomás poquito la miel. Iba jirviendo hasta el otro día, y le iban levantando poco a poco, a que le quitara toda esa espuma.

Cuando ya llegaba a la orilla tenían unos ajueros asina como un cañoncito así pa bajo. Y ai poníanos las devasanas, las devasanas, y ai caiba la miel ya hecha. Y ai estaba la miel. Todo eso los [nos] librábamos de comprar de la tienda.

We Used to Make Syrup
Macedonia Molina

We used to make syrup. Grandpa planted a lot of sugar-
cane, the kind they call Castilian or sorghum. Then he had a machine
we called a *trapiches* [a mill used to extract the juice from crops such as
sugarcane]. I guess that's what it was called, and then he would hook
up a horse to a pole, and the horse would go round and round, while
we fed sugarcane into the machine, into whatever that part was called.
Then we would put cans underneath. That's where the liquid from the
sugarcane would drip; it was very juicy.

And then to one side, they had something made of adobe, half-
fallen, half-raised. I don't know what to call it. You know what I mean,
sort of tilted, and there was a huge tin pan. It was stiff tin, and then
they had some little ones [pieces of tin], and the pan was tipped, and
they'd pour in the syrup from the cane. They'd pour it in there and
they'd light a match underneath. They'd start a fire and it would boil
very slowly. And then on one side, it had like what you use for irriga-
tion, little pieces of tin. You'd lift them just a little so they would let
only a little syrup go through. It would continue boiling like that until
next day, and they would lift it little by little, so that it got rid of all
that foam.

When the syrup reached the brim, there were holes like a little pipe
pointing downward. That's where we would set the jugs, and that's
where the syrup dripped down, already made. And there was the
syrup. That spared us from having to buy it at the store.

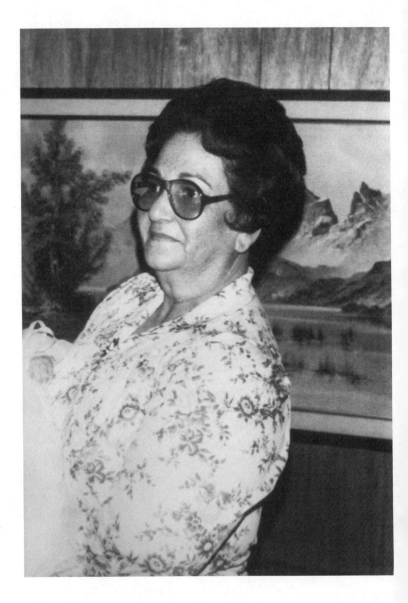

Elfides Apodaca-Baca, ca. 1980. Courtesy of Julia Jaramillo.

¿Qué no llegates a comer tú fideos?
Elfides Apodaca-Baca

Oye, ¿qué, qué no llegates a comer tú fideos? Esos fideos los hacía mi *grama*. Los amasaba con alquitrán y salían amarillos. Y los echaba *muy* delgadititos, delgadititos.

Los destendía en unas sábanas blancas que tenía ella. Y los ponía arriba la cama pa que se secaran, pero se secaban muy pronto. De un día para otro pus estaban tan delgadititos. Loo los cortaba chiquitos. Loo los cocía. Los cocía con agua de azúcar y les echaba pasas. Eso era fideos pa nojotros.

De masa, sí. Ella los amasaba, no te digo, con alquitrán, y no le

Didn't You Ever Get to Eat Fideos?
Elfides Apodaca-Baca

Listen, did, didn't you ever get to eat fideos? Those fideos, my grandma made them. And she kneaded the dough with pitch and they came out looking yellow. And she made them *extremely* thin, exceedingly thin.

She would spread them out on some white sheets that she had. Then she would put them on top of the bed so they'd dry, but they would dry very quickly. From one day to the next, why they were already so thin. Then she would cut them into small pieces. Then she would cook them. She'd cook them with sugar water and she'd throw raisins in. That's what fideos were for us.

echaba más de una poquita de sal, que yo me acuerdo, y los amasaba con ése [alquitrán] y salían amarillos. Alquitrán es *some kind of herb*. Nomás que, se me hace que es como una piedra. *I'm not sure*. No estoy cierta. Sí, es [como] el azafrán. Sí, el azafrán ese sí sé que es. Ése sí lo tengo yo. Pero el alquitrán, yo no sé si será como, yo creo que es como una *herb*, como una medecina.

Pues casi todas [las que hacían fideos] eran como ora de mi *grama*, ya de la edá de mi *grama*, como doña Natividá Romero. *You've heard of her.* Doña Delfinia. Y había otras señoras que los hacían. Yo creo que éstos [los fideos] vinieron de, como ora de España. Como ora las natillas, vienen de allá, asegún lo estoy viendo en las nuevas, en el televisión.

¿Qué no llegates a comer tú fideos?

Made from dough, yes. She would knead the dough, you see, with *alquitrán* [pitch], and she used no more than a little bit of salt, as I remember, and she would knead the dough with that alquitrán, and they came out looking yellow. Alquitrán is some kind of herb. The only thing is, I believe it's like some kind of medicine. I'm not sure. I'm not certain. Yes, it's like saffron. Yes, I know what saffron is like. I have some of that. But the alquitrán, I don't know if it's like, I believe it's like an herb, used as a medicine.

Well, just about all of the women who made fideos were like my grandma, already up in years, like Doña Natividad Romero. You've heard of her. Doña Delfinia also. And there were other ladies who made them. I believe that the fideos came from, like from Spain. Take the custard [*natillas*], for example, it came from over there, according to what I hear on the news on TV.

Abelina García-Valdez, Susanita García, Joe García *(grandson)*, Adelina Valdez-Baca, *and* Mary Valdez-Arriola, *cutting* chicharrones, *1958. Courtesy of Adelina Valdez-Baca.*

El día de la matanza
Eremita García-Griego de Lucero

De ayudale al marido a preparar todo lo que se iba a usar.
Como ora, la olla en que se van hacer los chicharrones, la mujer le
ayudaba de un lao al esposo. Tienen asas. Una asa la garraba la esposa
de un lao, el esposo del otro lao, porque la olla pa hacer chicharrones
es pesada. Es algo pesada y se ponían tamién, todo lo que es, lo que le
llamamos palitos, pa comenzar la lumbre. Se ponía la leña y too abajo
de esa olla que se iba a preparar. Preparaban [los hombres] la hacha. Si
iba ser posible, preparaban el rifle, pa matar el marrano. Se usaban
hachas y rifles pa matar el marrano.

Butchering Day
Eremita García-Griego de Lucero

The idea was to help the husband prepare everything that
was going to be used. For example, the pan in which the cracklings
[*chicharrones*] were going to be made, the wife worked side by side
with the husband. The pan has handles. The wife grabbed one side,
and the husband grabbed the other, because the pan for cracklings is
heavy. It's quite heavy. You had to put all around it what we called kin-
dling, in order to start the fire. You'd put wood and all that stuff under-
neath the pan that you were getting ready. They [the men] would
sharpen the axe. If they were possibly going to use a rifle, they would

Sí, el hombre sí [preparaba el hacha], y la mujer tamién ayudaba muncho a preparar y a poner todo lo que se iba usar pa otro día pa matar el marrano. Cuando ya el marrano acababan de matalo, le van quitando con muncho cuidao todo el cuero. ¡Todo! Cuando ya el marrano va quedando, que ya el cuero todo estaba quitao, la cabeza toda tamién trozada completamente de lo demás del marrano, antonces van cortando la carne en pedazos asegún la familia lo va usar.

Cuando ya la lumbre se prendía, que estaba lista la manteca, la mujer ayudaba a cortar lo que es la manteca, con carne, pedazos de carne, para hacer los chicharrones, [y ponerlos] en una mesa grande. Todo eso se iba haciendo. Ai ayudaba la mujer, la familia, la esposa, pero cuando ya estaba too listo pa echar en la olla, que estaba muy caliente, y se comienza hacer la manteca y va cresentando la manteca, nomás los hombres eran los que se arrimaban ai porque la lumbre era algo fuerte. Tenían un palo propio pa meniala la manteca onde los chicharrones se van haciendo.

La manteca se apartaba de los chicharrones—es lo que llamamos pedacitos de carne con manteca—pero la manteca tamién, de ai se iba preparando. Ai sí ayuda la mujer, apartar la manteca en botes. Cuando ya se enfría, pus ya es lista, nomás tapala y guardala pa, para el uso de la casa.

Las morcillas tamién se hacían. Las mujeres, sí. Eso los hombres nunca; no hacían eso. Las mujeres hacían las morcillas. La carne adobada se usaba muncho [tamién]. El chile colorao se usaba muncho el día de la matanza.

Pocas veces [deslonjaba la mujer], si es que había pocos hombres. En veces que nomás una familia mataba un marrano, y antonces todos los hijos o hijas ayudaban en todo eso, [pero cuasi siempre] venían vecinos, sí. Por eso es causa que cuando había munchos hombres pa hacer un negocio, las mujeres estaban dentro de la casa y hacían el negocio, lo que es de la mujer. Solamente que estuvieran ayudando nomás [los hijos y la mamá] al papá, antonces la familia y la esposa ayudaban más. Pero los vecinos ayudaban. Tamién llevaban siempre su poquito pa sus casas cuando los vecinos eran convidados. Otras familias tamién llevaban su poquito de chicharrones, su poquito de manteca, en botes, poquito de carne.

Mi agüelito mataba cuasi cada sábado, cada dos sábados, mataba un

get it ready as well to slaughter the hog. Both axes and rifles were used to kill the hog.

Yes, the man prepared the axe, and the wife also helped in preparing and getting everything ready that was going to be used the following day to butcher the hog. When they were through killing the hog, they carefully removed all of the skin [with the outer layer of fat]. Everything! When the hog was left, that is, when the skin was completely removed, the whole head was completely cut off from the rest of the hog. Then they proceeded to cut the meat in pieces according to what the family's needs would be.

When the fire was lit, and the lard was ready, the wife helped to cut pieces of fat with meat, so as to make the cracklings, and to put them on a large table when they were ready. All of that was done. And that's where the women, the family, and the wife helped, but when everything was ready to put in the pan, when it was very hot and the fat was melting into lard, only the men got close, because the fire was pretty hot. They had a special stick to stir the lard in the pan when the cracklings were being prepared.

The lard would then separate from the cracklings—that's what we call small pieces of meat with some fat—but that's also how the lard was made. At that stage the wife did help in pouring the lard into cans. When the lard turns cold, it's ready to use. All you have to do is cover it and put it away for domestic use.

They also made blood sausage. The women did. That's something the men never did; they didn't do that. The women made the blood sausages. Marinated meat was also used a lot. Red chile was used a lot on the day butchering took place.

The woman rarely would cut away the layers of fat, unless there were only a few men around. There were times when only a single family slaughtered a hog, and then all of the sons and daughters helped, but almost always neighbors came, yes. So whenever several men were around to do a certain chore, the women stayed inside the house doing whatever chores they had. If only the family was helping, then the children and the wife helped more. But the neighbors helped. Also, the neighbors always took a little something home with them when they were invited. Other families also took a few cracklings, a little lard in cans, and a little meat.

cabrito nomás pal uso de la familia, carne pa la familia. Tamién la mujer ayudaba [cuando mataban vacas]. En esos tiempos ponían un caballo. Amarraban un cabresto del caballo y loo el cabresto va amarrado a la vaca. Y la vaca, cuando el caballo camina—le ponían una rondadilla—y el cabresto va caminando hasta que sube arriba, por ejemplo, de un álamo. Cuasi era un álamo el que usaban pa colgar una vaca o un, sea, un toro. Tenían [sus abuelitos] un árbol grande adelante de la casa. Ai era onde se hizo muncha matanza en ese álamo. Era un álamo muy grande y muy fuerte.

My grandpa slaughtered just about every Saturday, every other Saturday, a young goat [*cabrito*], strictly for family use, meat for the family. The wife also helped whenever they slaughtered cows. Back in those days they'd hitch up a horse. They'd tie a rope to the horse's saddle and then the rope would be tied to the cow. And then the cow, when the horse walked forward—a pulley was used—the rope pulled the cow up, for example, into a tree. It was generally a cottonwood tree that was used to hang a cow, a bull, or whatever it might be. They [her grandparents] had a large tree in front of their house. That's where a lot of slaughtering was done, in that cottonwood. It was a very large, strong cottonwood.

3

Washboards, Stove Irons,
and Wool Mattresses

When we were kids, my mother would say to us: "L'agua no le tiene miedo a la roña" ("Water isn't afraid of dirt"). This was her subtle way of admonishing us not to come to the dinner table with dirty hands. On Saturday afternoon, she also had us heat water on the stove to take a bath. At times two of us bathed in the same water, in order not to be wasteful. Moreover, there were no shampoos, hair conditioners, or bath oils. It was plain water, a wash cloth, and soap; often the same bar soap (made with rancid lard and lye) was used both for bathing and washing clothes.

In this chapter, women take us into the world of washboards, irons, and mattresses, an environment in which their tolerance for primitive and harsh conditions is astounding, given today's conveniences. Susanita Ramírez de Armijo, in "No usábamos jabones de polvo" ("We Didn't Use Soap Powder"), provides us with a vivid depiction of their situation. Even so, it is difficult to grasp how women coped without hot running water and other amenities.

My mother, like so many women on the Río Puerco, made certain our clothes were always clean and pressed, in particular on Sunday morning, before heading for the placita to attend mass or a community function.

Once Sunday evening came, it was time for children to gather kindling, chop wood, and fill up the tin tubs (*cajetes*) or large tin cans (some people were so poor they did not have tubs). Ordinarily there were three tin tubs: one had lye or soap in boiling water; another contained plain hot water for a second wash; and a third, with cold water, was for rinsing clothes. Women customarily put bluing (Mrs. Stewart's) in the cold water to add a sparkle to the clothes. Clothes were separated and washed according to the type of material, color (white versus dark), and whether they consisted of pants, shirts, skirts, underwear, dresses, or lingerie. Women even washed the *ataderas* (garters) men used to hold up their sleeves when they were too long.

The water for washing came from rainwater collected in barrels or tanks from the *tejavanes* (pitched tin roofs) or the *canales* (rain spouts) from flat roofs. People hauled water in wagons in fifty-gallon barrels from *ojitos* (springs), *lagunas* (artificial lakes), or the river itself, in preparation for wash day, which for most families generally fell on Monday. How the practice began is unclear, but women at the turn of century in the Río Puerco valley already talked about Monday as wash day; it appears to have remained unchanged until well into the 1950s, when the villages became ghost towns.

Macedonia Molina, unlike some of the other women, did not learn to wash or to iron from her mother or grandmother. Being an orphan, with only her grandfather to guide her, she recalls with bittersweet humor, in "Yo no tenía días pa lavar" ("I Didn't Have Any Set Days for Washing"), how she would burn her grandfather's clothes; but she learned despite her bad experiences.

Wash day for my mother, I remember well, was a long and laborious day; scrubbing clothes on the washboard from morning to mid- or late afternoon, plus rinsing them, cleaning the clothesline, and hanging the clothing out to dry was no easy feat. This was especially trying during the cold winter months, when garments froze stiff on the clothesline; men's shirts resembled and felt like cowhides. The struggle to take them into the house along with the rest of the clothes was an ordeal that prompted laughter among us children, but it was not something my mother found humorous. Getting clothes ready to be ironed under those conditions was difficult indeed.

Women usually ironed on Tuesdays, but preparations for this chore

began on Monday evenings, when clothes were sprinkled and tucked in a tin tub until the following morning. They were also sprayed as they were ironed. How long it took to do the ironing depended on the amount of clothing,the number of irons on the stove at their disposal (generally, there were no ironing boards, so most women ironed on the dinner table), and whether the mother had a daughter or two to help her. Boys also were taught how to iron. At times it took all day to iron, particularly if the women had to starch several shirts, or press bedsheets, pillow cases, and dish towels. These last two were typically ironed first, followed by the bedsheets. Clothing was last. The majority of women ironed everything except socks, underwear, and lingerie.

In "Desbaratábanos el colchón y lavábanos la lana" ("We Would Tear the Mattress Apart and Wash the Wool"), Pina Lucero recalls having to retrieve at a young age the wool of dead sheep for stuffing mattresses and pillows. How often mattresses and pillows were taken apart and washed depended on factors related to health, personal hygiene, and whether families had bedsheets or not. At times it was not the wool so much that needed to be washed; rather, it was the mattress and pillow covers that were soiled. Other times the mattresses and pillows had become lifeless and flat (*aplastaos*). Keeping them clean was a matter only for women, but children were expected to help.

It was customary to wash mattresses and pillows (except pillows made from chicken feathers) in the summer. The mother would cut the seams and take out the wool, first from the pillows, then from the mattresses. After this was done, the covers were soaked in hot soapy water, scrubbed on the washboard, rinsed once or twice, and hung on the clothesline with *grampitas* (clothespins). Meantime the wool was also soaked in hot soapy water, rinsed once or twice, and spread on a tarpaulin to dry. Throughout the process, children helped, but our main duty, once the wool was dry, was to grab two *varas* (reeds) or *jaras* (willow rods)—one in each hand—and beat the wool, going up and down, first the right hand, then the left, in order to fluff it up before stuffing the mattresses and pillows so they were even, not lumpy. The mother then sewed them back together again, using a steel needle from 6 to 8 inches long to complete the task. Now both mattresses and pillows were ready for another year.

Hence, Mondays in the Río Puerco valley came and went, and regard-

less of the season, women faced the arduous duty of keeping clothes clean for the entire family. In most cases, since people were poor, the family wardrobe was limited; therefore, wash day was critical. Only extenuating circumstances, such as inclement weather or a serious illness, prevented women from fulfilling their washing responsibilities. Many things were unpredictable on the farm, but wash day was not one of them. Time and again I saw women and their children on Sunday evening up and down the Río Puerco valley fill their *cajetes* or large tin cans for boiling water and the *perchas* (clotheslines) wiped clean for the task at hand come Monday morning. Today, most of those remarkable women recall with mixed emotions their washing and ironing experiences of days gone by.

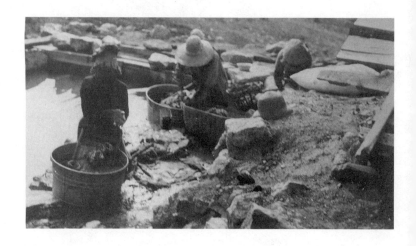

Women washing clothes, ca. 1920. Courtesy of Museum of New Mexico, neg. no. 8112

Yo no tenía días pa lavar
Macedonia Molina

Pues yo no tenía días pa lavar. Como estaba chamaca a veces teníamos [su abuelito y ella] agua y a veces no teníamos. Teníamos que carriar l'agua en barriles. Y había veces que no los [nos] dejaban gastar l'agua porque no había tiempo de ir a trae l'agua. Ai lavaba lo que podía uno. Lavaba en el lavadero. En veces planchaba; a veces no planchaba. Cuando ya crecí más sí, calentaba yo mis planchas y planchaba mi ropita con planchas de éstas de la estufa.

Pues solita. Naiden me enseñó [a planchar]. A veces [quemaba la

I Didn't Have Any Set Days for Washing
Macedonia Molina

Well, I didn't have any set days for washing. Being that I was a little girl, sometimes we had water and sometimes we didn't. We had to haul the water in barrels. And there were times when we couldn't use water, because there was no time to go after water. You simply washed as best you could. I used to wash using the washboard. At times I ironed; other times I didn't. When I got older, yes, I would heat the irons and I'd iron my clothing with those irons that you heat up on the stove.

ropa]; por eso me pegaban. Quemaba la ropa. Pero jueron muy crueles la gente de antes. Como les digo yo. "Ojali quisiera tener nomás un pedacito de él vivo todavía de mi *granpa*," les digo, "pa que les enseñara." Mi *granpa* nomás con los puros ojos los [nos] manejaba.

Pus pa todo nos hallábanos manias. Hacíanos como un cerquito redondo y ai poníanos un bote. No sé cómo le llamaban, y lo[o] le echaba uno lumbre abajo pa calentar l'agua, ¿no?, porque antes no teníamos [agua] caliente. Y de ai agarrábanos agua pa lavar. Y hervíamos la ropa tamién; la hervían con lejía pa que se limpiara. No había máquinas ni nada de eso. Y luego tamién lavaba uno sus forros de las colchas, y los remendaba y los volvía a poner patrás. Y tamién los colchones.

Well, I learned all by myself. Nobody taught me how to iron. There were times when I burned the clothes; they'd spank me for that. I'd burn the clothes. But people back then were very cruel. "I wish that I could have only a tiny piece of my grandpa alive," I tell my children, "so that he could teach you something." All my grandpa did was move his eyes to keep us in line.

We had ways of doing everything. We'd make like a little round fence and inside it we'd put a can. I don't know what they called that, and then you'd build a fire around it to heat up water, right?, because back then there was no hot water. That's where we got water for washing. We also boiled the clothes; we boiled them with lye so that they'd get clean.

There were no washing machines or anything like that. We also had to wash the bedspread covers, sew them, and put them back together again. The same thing was true of the mattresses.

Inesita Márez-Tafoya, 1990.

Nosotras acarriábanos l'agua
Inesita Márez-Tafoya

Por eso es lo que digo yo ahora. Ahora no. Ya no trabaja la gente [las mujeres] como trabajaban antes—lavando en el lavador, calentando l'agua, tendiendo la ropa. Se hacía tieso toda la ropa en el invierno. Y queriendo tener ropa seca par otro día, no podíanos. Teníanos que secarla como podíanos. Era muy duro, muy duro el tiempo de nosotras, antes, calentando afuera l'agua munchas veces pa poder jerbir la ropa pa que se hiciera blanca. Muy duro era el tiempo de nosotras, de antes, muy pesao.

Pues, el día principal pa la lavada siempre, siempre, pues, se ha dejao

We Hauled the Water
Inesita Márez-Tafoya

That's why I say what I say now. Now people, women, don't work the way they used to—washing on a washboard, heating water, and hanging up clothes. All the clothing got stiff during the winter. And wanting to have dry clothes for the following day, we just couldn't. We had to dry it any way we could. It was very hard. They were very difficult times for us, heating up water outside, to boil the clothes so that they'd turn white. Our days back then were very difficult, very strenuous.

Well, the principal day for washing always, always, has been left for

pa día lunes, pa los lunes. Y asina lo hacíanos. No faltaba el negocio de la casa; nunca se acababa.

Pues sí. Nosotras acarriábanos l'agua de allá del quinto patio. Del ojito acarriábanos l'agua. En el verano íbanos por agua fresca; nomás al propio íbanos por agua fresca. Estaba retirao pa trae l'agua en barriles pa lavar.

Güeno, yo tamién con mi plebe íbanos a salir con cubetas a trae l'agua cuando no estaba [mi esposo]. Había veces que le tocaba salir o no estaba allí o andaba trabajando de por allí o tenía uno que hacer los negocios de la casa. Porque el marido no estaba, tenía uno que entrale.

Monday, for Mondays. That's the way we did it. Household chores were never lacking; they never ended.

Why yes. We women hauled water from the middle of nowhere. We hauled water from the *ojito* (spring). In the summer we'd go after fresh water; we'd go just for that reason, to get fresh water. It was quite a ways to bring water in barrels for washing.

Well, the children along with me would take off with buckets to go fetch water when my husband wasn't home. There were times when he had to leave, or he wasn't there, or he was working somewhere around there, or there was household business to see to. If the husband wasn't home, you had to roll up your sleeves and go at it.

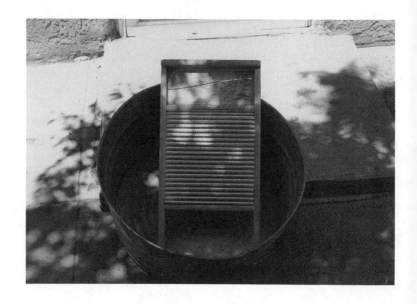

Cajete *(tin washtub) and* lavador *(washboard)*, Vicentita Chávez family, used during 1920s and 1930s.

No usábamos jabones de polvo
Susanita Ramírez de Armijo

No usábamos jabones de polvo como hay ora, ni nada de eso. Lo que usaban, que me acuerdo yo, que tenía mi mamá, llevaban de aquella lejía, que usan ora, y eso usaba nomás mi mamá pa cuando estuviera la ropa de que trabajaba [su marido], pa hacela blanca. Usaban de aquel jabón de barillas; de eso usaba mi mamá. Lavaba en lavador, diré por años.

Toavía cuando vinimos a San Ysidro eso usó por muncho tiempo hasta que, que no vinimos teniendo máquina de lavar, hasta que no,

We Didn't Use Soap Powder
Susanita Ramírez de Armijo

We didn't use soap powder or that sort of thing, like now. What we did use, that I remember my mother using, people had lye, that they use now, and that's what my mother used, so that my father's work clothes would turn white. People used bars of soap; that's what my mom used. She also washed on the washboard, for years, I would say.

Even when we came to San Ysidro, that's what she used for a long time, until the time came when we had a washing machine, which was,

güeno ya tendría yo, o ya tenía mis sesenta y ocho años cuando tuvimos máquina de lavar, que era el '83.

Güeno, sacaba mi mamá la ropa en cajetes. No nomás nojotros, los vecinos, como era su mamá de Juan, y su hermana. Estaba un ojo; diré que estuviera como de esa esquina, pueda que poquito más lejos. Le dicían el Ojo Atascozo. Este ojo no sirvía el agua para beber, nomás pa usala para lavar. Los animales la podían beber, pero la gente no, porque era una agua como que tenía azufre, dicía la gente.

Estaba otro ojito chiquito, ¿no? Y este ojito sí tenía agua pa beber pero no estaba cerquita del otro. Y ésa usábamos pa beber y este otro usábamos pa cuando lavábamos y echábamos la ropa toda esa en cajetes. Nos encaminaba mi mamá a mí y a mis hermanos y allá en el ojo poníamos una lonita para sombriar. Pus como había munchos palos, muncha leña, llevábamos su tina pa calentar l'agua pa lavar allá donde lavábamos en el ojo ese. Pus aá lavábamos y luego muncha ropa la tendía mi mamá en los parrales, los chamisos y la demás no. Las demás cosas grandes, como era sábanas, todo eso, las tráibamos y las tendíamos en la casa.

Se calentaba l'agua allá mismo onde el ojo ese. Allí echábamos la misma lumbre. Poníamos unas piedras, como ora hacen cuando van al piquinic. ¿Ponen unas piedras no? Y ai echábamos la lumbre y ai ponía mi mamá su tina, la que iba usar pa calentar l'agua. Ai calentaba l'agua y sacaba l'agua caliente pa usar pa lavar.

¿Cuál era el uso digo yo de que lavaban? Le daban dos lavadas en el lavador y luego de ai la sacaban otra vez y jirvían la ropa. ¿Cuál era la idea? ¿Por qué tenían ese costumbre? Izque pa que se hiciera blanca, dicía mi mamá. Yo no sé. Güeno, loo que ya que jirvían aquella ropa blanca, la sacaba de allá mi mamá, la enjuagaba bien con dos aguas y ya ésa estaba lista pa la que iba a usar pal almidón, y pa tendela y tenela tendida y logo otro, como día miércoles, día jueves, rociaba toda aquella ropa que íbamos a planchar.

No usábamos jabones de polvo

oh I must have been, I was already sixty-eight years old when we had a washing machine. That was in '83.

Well, my mom used to take out the clothes in tin tubs. Not just us, the neighbors too, like for example Juan's mother [her husband's mother] and his sister. There was a spring. I'd say it was from about here to that corner, perhaps a little bit farther. They called it Ojo Atascozo. The water from this spring was not good for drinking, only for washing. Animals could drink it, but not people, because the water had like sulphur in it, according to everyone.

There was another tiny spring, different, okay? And this spring did have drinking water, but it wasn't close to the other one. And that's what we used for drinking water, and the other we used for whenever we would wash and toss all the clothes in tin tubs. My mother led me and my brothers to where the spring was, and we'd set up a small tarp for shade. Since there were lots of sticks and a lot of wood, we'd take our tin tubs for heating the water for washing there at the spring. That's where we washed. A lot of the clothing my mom would spread on top of bushes, sagebrush, and so on, but not the rest. The rest of the large stuff, like bedsheets and so forth, we'd take them and hang them up at home.

Right there where the spring was, is where we heated the water. That's where we built the fire. We set up some rocks like they do nowadays for a picnic. They set up rocks, right? That's where we'd build a fire, and that's where my mom would put her tin tub, the one she was going to use for heating water. That's where she heated up the water and used it for washing.

And I ask myself, how did they go about washing? They gave the clothing two scrubbings on the washboard, and from there they'd take it out again and boil it. What was the purpose? Why did they have that custom? Supposedly it was so that it would turn white, according to my mother. I don't know. Okay, once the clothes boiled and were white, my mother would take them out, she'd rinse them well in two different changes of water, and then they'd be ready for the starch and to be strung on the clothesline. And then by next day, like Wednesday or Thursday, my mom would sprinkle the clothes that were going to be ironed.

El jabón es hecho con mantecas
Macedona Molina

El jabón es hecho con mantecas feyas, que se ponían rancias, ¿no? Dirritía uno la manteca. Jirvía l'agua con lejía. Trementina le echaban munchas veces. Le dicían el jabón de trementina, ese jabón amarillo. Le echaban botes de trementina, porque la gente usaba muncho la trementina pa enchasones y todo eso. Bueno, pus jirbía uno l'agua y ai echaba la lejía y echaba ésta [la trementina], si acaso querías que juera amarilla. Pues yo no sé qué, no me acuerdo qué más le echaban a l'agua. Y loo le echaban la manteca y la jirbían hasta que ya se hacía como espesa. Y luego de ai si querías, como te digo yo, unas hacían cajitas diferentes pa hacer barillas, unas de ojelata, otras de tabla, y loo ai la echabas [la manteca], la vaciabas de la olla y ai se hacían las barillitas. Y otras no. Otras nomás las hacían asina cuando estaba cuajándose. Con el cuchillo las cortaba uno.

[El jabón], pa lavar todo: suelos, ropa y todo. Pa veces que no tenía uno [más], y tamién la cara. Sí, tamién la cara los [nos] lavábamos. ¡No creas! Y tamién pa eso, como ora usan *shampoos*.

Nojotros tráibamos raiz de la negrita, de la yerba de la negrita. Le cortábamos la raiz y la pelábamos, la colgábamos. Teníamos un cuarto. La usábamos nojotros de *shampoo*, y lo[o] tamién aquel otro raice de amole.

Soap Is Made with Lard
Macedonia Molina

Soap is made from spoiled lard, lard that had turned rancid, right? You'd melt the lard. You'd boil the water with lye. Often times they'd add turpentine. They'd call that yellow soap, turpentine soap. They'd pour cans of turpentine into the soap, because people used to use turpentine a lot for swellings and stuff like that. Okay, you'd boil the water and then you poured in the lye, and the turpentine, in case you wanted the soap to turn yellow. Well, I don't remember what else was put into the water. Then came the lard, and they boiled it until it turned thick. And from there, if you wanted, as I say, some women prepared different little tin containers to pour the soap into; others were made from wood, and that's where you poured in the lard, from the pan, and that's how you made the bars of soap. Others did it differently. Other women merely made the soap by spreading it and then just letting it set. Then you'd cut the bars of soap.

The soap was used for washing everything: floors, clothes, and everything. At times you didn't have anything else, so you even used it on your face. Yes, we even used it for our face. Don't kid yourself! Just like we use shampoos today.

We used to carry home the *raiz de la negrita*, from the *yerba de la negrita* [bristly mallow]. We would cut off the root and we'd peel it. We'd hang it up. We had a separate room. We used it as a shampoo, as well as that other root, *raice de amole*.

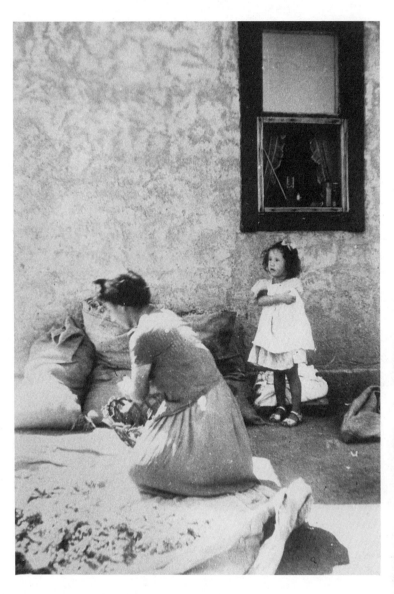

Teodorita García-Ruelas, washing and drying mattress wool, 1945.

Desbaratábanos el colchón y lavábanos la lana

Pina Lucero

En esos años cuando estaba yo muy mediana, se morían borregas ai cuando las andaban cuidando, y aquí vamos. "Ai se murió una borrega." Aquí vamos a quitale la lana y loo traela y la lavábanos en tantas aguas y le echábanos sal soda pa que se limpiara aquella lana pa hacer almuadas, pa hacer colchones.

Yo me acuerdo que mi mamá, nunca había colchones de otra clas más que de lana. Los lavaba. Desbaratábanos el colchón y lavábanos la lana y loo la tendíanos en una lona y loo ai la variábanos con las varas. Ai estaba con la vara, pa que se esponjara, que quedara *fluffy*.

We Would Tear the Mattress Apart and Wash the Wool

Pina Lucero

During those years when I was very young, sheep would die when we were taking care of them, so there we'd go. "A sheep died over there." There we'd be on our way to remove the wool from the sheep to bring it home, wash it in so many changes of water, and pour soda salt in it to clean the wool for making pillows, for making mattresses.

I remember that my mom had nothing but wool mattresses. She'd wash them. We'd tear apart the mattress and wash the wool, and then we'd spread it on a canvas and we'd whip it with wooden rods. There

Loo se ponía hacer el colchón otra vez. Loo tenía bastas el colchón. Le echaba uno la lana pa dentro y loo amarraba la basta. Loo volvía otra vez hasta que le había hecho; tare bien tino que le tenía ese colchón derecho. Es contada la vez que lo tenía uno que desatar otra vez pa golvelo hacer.

Güeno, más antes ya le tenían puesto bastas al colchón. Lo voltiaban al revés y le cosían. Cortaban [las mujeres] una tira como un listón, y se la cosían de un lao y loo del otro. Y loo cuando ya llenaban de lana amarraba ese listón. Después entró la abuja esa que la podía uno pasar pa hacer la basta. Unas abujas [largas]. Tavía tengo yo una de ésas. Pero muncho más antes, ya estaba cosida [la basta]. Eran en pedazos, como un listón, en cada lao.

¡Uhhh! Cada seis meses [lavábamos los colchones], porque la gente en esos años quizás estaba muy atrasaa. No usaban munchas sábanas. Ora se pudre el colchón ai y lo tapan un atajo de veces con la sábana. No es como antes.

¡Ora aquellas almuadas! Yo me acuerdo que mi mamá las lavaba cada tres meses—y la lana. Tavía tengo yo de esas almuadas de lana.

Desbaratábanos el colchón y lavábanos la lana

you were with the wooden rods. We would whip the wool so that it'd fluff up, so that it'd come out fluffy.

Then you got down to making the mattress over again. The mattress also had quilting. Once you put the wool inside the mattress, then you tacked down the quilting. Then you would repeat the process [about every 6–8 inches apart in straight horizontal lines] until it was finished; it took a lot of skill to keep the mattress quilted straight. Rarely did you have to take it apart so as to redo it [due to crooked lines].

Now, back then mattresses already had quilting on one side. Then you turned the mattress over and you sewed it on the other side. The women would cut a strip of rag like a ribbon, and they'd sew it from one side of the mattress and then from the other. Then when a section of the mattress was stuffed with wool, you tied that ribbon. Later the long needle was introduced so that you could run it through the mattress, from top to bottom, to do the quilting. They were long needles. I still have one of them. But way back then, the quilting was already sewn. They came in pieces, like a ribbon, one on each side.

Uhhh! We used to wash mattresses every six months, because people in those days were very poor. They didn't use a lot of bedsheets. Nowadays the mattress rots and people cover it a bunch of times with the sheet. It's not like it used to be.

You should have seen those pillows! I recall that my mom used to wash the covers—and the wool also—every three months. I still have one of those wool pillows.

Cadrar la lana
Dorela Romero

Sí, todo el tiempo [lavábamos colchones]. Pus rociábamos la lana de todos los colchones, y loo calentábamos l'agua y nos poníamos a lavalos y tendelos. A veces teníamos que ir a lavar hasta la lana. Mamá tenía idea todos los veranos de lavar la lana, en el verano, porque ella nos mandaba.

Teníamos que variar la lana y teníamos como unas jaras pa variala, y unas cardas pa cadrar la lana pa que se esponjara. Mamá tenía cuatro: dos pa mi hermana y dos pa mí. Cardas, como un peine, nomás que era diferente la carda adentro, más menudita. Asina eran ésas nomás que eran más menuditas, más chiquitas. La cadraban y la levantaban—cadrar la lana.

Las almuadas [tamién], sí. Lana de borrega y asina. De pluma tamién. Mamá no nos dejaba desbaratalas. Las echaba, las lavábamos por fuera. Ya cuando teníamos la máquina no, era nomás destapalas y ya está. Pero cuando las esprimíamos con la mano, antonces era la broma. Mi hermana las esprimía, y luego las colgábamos.

Trabajábamos duro.

To Card the Wool
Dorela Romero

Yes, we used to wash the mattresses all the time. Well, we'd rinse the wool from all of the mattresses, and then we'd heat the water and get down to washing and hanging up the mattress covers. There were times when we even had to go wash the wool. Mom had a habit of washing the wool every summer, during the summer, because she had us do it.

We had to beat the wool and we had rods to do it with, and cards for combing the wool so that it'd get fluffy. Mom had four: two for my sister and two for me. Cards, like combs, except the card had finer teeth in the middle, much smaller. That's the way they were, except that the wires were finer, smaller. They would comb the wool and toss it up in the air. To card the wool [that's what it was called].

We did the same thing to the pillows, lamb's wool and so forth. Those made with feathers also. Mom wouldn't let us rip them apart. She'd toss them, we'd wash them on the outside. Once we had a washing machine it was just a matter of tearing them apart and that's it. But whenever we had to wring them out by hand, that's when it was a pain. My sister would wring them out, and then we would hang them to dry.

We used to work very hard.

4

Sewing, Mending, and Embroidering

The narratives in this chapter detail the numerous ways in which women provided clothing for their families, as well as other essentials such as dish towels, bedsheets, and pillow cases. Regardless of the undertaking, women accepted the challenge with aplomb, but the right yarn goods, needles, and thread were helpful in fulfilling their commitments.

Each one of the contributors has a unique story to tell. The reminiscences seem to stretch far back into the distant past, but they bring to life a clear and vibrant picture of their sewing and mending days. Recollections like Pina Lucero's "*Blouses* de sacos de harina" ("Blouses from Flour Sacks") and María Catalina Griego y Sánchez's "Delantares" ("Aprons") are slices of life touched with both humor and sadness. Individual needs assumed priority over concern for how a person looked in public. Everyone was in the same socioeconomic situation, so it did not matter whether girls wore blouses made from flour sacks or if boys' underwear was made from tiny Golden Grain or Bull Durham tobacco sacks. Money to purchase items such as underwear in Albuquerque was scarce, and people thus saved it for more precious (and visible) pieces of clothing such as shoes, cowboy boots, socks, dress pants, blue demins or overalls (*lonas*), First Holy Communion dresses, and wedding outfits. There were few women such as my paternal grandmother who owned a mantilla

and a *tápalo* (shawl), both of which had come either from Spain or Mexico and were worn for special religious occasions.

Women who possessed the talent made ends meet in whatever ways they could dream up or invent—such as sewing two to three hundred tiny tobacco sacks together to make a bedspread. These little cotton sacks became a popular item in many households with both male and female smokers; they were also used to make tablecloths and bedsheets, many of which are family heirlooms today. A core of women existed who, given the right material and sewing tools (for example, needles, cotton thread, scissors, tape measures, etc.), could look at a picture in a clothing catalogue and cut out a dress with a circular hem, or a blouse or skirt requiring basic stitches such as hemming, running, slip, or overhand stitches.

Others, like Dorela Romero in "Bordábanos fundas" ("We Embroidered Pillow Cases") confess to being poor seamstresses, barely able to patch up the holes in boys' pants caused by shooting too many marbles (*bolitas*), let alone sewing buttons on shirts. But the introduction of Singer sewing machines in the Río Puerco valley during the 1930s and early 1940s certainly made the task of making clothes a lot simpler. While women like Dorela Romero shunned sewing, some were quite capable of using *correa*, or strands of leather, to sew up shoe seams that had come apart.

We as children learned a lot about sewing from watching our mother, something she encouraged us to do. She also made sure that we observed at least how to thread a needle and mend our own socks by inserting a bottle in them, which made it easier. We even embroidered dish towels.

I clearly recall one episode involving my brothers and sisters, six in all; each one of us had to embroider a dish towel with the name of one of the days of the week. Sunday was reserved for my mother. The teachings and attitudes stemming from this single experience remain a part of my personality today.

One outstanding characteristic of the people of the Río Puerco valley was their altruism. As Adelita Gonzales says, if a boy or man went and asked to borrow a shirt, you simply loaned it to him ("Se la prestaba uno al otro"). The same attitude applied to the ladies. If one of them said,

"Préstame ese túnico," ("Loan me that dress"), you let her borrow it. People were poor and helped each other in the best way possible. In addition, there was no stigma to being seen in public wearing somebody else's shirt, pants, or blouse. This was equally true of clothing that had been mended or did not match; nobody made disparaging remarks about how you looked, whether you were a child or a grown-up. "No había quien se buslara" ("No one made fun of you"), exclaims Adelita Gonzales—even if your pants clashed with the color of the shirt you were wearing.

Hand-me-downs were also common, worn until they were no longer wearable. In fact it was not unusual, albeit embarrassing and even humiliating, for boys to have to wear their older sisters' panties, called bloomers. In a large family, the beneficiary of new clothing was generally the eldest or the youngest. The eldest, either boy or girl, as a rule did not wear the mother's or father's clothes; as far as the last child of the family was concerned, most siblings' shirts, blouses, pants, undergarments, and so on wore out by the time they got that far.

Whether one talks about blouses, knee patches, underwear, dish towels, or bedsheets, the narrative that best synthesizes the spirit and contents of this chapter is Mary Jaramillo Gabaldón's "Mis vecinas hacían sábanas de puros saquitos de tabaco" ("My Neighbors Made Bedsheets From Little Tobacco Sacks"). Her comments about making aprons and slips, about mending and crocheting, or about embroidering pillow cases, the latter still in her possession at the time of our interview (she has since passed away), are altogether comprehensive. Her expression of gratitude, like that of her comadres, for the practical and comprehensive knowledge they gained from their foremothers is repeated numerous times in this chapter.

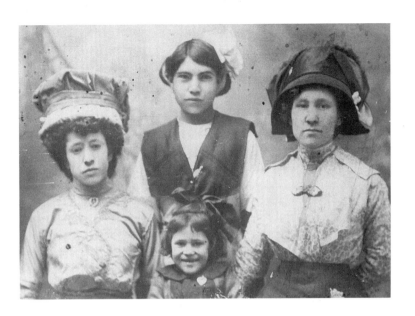

Mother and daughters dressed for a special occasion, ca. 1900.

Custoriaban muncho
María Catalina Griego y Sánchez

Custoriaban muncho. Mamá Emilia, mamá Trinidá hacían la ropa pa la familia: pantalones, camisas y todo. Y quedaban muy bien. Ora si no la hace uno exaitamente no la quieren usar. Porque yo después de casada, que crié a mi familia, enviudé muy joven. Yo hacía la ropa de mis hijitas, de mis hijitos. Nomás lo que no podía hacer bien en los pantalones de mis hijitos era la bragueta. (Risas). No la podía hacer pa que quedara bien, pero al fin aprendí. Sí, allá [en Guadalupe] custoriábanos muncho.

Cuando vinían mamá Emilia, mamá Trinidá, pacá pal Alburquerque, llevaban muncho material y con que costuriar y bordar. Oh, llevaban munchas clases de materiales pa hacer cortinas, pa hacer tuallas, y too lo que necitábanos. Pa hacer las sábanas.

Túnicos con mangas muy bonitas. Quedaban enponjadas, muy bonitas. Levitas. Nos hacían levitas, que se parecían a los túnicos. Cuando íbanos a misa, que iba el padre de ai de Cuba, íbanos muy vestiditas. No faltaba la papalina. Muy bonita. Ora quisiera yo hallar muestras pa poder hacer papalinas. Eran muy bonitas.

Munchas veces los mayores cuidaban muncho su ropa y quedaba flamantita, quedaba pa golver a usar. Se la pasaban al otro en seguida. Allá [en Guadalupe] cuando uno se vistía tenía la ropa muy bonita, alzada, con almidón. Todo era con almidón.

Sí. [Hacían ropa de abajo de sacos] de harina. Que munchas veces hacía uno chiste que tenía una rosa de castilla el saco, que quedaba en las nalgas. (Risas). Quedaba pintada la rosa. Sí hacían pantaletas que les dicían, antes *bloomers*, con lástico, hasta bajo de la rodilla, porque no se enseñaba la rodilla por nada. El túnico era largo y las medias quedaban abajo del lástico de las pantaletas, de los *bloomers*. ¡Pero no pasábanos frío.

Women Sewed a Lot
María Catalina Griego y Sánchez

Women sewed a lot. Mother Emilia [her maternal grandmother] and Mother Trinidad [her paternal grandmother] made the family clothing: pants, shirts, and everything. And they fit very well. Nowadays if you don't have it exactly right, children won't wear it. After I got married, when I was raising my family, I became a widow at a young age. I used to make my sons' and daughters' clothing. The only thing that I couldn't do very well was the fly on my sons' pants, but I finally learned how to do it. Yes, over in Guadalupe we sewed a lot.

Whenever Mother Emilia and Mother Trinidad came here to Albuquerque, they took back a lot of material and what have you to sew and embroider with. Oh, they would take back all kinds of yard goods for making curtains, for making towels, and everything we needed. For making bedsheets.

They made dresses with very pretty sleeves. The sleeves would turn out puffy, very pretty. Little jackets. They made us little jackets, that matched the dresses. Whenever we went to mass, when the priest came from over in Cuba, we'd be all dressed up. The sun bonnet was never missing. Very pretty. Now I wish I could find patterns to be able to make sun bonnets. They were very pretty.

A lot of times the older kids really took care of their clothes and they were like brand-new, ready to be worn again. They were passed on to the next one in line. Over in Guadalupe when you got dressed up the clothes were very pretty, puffed-up, with starch. Everything had starch in it.

Yes. [Women made underclothes from sacks] of flour. Many times you'd crack a joke because the sack had a rose and it'd end up on your butt. (Laughter). The rose was clearly visible. And they used to make knickers, bloomers they used to call them, with elastic, that came down to the knee, because you wouldn't show your knee for anything. The dress was long and the stockings were tucked under the elastic of the knickers, that is, the bloomers. But we didn't get cold!

Blouses de sacos de harina
Pina Lucero

Había veces que era tan duro pa jallar material, pero juntaban [las mujeres] saquitos de la harina. Yo me acuerdo que mi mamá llegó hacer *blouses* a mí de sacos de harina. Nomás ponía un papel y ai cortaba de otro. Sacaba el molde de otro cuerpo antes de que se acabara de moler. De ai cortaba el molde. [Salía yo] con el letrero en el espinazo. (Risas). La Paloma, le dijían. Ese *blouse* que me hizo mi mamá una vez vinían unos sacos y estaban rayaos azules. Pus no se le quitó la marca porque en esos años no había Clorox, ni Purex como hay ora. *So,* el *blouse* salió rayao pero asina lo usé. Todas, todas [las muchachas]. No se buslaban porque todas estaban iguales.

[Saquitos] de tabaco, los juntaban y loo los añidían y hacían tuallas de los trastes, o hacían colchas pa tapar las camaltas, porque en esos años no había *bedspreads*. Solamente las que hacían, ¿ves?

Compraban el lienzo que le dijían pa hacer las sábanas y hacían una grandota y loo la bordaban pa ponela pa la camalta. Y las almuadas no las tapaban antes. Tenían que ir las fundas de almuada, las almuadas con las fundas de almuada, y por eso tenían muncho almidón pa que estuvieran bonitas. Ai se vían con los embordes en los laos.

Yo me acuerdo que con los saquitos les hacían *shortes* a los muchachos. Ropa de abajo. Sí, es verdad, *the underwear*. (Risas). Era muy duro jallar materiales. No como ora. Ora tiran muncho la plebe, la gente. Tiran munchas garras, munchas cosas güenas.

Muncho remendaban [las mujeres]. Mi mamá remendaba muncho. Casi con la mano. Me acuerdo que se estaba hasta medianoche en el invierno cosiendo—los calzones, las camisas, poniendo botones, los zapatos con correa de los muchachos.

Los zapatos se descosían porque en esos años sí vendían güenos zapatos, pero se descosían y loo los cosían con correa. Yo me acuerdo que mi mamá se estaba cosiendo los zapatos con correa ai. Tamién los asolaba y loo los cosía con correa. Casi los hacía nuevos otra vez. Sí, mi mamá hacía eso.

Desde que estaba chiquita [tamién] comencé a bordar yo. Me

Blouses from Flour Sacks

Pina Lucero

There were times when it was really difficult to find sewing material, but women collected small flour sacks. I recall that my mom made blouses from flour sacks. All she did was to use a piece of paper and cut out the pattern. She'd cut out the pattern using another blouse before it wore out. That's how she did it. I'd go out in public with the letters from the flour sacks still showing on my back. (Laughter). La Paloma ("The Pigeon"), as we used to call it, was the name of one brand. My mom made me a blouse once from some flour sacks that had blue stripes. The stripes simply didn't come off, because back in those days there was no Clorox or Purex as there is today. So the blouse came out with blue stripes, but that's the way I wore it. All, all of the girls were in the same boat, so they didn't make fun of one another.

Little tobacco sacks is what women collected and then they stitched them together to make dish towels, or they'd make bedspreads, because back then there were no bedspreads. The only ones around were the ones they made, you see?

People would buy linen, as it was called, to make bedsheets, and they would make huge ones, and then they'd embroider them for the beds. And the pillows, back then people didn't put on pillow covers. The pillows and pillow cases were one and the same, and that's the reason they had a lot of starch, so they'd be pretty. You could see the embroidery along the edges.

I recall that mothers made shorts for the boys from the little sacks. Underwear. Yes, that's right. Underwear. (Laughter). It was very difficult to find sewing materials. Not like now. Nowadays the kids, people in general, throw a lot of material away. They throw away rags, lots of good things.

Women mended a lot. My mom used to mend a lot. She did most of it by hand. I remember that she'd stay up till midnight during the winter sewing pants, shirts, replacing buttons, plus the boys' shoes, with leather thread.

enseñaba mi mamá. Me enseñaban mis tías. [Bordaba] las fundas, las tuallas de los trastes o manteles pa las mesitas, porque en esos años usaban puros manteles pa las mesitas. D*oilies, doilies.* Todo eso. Todo hacía, que nos enseñaba la mamá, la agüelita.

If the shoes came apart at the seams—because back in those years they did sell good shoes, but they would come apart—then they'd sew them back together with leather thread. I recall that Mom would spend a lot of time sewing the shoes with leather thread. She also put soles on them. She practically made them look like new. Yes, my mom did all of that.

When I was a little girl I started to embroider, yes. My mom used to teach me. My aunts taught me. I'd embroider the pillow cases, the dish towels, or small tablecloths, because back then they used only table-cloths on tables. Doilies, doilies.

I did all of that. I made everything, which is what Mom taught us, as did my grandma.

Delantares

María Catalina Griego y Sánchez

Déjame platicarte de los delantares. Mi mamá Emilia, yo y Eremita [su hermana] y mi tía Taida y mi tía Agapita, todas nos juntábanos en la tarde ai en el portal [del Lolo, su abuelo] en Gualupe. Bueno, pues, eh, enbordábanos munchos delantares y mamá Emilia nos hacía papalinas, muy bonitas.

Y a mi y a Eremita nos mandaban muy de mañana con un botecito de café con lonche a cuidar las cabras arriba de la mesa, que está ai seguida de la casa de en papá Teodoro. Y yo era poco más rezongona, y le dijía yo a Eremita—nos mandaba mamá Emilia con los túnicos muy planchaditos y papalinas y delantares bordaos—y le dijía yo, "¿Pus qué nos molestamos en bordar estos delantares nomás pa ir allá a la mesa a cuidar las cabras?" Y me dijía Eremita, "¡Cállate! No rezongues. No digas nada. Se nos va enojar mamá Emilia."

Pus no, yo siempre estaba un poco más rezongona. Pero me acuerdo que eran unos delantares muy bonitos, papalinas, y los vestidos estaban poco largos. No eran rabones. Y le dijía a Eremita, "Bueno, tan siquiera con el vestido largo no nos repelamos las rodillas." Pero eran los tiempos muy alegres, muy bonitos.

Aprons
María Catalina Griego y Sánchez

Let me tell you about aprons. My mother Emilia, Eremita [her sister] and I and my aunt Taida and my aunt Agapita, we'd all get together in the evening on Lolo's [the grandfather's] front porch in Guadalupe. Very well, then, we would embroider lots of aprons, and Mother Emilia would make us very pretty sun bonnets.

They used to send us off, Eremita and me, very early in the morning, with lunch packed in a little coffee can to take care of the goats on top of the mesa, which is right next to Father Teodoro's house. And I used to be a bit of a grumbler, and I'd tell Eremita [her sister]—Mother Emilia would send us off with newly ironed dresses and sun bonnets and embroidered aprons—and I would say to her, "Why do we bother to embroider these aprons just to go to the mesa to take care of the goats?" And Eremita would say to me, "Shut up! Quit complaining. Don't say anything. Mother Emilia's going to get mad at us."

But no, I was always a bit more of a grumbler. But I remember that the aprons, and the sun bonnets, were beautiful. And the dresses were quite long. They weren't short. And I'd say to Eremita: "Well, at least with a long dress we won't get our knees scraped." But they were very happy times, very nice.

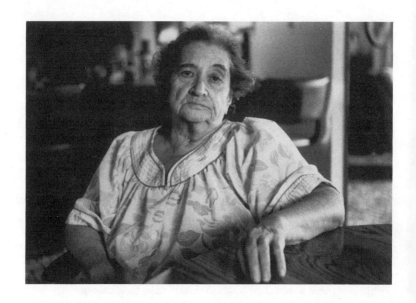

Dorela Romero, 1990.

Bordábamos fundas
Dorela Romero

Mi suegra, sí. Ella era costurera y ella me hacía la ropa. Y me cosía lo que yo quería. Pero yo no. Cosía con la mano asina, pero costurera no jui como ella. Ella sí cosía muy bonito.

La hacía [ropa para los hijos], y hasta los vestidos pa la escuela. Ella no necesitaba molde pa cortar lo que quería. Ella lo que vía lo cortaba y el otro día lo cosía. Yo no podía hacer nada. Ni tenía la idea. Mi agüelita mía no jue costurera [tampoco]. Sí cosía asina pero no como mi suegra.

Yo no llegué a ver ropa. Yo llegué a ver tuallas de trastes de saquitos pero ropa no. Mi papá era muy chupador, y mamá tamién. Y ellos

We Embroidered Pillow Cases
Dorela Romero

My mother-in-law, yes. She was a seamstress, and she made me my clothing. She would sew whatever I wanted. But not me. I could sew with my hands, yes, but a seamstress I was not, not like her. She sewed beautifully.

She made clothes for her children, and even the uniforms for school. She didn't need a pattern to cut out whatever she wanted. Whatever she saw, she'd cut out, and the next day she'd sew it. I couldn't make anything. I didn't have the knack. My grandma wasn't a seamstress either. She would sew simple things, but not like my mother-in-law.

juntaban todos los saquitos y luego nos ponían a desbaratalos y de ai hacían las tuallas de los trastes. Con la mano. Salían muy suave. A mí no me gustaba coselos con la máquina. Yo los cosía con la mano. Mi hermana sí, ella usaba la máquina. Yo no.

Todavía bordo. Bordábamos fundas. Bordábamos tuallas de los trastes. [Tamién remendábamos] pantalones de lona. Era un encanto que queríamos muncho, y teníamos hermanos [que] siempre andaban con las rodillas de ajuera. Las rodillas. Ésos que jugaban a la bolita.

[Crochaba] muy poco. Yo no sé crochar. Mi suegra sí, ¡qué bonito crochaba! Si vía una cosa yo, y le dijía yo, "Vi esa cosa en tal lugar, y tan bonita que estaba," nomás le dijía cómo era, y ella me la sacaba. Yo no, ni viendo la garra podía.

I never saw clothes made from them. I saw dish towels made from little tobacco sacks, but not clothing. My dad was quite a smoker, and my mother also. They used to gather all the little sacks and then they had us rip them apart, and that's how they made dish towels. By hand. They came out really neat. I didn't like to sew them on the sewing machine. I did them by hand. My sister, yes, she used the sewing machine. Not me.

I still embroider. We would embroider pillow cases. We would embroider the dish towels. I used to mend denim pants. That's something we really enjoyed doing, and we had brothers who always went around with their knees sticking out. Those who played marbles.

I used to crochet very little. I don't know how to crochet. My mother-in-law, yes. Boy did she crochet beautifully! If I saw something, and I said to her, "I saw this thing in such and such a place, and it was so pretty," all I had to tell her was what it looked like, and she'd duplicate it for me. Not me, not even by looking at the silly thing.

Tablecloth, made from 150 tiny Golden Grain and Bull Durham tobacco sacks, ca. 1890.

Mis vecinas hacían sábanas de puros saquitos de tabaco

Mary Jaramillo Gabaldón

Yo no, yo no cosía ropa. Podía hacer delantares, sí, pero cortar ropa no, solamente con un molde, pero cortar ropa no. Pero de este trabajo sí, de croche sí. De túnicos viejos [hacía los delantales]. O de algún material que quedaba ai. De los sacos de harina. Naguas de abajo hacía con sacos de harina.

Yo remendaba. Remendaba mis medias, y remendaba la ropa de mi esposo. Algunas las chábanos *darn*, darniarlas, o una botella dentro de la media. Y otros [pantalones] les chábanos remiendos. Poníanos un parche y los cosíanos.

My Neighbors Made Bedsheets from Little Tobacco Sacks

Mary Jaramillo Gabaldón

Not me. I didn't make any clothes. I could make aprons, yes, but cutting out clothes, no way, only using a pattern. But cutting out clothes, not a chance. But when it came to this kind of work, like crocheting, yes. I used to make aprons from old dresses, or from some leftover piece of material. From flour sacks. I used to make slips from flour sacks.

I would mend. I'd mend my stockings and my husband's clothes. Some of the clothing we'd darn; we'd darn it. Or we'd put a bottle in-

Yo bordaba tamién—mis tuallas de trastes, mis fundas de almuada. Todas están bordadas. Todas mis fundas están bordadas. Tavía tengo trabajo que hice en San Luis. Tavía tengo fundas de almuada, tuallas de trastes, bordadas que bordé allá en casa, en San Luis.

Pus sabe que yo aprendí el croche y a bordar cuando estuve en la escuela en Cuba, con las hermanas, con las hermanas franciscanas, porque ellas nos enseñaban. Casi nos enseñaban más a trabajar que en la escuela, porque yo aprendí muy poco.

En el veinte y cuatro y de ai pallá, hasta el veinte y siete, me estuve trabajando aquí yo con las hermanas en el huerfanato, que estaba aquí en la Plaza, en Alburquerque. Ai estuve en el veinte y siete.

Sábanas, sábanas hacían [las mujeres]. Yo no llegué hacer, pero yo vide a mis vecinas que hacían sábanas de puro saquitos de tabaco. ¡De puro saquitos de tabaco! Naiden lo puede creer, porque, pus, el pedacito, ¿qué es un saquito de tabaco del Duque? ¡Lo que sí que los salvaban que no sólo! Tuallas de trastes hacían del saquito de tabaco.

La mamá de Manuel, ella jue la que me crió. Ella jue la que me crió, y ella era muy estrita. Ella me enseñó a todo. A todo me enseñó, a hacer mi negocio, la casa. Ora no hago nada porque ora no sirvo pa nada.

Mis vecinas hacían sábanas de puros saquitos de tabaco

side the sock. And pants, we'd patch them. We'd put on a patch and mend them.

I also used to embroider—my dish towels, my pillow cases. They're all embroidered. All of my pillow cases are embroidered. I still have some of the work I did in San Luis. I still have pillow cases, dish towels, that I embroidered at home, in San Luis.

You know that I learned about crocheting and embroidery when I was in school in Cuba with the sisters, with the Franciscan Sisters, because they taught us. They actually taught us more about working than about education, because I learned very little in school.

From the year 1924 and onward, up until 1927, I worked with the sisters at the orphanage that was here in Albuquerque. I was there in 1927.

Bedsheets, the women made bedsheets. I never made any, but I saw my neighbors make them just from little sacks of tobacco. Just from little sacks of tobacco! No one can believe it because, well, how big is a little sack of Duke [Bull Durham] tobacco? One thing for sure, boy did they save those little sacks! Women also made dish towels from little tobacco sacks.

Manuel's mother, she's the one who raised me. She's the one who raised me, and she was very strict. She taught me everything. She taught me everything, domestic chores and all. Now I don't do anything, because I'm not worth a hoot for anything.

5

Gypsum, Wallpaper, and Mud

The cold, often bitter winter months came and went. Spring and summer were a welcome relief, because by then one could begin to shed clothing, open windows, and shake out (*sacudir*) the house. This meant cleaning it inside and out—from whitewashing the walls, to wallpapering the ceiling or *vigas* (beams), to mud-plastering. These endeavors fell on the woman's shoulders. When it concerned the home, there was a tacit understanding between husband and wife that it was her duty, and hers alone. Both had their own protective turf, or *querencia*, so they knew when not to infringe on each other's area of responsibility.

This arrangement prevailed in households throughout the Río Puerco valley. The expression, "No metas la pata en lo que no te conviene" ("Don't stick your nose in someone else's business"), was quite apropos in this case. Yet the cooperation of both was essential at times for certain tasks to be accomplished. For example, if a family needed gypsum, which was used for whitewashing, then the husband alone or accompanied by his wife hitched up the horses and traveled 20 to 30 miles, to Los Bancos near San Ysidro, northwest of Albuquerque en route to Cuba, for a wagonload of the white stuff. Frequently they carried back enough to share with their neighbors.

Once the gypsum was unloaded, the woman's work began in earnest. Foremost among her duties was to break the large rocks into smaller

pieces before "roasting," or browning, them in the stove or the horno. At times the husband helped smash the gypsum into smaller pieces with a sledge hammer (*un marro*). "Yo hacía todo eso" ("I did all of that"), says Macedonia Molina.

After the gypsum was roasted, women either ground it on a metate into a fine white powder or granulated it using a hammer. For the *yeso*, or *jaspe*, to stick to the adobe walls, they had to be smooth; and a batch of so-called *poliadas* (a concoction of water and flour) was prepared and mixed in with the gypsum. Small pieces of wool were used in applying it, as they were years later, when calcimine came into existence and gypsum became a thing of the past.

Whitewashing the inside of homes became an easier venture with the use of calcimine. "Ya era más alivioso pa nosotras" ("It was easier for us"), says Adelita Gonzales. This occurred around the 1930s, according to some of the women. Unlike gypsum, which people had to haul for many miles and which was difficult to prepare, calcimine was available in stores such as the Bernalillo Mercantile.

Women also wallpapered ceilings or vigas and sometimes *latías* (*latillas*), but wallpaper for the walls was more for the "rich" folks and not economically feasible for ordinary people. Consequently what women on the Río Puerco valley did was to utilize pages from Penny's or Montgomery Ward catalogues. The juxtaposition of people, clothing, and toys evoked both laughter and entertainment among the children. A good depiction of this can be found in Pina Lucero's account "Enpapelaban con catálogos" ("Women Wallpapered with Catalogues"). Boys and girls at times painted flowers on the whitewashed walls instead of using catalogue pictures. Gunnysacks (*guangoches*) were also used to cover the vigas or latías, until wallpaper became more plentiful and affordable in San Luis, Cabezón, Guadalupe, and Casa Salazar. This meant the end of *monos*, or toylike figures on ceilings or wooden partitions called *tabiques*.

The woman also handled mud, from setting mud floors, to mudplastering, to making adobes (the golden bricks of today and the poor man's cinder blocks of yesteryear). They were made by mixing dirt, straw, and water with a hoe. Afterward the mud was put into a mold called an *adobera*, then packed and smoothed at the top with a board. The adobera was then removed and the adobes left to dry flat on the

ground. A few days later they were placed on their sides so the bottom of the adobes could dry before they were used. Making adobes was hardly unwomanly or an anathema. As Vicentita Chávez said, "Mom made adobes. She helped Dad in everything. They mixed the mud and then they had like little wooden crates, molds, as they were called. Sometimes they came in twos or threes, and that's how they made the adobes." Orlando Romero reaffirms Vicentita Chávez' testimony in *Adobe: Building and Living with Earth* (1994): "Native American and Hispanic women have a long and continuous involvement in adobe construction. From making the bricks to building the fireplaces to actual construction, their roles have been vital to the survival of adobe, and of their cultures as well."

The utilization of mud in construction has a long-standing history, going back to antiquity. The word *adobe*, according to Edward W. Smith in *Adobe Bricks in New Mexico* (1982), "has its roots in an Egyptian hieroglyph denoting brick. The etymological chain of events ultimately yielded the Arabic 'at-tob' or 'al-tob' (sun-dried brick), which then spread to Spain in the form of the verb 'adobar,' meaning to daub or to plaster. Through Spanish conquests of the New World, the word adobe was brought to the Americas, where it still exists."

Some homes had dirt or mud floors. These were laid or set once a year with regular adobe mud; it was spread and smoothed with a piece of wool. If the mud cracked after two to three days of drying, the cracks were filled with mud and smoothed using a brush or a piece of wool once again, with a bit of water to finish the job, until the floor was dry and ready to use. Later on wooden floors, called *entarimes*, were introduced. They required constant washing. To this day I can still picture my mother on her bare knees, scrubbing the kitchen floor with soap, water, and a hard bristle brush, a chore she performed every Saturday afternoon to get ready for Sunday, "el día de descanso," the day of rest. In these duties, as Eremita García-Griego de Lucero says, "the husband . . . was not in the habit of helping the wife."

Although it was customarily the woman's job to mud-plaster the house, the husband did assist her from time to time. It was not uncommon either, as we see in Adelita Gonzales's "Hoy vamos enjarrar" ("Today We're Going to Mud-Plaster"), for women in the village to get together and plaster each other's homes. This was a vivid manifestation

of the camaraderie and goodwill that existed among them in placitas like Guadalupe, a reality either overlooked by, or hardly known to, those outside their immediate environment. Orlando Romero acknowledges in his book *Adobe* the profound importance of Hispanas as mud-plasterers (*enjarradoras*). "Today . . . they are always sought for their skills as *enjaradoras* [*sic*]. The saying in Hispanic culture is El *hombre las levanta, la mujer las enjara* [*sic*]—'The man builds the walls and the woman plasters them.' "

Women also painted the outside window frames, usually in blue, to ward off witches (*brujas*) some people would say, and they also painted the *trasteros*. It was not unheard of either for a woman to make *bolillos* (rolling pins) with an *escofina* (rasp) and a *lima* (file) from a piece of lumber, to replace the old ones. Other times part of a broomstick was filed and used. Women would also patch up screen doors in the spring, before the flies became a menacing problem.

The episodes in this chapter provide us with yet another dimension of the responsibilities of the woman in the Río Puerco valley. She worked diligently in the upkeep of her home, inside and out, from whitewashing, wallpapering, and setting floors, to mud-plastering, adobe making, and painting windows, providing yet another challenge to the stereotype of the Hispana as primarily decorative.

Acarriábanos las piedras de yeso
Macedona Molina

De ai de San Ysidro acarriábanos las piedras de yeso pa
pintarlas [las casas]. Viníanos en el carro de bestias a la cuesta esa, una
cuesta que le dicían Chucho. Ai, pues, ai cerca de San Ysidro, y luego
llevábanos las piedras estas y las quebrábanos con la hacha. Pues yo
hacía todo eso porque el *granpa* ya no quebraba las piedras. Él nomás me
enseñaba y loo las echaba en la estufa, en el *oven*, hasta que se
quemaban, o en el horno ajuera. Se quemaba el yeso, que ya quedaba
bien blandito. Y luego ponía uno un metate que le llamaba uno, y ai lo
remolías como muy finito y lo hacías en agua fría. Ai estabas
meniándolo porque este yeso si no lo meniabas se hacía como un
tapanzo, como un yeso de éste que enjarran ora. Cimento.
 Teníamos que hacer una olla de poliadas, que le llamaban, de harina.
Hirvíamos l'agua y lo[o] echábanos la harina. Ai se hacía hasta que se
hacía la poliada, y lo[o] onde estabas meniando el yeso, ai le chábanos
la poliada pa que no se hiciera duro el yeso. Ya nomás le chábanos la
poliada y lo meniábanos ya no se hacía duro; ya quedaba regular.
 Y lo[o] lavaban zaleas de ésas de borrega, pedacitos de zalea. Y las
lavábanos bien lavadas pa con ésas pintaban, con las zaleas. Y nos dijían
que esa poliada era pa que si se atrincaba uno a la pader, que no se
prendiera el yeso. Es lo que los [nos] dicían.
 Calsamán había, pero no conocí calsamán hasta después. Era eso, el
yeso, pero yo no sé con qué coloriaban el yeso. Yo me acuerdo que
muncha gente cortaba de estos hules de mesa, las flores esas de las
mesas. Y loo una lo detenía y lotra pintaba las flores en las paderes de
color. Pero no me acuerdo qué clase de color. Y ponía uno una sanefa
como le dicían, toda la orilla nomás. La sanefa. Toda la orilla así le ponía
uno algo, pa una rula pa midila pa que saliera derecha. Y lo[o] le ponía
uno las flores toda la orilla. Quedaba muy bonita la casa.
 [Para las vigas] les poníanos guangoche. Tirantiábanos los guanchos

We Used to Haul the Gypsum Rocks
Macedona Molina

We used to haul the gypsum rocks from San Ysidro to whitewash the homes. We'd come by horse wagon to that slope, a slope people called Chucho. It was there close to San Ysidro, and then we'd haul these rocks and break them up with an axe. I used to do all of that because grandpa could no longer break the rocks. All he did was to teach me how, and then I'd put them in the stove, in the oven, until they were roasted, or we'd do it outside in the horno, where the gypsum was cooked, and it'd come out very soft. Then you'd get a *metate* (grinding stone), as it was called, and that's where you ground up the gypsum very finely, and then you mixed it with water. You had to stir it and stir it, because the gypsum, if you don't stir it, it can turn hard like the cement that's used nowadays for plastering.

We had to mix a pan of *poliadas* (paste), made from flour. We'd boil the water and then we'd pour in the flour. It would boil until the poliada was ready, and then as you stirred the gypsum, you poured in the paste so that the gypsum wouldn't get hard. Once you put in the paste, the gypsum wouldn't get hard. It would turn out fine.

Then people would wash small pieces of sheepskin. We washed them really clean, because that's what we whitewashed with. And we children were told that the poliada was used so that if you leaned up against the wall, the whitewash wouldn't come off on your clothing. That's what we were told.

There was calcimine, but I didn't get to use it until later on. What we used was gypsum, but I don't know what they used to color it with. I remember that a lot of people used to cut out flowers from those oilcloth tablecloths. Then one person would hold the flowers, while another pasted them on the colored walls, but I don't remember what kind of coloring it was. We also used to paint a border at the bottom of the walls, all around the bottom of the walls. It was called a *sanefa*. We'd

arriba de las vigas. Quedaban bien tirantes y loo de esos magazines pegábanos, pero, ¡ay cómo batallaba uno pa pegar el primer magazín en el guanche! De a pedacito los pegábanos. Y lo[o] ya después lo garraba entero, y quedaba bien firme. Ai estábanos viendo el monerío. (Risas). ¡Oh, tabiques igual!

Acarriábanos las piedras de yeso

mark the border around with a ruler as a guide, so that it'd be straight. Then you could paint or paste the flowers along these borders. The house would turn out very pretty.

For the vigas we used burlap. We'd stretch the burlap to cover the beams. The gunnysacks would be very tight, and then we'd decorate them with magazines, but, boy, did we work hard to get the first magazine pieces pasted on the burlap! Piece by piece we would paste them. After a while you got the hang of it, and you could paste whole magazine pages and they'd stick. There we were looking at all the silly pictures. (Laughter). We'd do the same with wooden partitions!

Encalábanos todo el santo día
Adelita Gonzales

El yeso lo llevábanos de San Ysidro pa ai. Había. No sé si habrá toavía. Pues de ai llevábanos el yeso. Lo quebrábanos. Lo quemábanos primeramente en la estufa. Luego lo sacábanos, lo machucábanos, y lo volvíanos como harina. Luego de ai lo poníanos en un cajete con agua. Le echábanos l'agua y ai teníanos que estale dale güelta y güelta porque el yeso se adormía. Se adormía. Luego que ya se estaba durmiendo, le echábanos agua y agua y agua hasta que se quedaba yeso. Luego de ai lo quitábanos y lo echábanos en un bote. Con una zalellita de borreguitas, de ai cortaban la zalellita, y loo de ai encalábanos. Encalábanos todo el santo día. Desde arriba hasta abajo.

Y arriba teníanos manta en el techo. La clavábanos como si juera cielo, ves, ai. Ai la clavábanos. Pues la manta teníanos que quitala cada vez que íbanos a componer la casa, a encalar. Teníanos que quitar esa manta y loo volvela a poner. En las vigas.

[Más tarde usábanos] calsamán, sí. Ya lo compraban en la tienda. Ya era más alivioso pa nosotros. Pero el yeso no, el yeso teníanos que trabajar.

Pos yo varias veces puse en mi casa papel o periódico en las vigas. Munchas [mujeres] ponían como ora, dígase que poníanos como una garra parriba, y luego con poliadas poníanos los papeles. Pero teníanos que poner primeramente como una garra y luego sobre esa garra enpapelábanos. En la casa mía, envolvíanos ai todas las vigas. Las poníanos con papel. Ai enpapelábanos todas las vigas.

We Whitewashed All Day Long

Adelita Gonzales

We used to haul the gypsum from San Ysidro. There was plenty. I don't know if there's still some or not. Well, it's from there that we used to take the gypsum. We'd break it. First we'd burn it in the stove. Then we'd take it out, grind it, and turn it into like flour. From there we'd put it into a tin bathtub full of water. We'd fill it up with water, and there we'd be stirring it and stirring it. If not, the gypsum would turn hard. It would turn hard. As soon as we noticed that it was getting hard, we'd pour more and more water in until it was ready to use. From there we would fill up a can with gypsum and put it on with a small piece of wool. They'd cut a small piece, and that's how we whitewashed. We whitewashed all day long. From top to bottom.

And we had a cloth to cover the ceiling with. We would nail it there, to the ceiling, as though it were the sky. That's where we nailed it. Of course we had to remove it every time we fixed up the house, like whitewashing. We had to take down that cloth and then put it back up again. On the vigas.

Later on we began to use calcimine. By that time you could buy it in the stores, which made it easier for us. But not with gypsum. We had to work at it.

As for me, there were times when I used paper, newspaper on the vigas. Many of us women would use, let us say, like a gauze, and then we'd attach the paper with flour paste. But first we had to put like a gauze and then on top of it we would wallpaper. In my house, we all got involved wallpapering the vigas. We covered them with newspapers. We would cover all of the vigas with newspaper.

Enpapelaban con catálagos

Pina Lucero

[Las mujeres] enpapelaban con catálagos. Ésos le sirvían a uno pa estarse viendo en la noche parriba del techo a ver todo los monos del catálago. (Risas). Yo me acuerdo que teníanos un tabique. Había hecho un cuarto muy grande mi apá, y loo pusieron un tabique. Y logo le enpapelaron con *munchos* catálagos. So me sentaba arriba de una tarima en la mesa y ai me estaba viendo yo todos los túnicos y la ropa y los monos que estaban. Los carritos. Cuando no tenía que hacer, me ponía a ver el tabique ese de lo que estaba puesto ai.

Era el *Mongomers.* ¿Cómo se llamaba el otro? El Bella Hess. Yo no me acuerdo cómo se llamaba el otro. Era Spiegels, que vinía más antes. Ya ora no hay de esos catálagos. Bueno Montgomery Ward sí está toavía. Pero el Bella Hess, ése lo usaba muncho. Ése vinía muncho seguido a la gente.

Oh, uno recogía esos papeles que cállese. Andaba sobre de eso. Me acuerdo que vinía mi tía y mi tío Tomás pa case, mis tíos míos, y le dijía mi mamá: "Comadre," le dijía, "ai en Bernalillo pregunte a ver ónde hay papeles pa que me traigan un saco." Quizás buscaban ai, y aquí iban [para el rancho] con papeles de todas clases. ¡Uh! Se golvía uno loca enpapelando el tabique con papel de todos colores, pero lo enpapelaba, que estuviera limpio.

Hacía uno la poliada con la harina. Echaba la harina en un cajete, y loo le echaba agua, y ai la iba meniando. Luego si tenía lumbre la jerbía poco pa que saliera más mejor porque entonces no se pegaba. Logo la untaba uno con la zaleíta esa y la ponían en la pader. [Estaba uno] hasta que acabara. Mi mamá se llegó estar hasta las tres de la mañana enpapelando porque no había ruido, ni quién la molestara. Yo mirándola y dándole. Ai es onde aprendí yo.

[Las mujeres enpapelaban] pa lo limpio, pa tener limpio. Con los tabiques pus no había suficiente [tabla]. Estaba tan atrasada la gente que no tenían suficiente tabla, so, ponían tanta tabla. Se paraba asina [el

Women Wallpapered with Catalogues

Pina Lucero

Women wallpapered with catalogues. They came in handy at night when looking at all the silly pictures on the ceiling. (Laughter). I remember that we had a wooden partition. My dad had built a really large room, and then they put up a wooden partition. It was wallpapered with *lots* of catalogue pictures. So, I'd sit down on a bench, and there I'd be looking at all the dresses, the clothing, and all the pictures, including the little toys. Whenever I didn't have anything else to do, I'd sit down and look at the partition, and all that was on it.

It was Montgomery Ward. What was the name of the other? Bella Hess. I don't remember the name of the other one. It was Spiegels, which we had long time ago. You can't find those catalogues anymore. Okay, Montgomery Ward, yes. But Bella Hess, I used that one a lot. That one came to people quite frequently.

Oh, we used to collect those catalogues like you wouldn't believe. People were always after them. I remember that my aunt and my Uncle Tomás would come visit this aunt and uncle of mine, and my mom would say to her: "Comadre," she'd say to her, "when you're in Bernalillo, ask where you might find catalogues so you can bring me a sack full." I guess they looked for them there in Bernalillo, so here they'd be headed for the ranch with all kinds of papers. Uh! You'd go crazy wallpapering the partition with all kinds of different colored paper, but you did it so it'd be clean.

You'd make paste from flour. You poured the flour in a tin washtub, then you poured in water, then you stirred it. Then if you had a fire going, you could boil it a little so that it'd come out better; otherwise it wouldn't stick. Next you applied it on the wall with a small piece of sheepskin. You did that till you finished. My mom would stay up until three o'clock in the morning wallpapering, because there was no noise, nor anyone to bother her. I would watch her and help her. That's how I learned.

tabique] y loo ponían sacos de guangoche. Ésa era la pader y loo por eso lo enpapelaban pa que se mirara bonito, limpio.

El papel [moderno], ya comenzamos a poneles a los techos. Le empezamos a poner el papel tamién porque en esos años como techaban con latías, ves, quedaba muy fiero la latía. Si la gente *could afford* le ponían manta o le ponían de ese guangoche, y loo lo enpapelaba uno con catálagos tamién, pero ya cuando entró el papel, uf, era una riqueza porque empezamos a poner papel en medio, y se vía muy bonito. ¡[No más] monos!

Enpapelaban con catálagos

Women wallpapered to make the house clean. With the wood partitions, there wasn't enough lumber left. People were so poor that they didn't have enough lumber, so they used only so much. The partition would stretch so far, and then they'd use gunny sacks. That served as the wall, and that's the reason why they wallpapered, so that the house would look pretty and clean.

As for the modern wallpaper, we began to use it on the ceilings. We started to use wallpaper on them also, because during those years since we had *latías* (peeled wood poles used as ceilings), you see, the *latías* looked very ugly. If people could afford it, they'd use muslin ceiling cloth or gunny sacks. Then came the use of catalogue paper to cover them, but when wallpaper came into existence, wow, it was a delight, because we started to use paper on the ceiling, and it looked very pretty. No more silly pictures!

Nos hacían pintar flores en la pader
Dorela Romero

Pues a ver. Nos tardábanos dos semanas, a veces tres, porque yo no sé. Nos tenían trabajando, yo creo. Nos hacían encalar hasta el tabique y luego pintala [la casa]. Nos hacían pintar flores de modo que parecía que la casa estaba enpapelada, no encalada. Y nos hacían pintar las flores en la pader. Las muchachas. Yo y mi hermana y mis hermanos teníanos nomás la noche y creo que daban moldecito. Pa otro día amanecía [la casa media] pintada.

Con tinta. La florecita era como color de rosa. Y loo las cajitas eran verdes. El color que ella [su mamá] quería, teníamos que pintala. Pues las pintábamos [las paredes] nosotros.

Comenzábanos en la noche. Como tres, cuatro noches nos tardábamos, porque en el día trabajaban ellos [los hombres] y nos quedábamos nosotras haciendo otro negocio. Y de noche nos juntábamos hasta que acabábamos de pintar la casa. No, la cocina la dejábamos.

They Made Us Paint Flowers on the Wall

Dorela Romero

Well, let's see. We'd take about two weeks, sometimes three, but I don't know why. They had us working, I guess. They made us whitewash even the partition, and then we had to paint the house. They made us paint flowers in such a way that it seemed as though the house was wallpapered, not whitewashed. They made us paint flowers on the wall. The girls. My sister and I—and my brothers—had only the evenings to do the work. I think they gave us a pattern. By the next morning the house was painted with flowers.

With paint. The flowers were sort of pink. And then the little boxes were green. Whatever color Mom wanted, that's the color we had to paint. We're the ones who painted the walls.

We would get started in the evening. It would take us about three, four nights, because during the day the men worked and we [women] were doing other chores. At night is when we would get together, until we finished painting the house. No, we didn't touch the kitchen.

Eremita García-Griego de Lucero, 1990.

Los suelos los lavábamos
dos veces la semana
Eremita García-Griego de Lucero

Los suelos los lavábamos, dos veces la semana,
especialmente el sábado pa que estuviera todo limpio pal domingo. Y
siempre era costumbre esperar gente, esperar visitantes los domingos.
Los sábados Emilia García, que era mi agüelita, el sábado en la mañana
tenía costumbre de echar el pan en un horno, que va fuera. Hacía pan,
pan dulce y pan salao pa comida. Tamién se cocía la comida en los
sábados en caso que tuviera uno visitantes, los domingos.
 [Los suelos eran] de tabla. Lo llamamos entarime. Munchas casas sí

We Washed the Floors
Twice a Week
Eremita García-Griego de Lucero

We washed the floors twice a week, especially on Satur-
days, so that everything would be clean for Sunday. It was always
customary to expect guests, to expect visitors on Sundays. On Satur-
days Emilia García, who was my grandma, on Saturday mornings, she
was in the habit of baking bread in the horno. She baked bread: sweet
bread and regular bread for lunch. People also cooked food on Satur-
days in case one had visitors on Sundays.
 The floors were made of wood. We call them *entarimes* (wooden

127

tenían suelos de tierra, pero en la casa de Emilia García y Teodoro García tenían entarime, que le llamamos nosotros, pero no usaban *linoleum*, que le llamamos nosotros ahora. El entarime, por eso se lavaba dos veces la semana, con un cepillo muy bravo, muy duro.

[El suelo de tierra] se va echando l'agua, l'agua y la tierra regüelta. Se hace a modo a que quede el zoquete no muy aguado; nomás el tener que el suelo quedara duro. Se hace duro en cinco días; se está mojado como cinco días. Cuasi el estilo era, en el año que yo tendría catorce años—doce años, todo con la mano. No se usaba cuchara como hay ora cucharas para enjarrar. Era el oficio de la mujer y lo hacía muy bien hecho.

El esposo nunca, no tenía el estilo de ayudale a la mujer, como ora lavar suelos, o lavar trastes, porque en esos tiempos el hombre era lo que le llamamos ora en día *the macho man*.

floors). Many homes had dirt floors, but in Emilia García's and Teodoro García's home they had *entarimes*, as we called them, but they didn't use linoleum. Since they were wooden floors, that is the reason we washed them twice a week, with a very hard and rough brush.

The dirt floors you'd do by pouring water, water mixed with dirt, done in such a way that the mud did not turn very soft, so that the floor would stay hard. It turns hard in five days; it remains damp for about five days. When I was about twelve, fourteen years old, the mud floors were done by hand. You didn't use a trowel, such as the ones you have now for plastering. It was something the woman did, and she did it very well.

The husband was never in the habit of helping the wife when it came to washing floors or washing dishes, because back in those days the man was what we would consider today "the macho man."

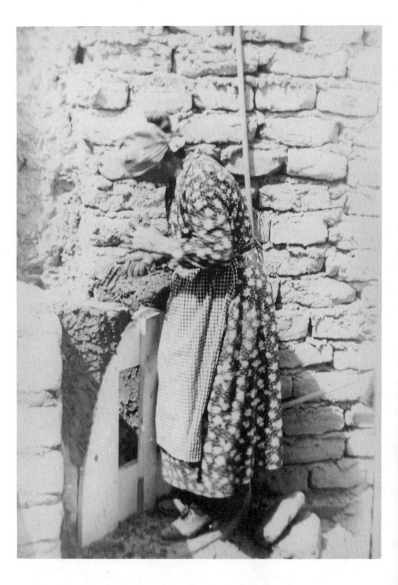

Building with adobe, date unknown. Courtesy of Museum of New Mexico, neg. no. 21225.

Hoy vamos enjarrar
Adelita Gonzales

Güeno pues, como ora, hoy vamos a enjarrar. Güeno, pues, hacíanos un joyo grande. Acarriábanos en barriles l'agua. Íbanos y tráibanos l'agua del Ojito. La acarriábanos y la poníanos en botes allí [en el joyo].

De ai enjarraba uno una casa. Hoy vamos a enjarrar la casa de mi mamá. Güeno, pues ai teníanos l'agua. Ai hacíanos un joyo y tráibanos todo lo que se necesitaba, porque le echaba paja al zoquete. Yo era la que hacía el zoquete. Y luego de ai yo se lo llevaba a los que estaban enjarrando, como en papá, mi mamá. Ellos eran los que enjarraban. Yo

Today We're Going to Mud-Plaster
Adelita Gonzales

Well like now, let us say we're going to mud-plaster today. Well, the first thing you did was to dig a big hole. We would carry the water in barrels. We'd go and bring the water from the Ojito. We'd carry it and pour it with cans into the hole.

From there you started plastering the house. Let's say that today we're going to plaster my mom's house. Well, the water was there already. That's where we dug a hole and we brought everything that we needed, because you also needed straw for the mud. I was the one who mixed the mud. From there I would take it to those who were

les llevaba el zoquete de aquí del joyo. Se lo ponía arriba de las mesas y ai a enjarrar. Ellos lo ponían a la pader.

Yo sí llegué a enjarrar. Yo llegué a enjarrar. Se juntaban ai en casa ocho, ocho personas. Las mujeres se juntaban unas con otras, y ellas eran las que enjarraban [tamién]. Se juntaban, como ora, dicir, todas las vecinas.

En papá era el que iba por arriba y las mujeres iban por aquí abajo, enjarrando todo. Le ponían como unos andames, que les dicíanos, endames, y el hombre va parriba y las mujeres vienen aquí abajo.

Unas planas. Unas planas. Planas les llamaban, y luego las cucharas. Nosotros [usábanos] cucharas pa enjarrar. Eran unas cucharas grandotas, y loo tenían como un bolillo aquí donde [que] agarrábanos. Eso hacíanos.

Güeno, a la entrada de otubre, en setiembre, otubre, antes de que entrara el frío, enjarraban las casas. Oh, cada dos años enjarraban. Cada dos años enjarraban las casas.

Echábanos suelos [tamién]. Bueno, mira, como ora esta casa aquí. Ya aquí teníanos suelos de tierra, suelos de tierra. Pues, aquí hoy vamos a echar suelos a case mi comadre. Güeno, pues, de allá juera tráibanos el zoquete y lo tirábanos aquí en la casa. De aquí lo destendíanos bien, o como tanto asina, dos, tres pulgadas de zoquete. Lo destendíanos. Lo alisábanos bien lisito con la plana esa que te digo yo. [Tamién] con la cuchara, hasta que llegábanos a la mera orilla. Nos llevábanos todo el día echando un suelo.

Unas [mujeres] a las otras. Unas a las otras [se ayudaban]. No había [suelos] de tabla. No había nada. Y los suelos estos, pues, duraban como quien dice todo, todo el año. Casi cada año teníanos que estar echando esos suelos.

plastering, like my father, my mother. They were the ones who did the plastering. I would take them the mud from where the hole was. I would set it on top of the tables [scaffolds], ready for plastering. They're the ones who put it on the walls.

Yes, I took my turn at plastering. I took my turn at plastering. About eight, eight women used to gather there at the house. The women would get together, and they were the ones who would plaster also. They would gather, like now, all of the neighbor women.

My father is the one who would plaster the top part of the wall, and the women would do the lower part, plastering everything. They had like scaffolds, as they were called, and the man goes along the top part and the women down here.

"Planes." They were called "planes." That's what they were called, and then there were the trowels. We used trowels for plastering. They were these huge trowels, and then they had like a rolling pin where you grabbed ahold of them. That's what we did.

Okay. At the beginning of October, September, October, before it started to get cold, that's when people plastered their homes. Oh, they plastered every two years. They mud-plastered their homes every two years.

We also laid mud floors. Well, look, like this house here now. We already had mud floors, mud floors. So today we're going to lay floors at my comadre's house. Now, then, we'd bring in the mud from outside and we'd spread it. From here we'd spread it well, oh, about two, three inches of mud. We'd spread it. We would then smooth it, very smoothly with that "plane" that I mentioned to you, as well as with the trowels, until we got to the edge. It would take us all day to lay a floor.

Women would help one another. They would help one another. There were no wooden floors. Nothing like that. And these floors, well, they'd last more or less all year long. Just about every year we would have to be laying those floors.

Today We're Going to Mud-Plaster 133

6

Planting, Hoeing, and Harvesting

To reiterate, the woman's obligations did not begin and end in the kitchen. The countless directions in which she stretched herself to ensure the survival and well-being of her family may be unfathomable to some, but not to her and her cohorts. The woman went from clean hands in the kitchen to dirty fingernails in the fields.

The stories found in this chapter are living testimony to the role women played in the fields. They were just as apt to till the soil as they were to plant, hoe, or harvest crops. Other chores, such as raking the fields, may have been incidental to the main agricultural tasks, but they were nevertheless an integral part of women's contributions to raising ample crops for domestic use.

Once springtime arrived, and the cold winter months were put to rest, it was time to look to the planting season. There was no better evidence of spring than my *abuelito* consulting his latest edition of *The Farmer's Almanac.* After his laborious calculations, coupled with his own hard-won knowledge of weather patterns, phases of the moon, and the night skies, it was time to begin a new season, a new cycle on the farm.

First on the list of priorities, and a yearly tradition, was to clean the irrigation ditches up and down the Río Puerco valley, during the time when farmers still had the good fortune of a dam with irrigating capabilities. While there was a commission that oversaw the operation of

the entire ditch system, it was the mayordomo who was charged with carrying out the commission's policies. He made certain that all property owners—both men and women—did their share to keep the ditches clean and secured and free from potential leaks caused by gophers (*tejones*) or field mice. The entire task fell on the men's shoulders. It was their world, in a manner of speaking, but women infiltrated it from time to time.

Adelita Gonzales, in "Muncho ayudaba la mujer," ("The Woman Helped a Lot"), stresses how women helped to clear the ditches by burning tumbleweeds, but as a rule their role was rather limited, because the mayordomo's crew comprised farmers from throughout the valley. A woman might help, but only with clearing the ditch or ditches pertaining to the family's property, or to her own, and only if men from other families were not present. Otherwise she hired someone to do her share of ditch cleaning.

Nevertheless, as Adelita Gonzales says, "the woman helped a lot," and this applied also to raking, planting, and hoeing. The horse and plow were utilized in planting. Susanita Ramírez de Armijo and her comadres recount how they helped plant corn and pinto beans. Perhaps no other farming task demanded as much time and attention as did hoeing and harvesting crops. This was especially true when the corn, pinto beans, melons, and pumpkins began to sprout and the plants were in their infancy. One had to make sure that the proper weeding and thinning took place; otherwise the plants were in danger of dying.

Caring for the sown fields was thus a family affair. By six o'clock in the morning, the father (provided he was not away working), the mother, and the children were already up and working, before it got too hot. The males put on their straw hats (*saguaripas*) and the females donned their homemade *papalinas* (sunbonnets). Between eight and nine o'clock, the mother would return home to fix breakfast, before returning to the fields until it was time for her to prepare lunch, usually around eleven. After lunch, during the heat of the day, everyone took a siesta (a nap)— the parents on the bed and the kids under it—for about an hour. Most families went back to hoeing, with the exception of the mother, who tended to other chores, from around four o'clock for at least several hours, before a light supper was served.

No one could state more eloquently the fundamental importance of

women in farming and harvesting than Vicentita Chávez, in "Nojotras ayudamos muncho en la siembra" ("We Girls Helped a Lot in the Fields"). This meant not only hoeing, shucking corn by hand in the evening and putting it in gunnysacks or barrels (one had to save the very thin corn husks for grown-ups to use for rolling their cigarettes), but also threshing pinto beans and winnowing wheat. Goats and sheep were used on the *era* (threshing floor), specially set aside for these harvesting tasks.

When the time came to pick the crops, in August and September, the entire family got involved. Women helped in a number of ways. They gathered pinto beans, ground corn, and threshed wheat, as we learn from women such as Eremita García-Griego de Lucero and Mary Jaramillo Gabaldón, in "Cosecha" ("Harvesttime") and "Teníamos que arrancar el maiz" ("We Had to Pick the Corn"). This last account discusses the different varieties of corn that were planted and harvested, each with a different purpose in mind. Regardless of what had to be done, wives assisted their husbands in the fields. In turn children helped their mothers, and women, as during mud-plastering, joined forces and helped each other in shucking and storing the corn in an area safe from the field mice.

The spirit of cooperation in a community emanated first from within the family, with a special impetus provided by the mother. That is the genuine esprit de corps embodied in the narratives that follow, by women who experienced first-hand the trials and tribulations—and sometimes joys—of working in the fields.

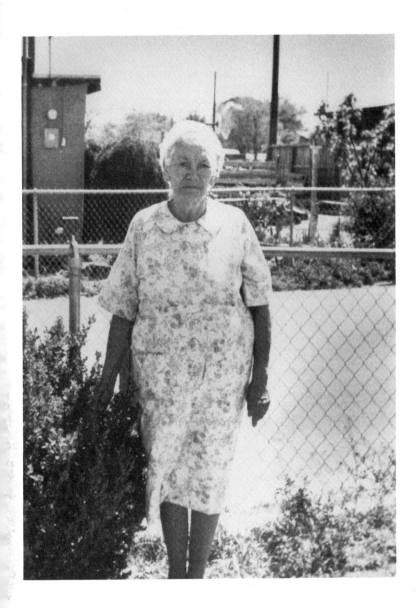

Adelita Gonzales, 1987. Courtesy of Marian Salazar.

Planting, Hoeing, and Harvesting

Muncho ayudaba la mujer
Adelita Gonzales

[La mujer ayudaba] a limpiar las cequias. Pues quitar las yerbas de las cequias. Los hombres más antes iban al atarque; el atarque toavía corría l'agua sobre la cequia. Ai no íbanos nosotras. Ai iban nomás los hombres hacer ese negocio.

[Quemaba] las cizañas de la cequia; eso sí hacía uno [la mujer]. Todo lo que hacía nomás, quemar. Muy pocas veces íbanos ayudales, muy pocas veces, a rastrillar. No, casi eso no. El hombre era el que hacía todo eso—barbechar.

Ayudaba, sí. [La mujer] ayudaba a sembrar. Pues ai en veces íbanos a ayudales [a los hombres] a echar maiz, a echar frijol. Eso era lo que hacíanos nosotras, porque se juntaban dos o tres vecinos y ellos araban pa sembrar. Uno tenía que ayudales a echar maiz o echar frijol o lo que sea. La semilla, sí.

A escardar, sí. Sí ayudábanos a escardar. Desde la mañana ya andábanos allá ayudándole [al papá] antes de que juera la calor. Loo viníanos, almorzábanos. Si no estaba muy caliente, volvíanos a ir a escardar. Pues por en la tarde, como de las tres, las cuatro de la tarde, no íbanos a volver escardar.

¡Oh! Muncho ayudaba la mujer.

The Woman Helped a Lot
Adelita Gonzales

The woman helped to clean out the ditches. Well, to re-
move the weeds from the ditches. The men back then used to go to
the dam. The dam was still supplying water to the ditch system. We
[the women] didn't get involved in that. Only the men went to do that
chore.

I would burn the tumbleweeds in the ditches; that the woman used
to do. That's all she did, was to burn them. We also went a very few
times, a very few times, to rake. No, that we rarely did. The man is the
one who did all of that—plowing.

Yes, the woman helped. She helped to plant. At times we would go
help the men plant corn, plant beans. That's what we women did, be-
cause two or three neighbors got together and they plowed to prepare
the land for planting. One had to help them plant corn or beans or
whatever. The seed, yes.

Hoeing, yes. Yes, we helped in the hoeing. From early in the morn-
ing we were already helping Dad, before it got too hot. Then we would
come back and eat breakfast. If it wasn't too hot, we would go back to
hoe. In the afternoon, we didn't go back to hoeing until around three
or four o'clock in the afternoon.

Oh! The woman helped a lot.

Él araba y ella echaba la semilla
Susanita Ramírez de Armijo

Yo vía a case de mi agüelo y de nosotros que cuando ya aflojaban la tierra, prendían el tiro, que esta Reyitas, a ella le gustaba el tiro. Y otra prima que le gustaba muncho manijar el tiro era Lola. No le gustó trabajo de casa como mujer. ¡Nunca! Pero que le dijieran a ella, "Ve traete aquel caballo. Ve traete aquellas cien . . . Ve traete aquellas vacas," o lo que juere, ella montaba el caballo y lo hacía. Ella hizo trabajo mejor de hombre que de casa.

Tú sabes cómo sembraban. Hacían toda la siembra, ponían el arao, y aquí va el arao sembrando y aquí va el tiro pa delante. A mí me ponían a echar maiz o frijol, lo que juera en las zanjas.

Tamién manijaba [la mujer] el arao y tiro como un hombre. Yo lo digo por mi mamá. [La mujer iba] con vestido de mujer, porque allá no se vistían con vestido de hombre como ora. Todas las mujeres usaban sus vestidos como era mujer. Aunque jueran las milpas, o juera lo que fuere o jueran a trabajar el trabajo del hombre, ellas iban vestidas de mujer, con sus papalinas o lo que hacían. Se vistían como de mujer, sí.

Güeno, yo diré de mi caso, ¿no? Yo diré que cuando mi *daddy* iba a sembrar, que comenzaba ya la siembra, como ya de este tiempo [marzo], ya él comenzaba a sembrar ya juera maiz, . . . Ahora en marzo comenzaban a sembrar.

Güeno, ya iban a la sabana, al terreno. Mi *daddy* tenía su arao preparao, sus bestias. Guardaban su semilla, cuando cosechábamos en el invierno. Mi *daddy* la apartaba. "Ésta va a ser pa semilla pal año que viene." Ya juera frijol o el maiz, lo que iban a sembrar. Eso no se movía hasta que no íbamos a hacelo. Agarraba mi *daddy* su arao, sus bestias, y mi mamá se vestía y aquí vamos a sembrar, a voltiar la tierra pa sembrar. Tamién las mujeres manijaban los araos, lo mismo que el hombre. Había veces que ellos los dos, él araba y ella echaba la semilla.

Güeno, como ya, que ya comenzaba a salir la mata, que comienza, que ya se mira, mi *daddy* dicía, "Vamos a levantarnos muy de mañana, mañana," como ya eran las cinco, que ya de día. "Vamos a escardar."

He Plowed and
She Planted the Seeds

Susanita Ramírez de Armijo

I used to see at my grandfather's house and ours that when the soil had been loosened up, they'd hitch up the team of horses, which Reyitas liked. And another cousin who liked to handle the team a lot also was Lola. She didn't ever like woman's housework. Never! But if you told her, "Go fetch that horse. Go get those one hundred . . . Go get those cows," or whatever, she'd get on the horse and do it. She did man's work much better than housework.

You know how they planted. The way the whole planting routine took place, the way in which the plow was handled, here goes the plow and the team of horses. They'd get me to plant corn or the beans or whatever in the furrows.

The woman also handled the plow and team of horses just like a man. I can vouch for it myself. The woman was dressed like a lady because over there the women didn't dress like men, as they do now. All of the women dressed in women's clothing. Even if it was in the corn-fields or wherever, they went dressed as a woman, with their sunbonnets or what have you. They dressed like a woman, that's right.

Well, I'm speaking for myself, okay? I'll say that when my daddy went to plant, when the planting season started, like now in March, he'd start planing corn or whatever. Now in March is when they started planting.

Well, it was time to head for the prairie, the land. My daddy had his plow ready and his horses. They would save their seed when we harvested in the winter. My daddy would separate it. "This seed is going to be for next year." Whether it was beans or corn, whatever seed was going to be planted, it wasn't disturbed until we were going to use it. Women also handled the plows, just as the man did. There were times when both of them were working—he plowed and she planted the seeds.

Okay. As soon as the plants began to come up, when they started to

Cada uno tenía su cavador: mis hermanos, yo, mi mamá y mi *daddy*. Nos íbamos a escardar la mata, lo que juera. Pa las once ya estaba el sol muy caliente, ¿no? Dicía mi *daddy*, "Aquí y nos vamos a descansar hasta las cuatro de la tarde porque ya está la calor. Ya no podemos hacer nada." Como desde las cinco, diré yo, de las cinco de la mañana hasta las once, íbamos a escardar la siembra.

Café nos llevaba mi mamá. Echaba café en unas ollitas, y nos llevaba siempre cosas duces, ya sea bizcochitos. Teníanos un, como *break*, que dicen ora. Serían como las siete, las ocho, por ai. [No almorzábamos] hasta que no viníanos para tras. Ya mi mamá se vinía temprano pa calentarnos el almuerzo pa comer, porque ya era tarde.

Cada quien si quería descansar un ratito, nos dejaba mi *daddy* que se sentara cada quien y loo siguía su trabajo. Ese costumbre teníamos yo y mis hermanos.

Él araba y ella echaba la semilla

grow, when you could see them, my daddy would say: "We're going to get up very early tomorrow," which would have been five o'clock, already dawn. "We're going to hoe." Each one of us had our own hoe: my brothers, I, and my mom, and my daddy. We'd go out to hoe the plants. By eleven o'clock the sun was already very hot, right? My daddy would say, "Hoe up to here and we'll go rest until four in the afternoon, because it's already hot. We can't do any more." From about five o'clock, I would say, from five o'clock in the morning until eleven, we'd be hoeing the fields.

My mother would bring us coffee in small pans, and she always brought us something sweet, like bizcochitos. That's what my mother brought us; it was like a break, as it's called now. It was around seven, eight o'clock, thereabouts. We didn't eat breakfast until we got back. My mother would go back early to heat up breakfast, because it was already very late.

Each one of us, if we wanted to rest a little while, my daddy would let us sit down and then go on with our work. That's a habit my brothers and I had.

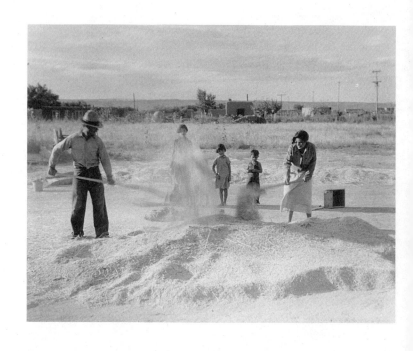

Winnowing grain, ca. 1935. T. Harmon Parkhurst, courtesy of Museum of New Mexico, neg. no. 69964.

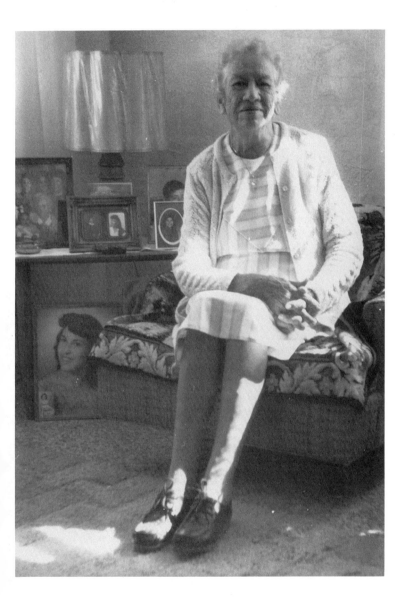

Vicentita Chávez, 1990.

Nojotras ayudamos muncho en la siembra

Vicentita Chávez

Aá [en Guadalupe] se levantaba uno en de cuasi nomás salía [el sol], que se aclaraba bien, ves, porque escardaba uno muy temprano. Se levantaba uno y loo ya cuando venía el calor se iba uno a descansar, hasta que pasaba el calor, y loo ai va uno otra vez, por la tarde.

Y loo poníanos un melón aá en la meda, hasta onde íbanos a llegar aquella noche. Hasta ai nomás era la seña que hasta ai íbanos a descardar. (Risas). Un melón o sandía.

Y loo el maiz, lo juntaban, lo amontonaban todo, pilas grandotas, y loo en la noche, se juntaban todos los vecinos y ai estaba uno deshojando el maiz. Y después que ya estaba deshojao yo y—tú no los conocistes, la gente de Bacas, el Evardito Baca y todos ellos—esta Pora y yo desgranábanos maiz en esas máquinas que tenían. Les echaba uno el elote, de uno, de a dos. Llenábanos no sé cuántos sacos, llenábanos de maiz.

Tamién con la mano desgranaba uno cuando no jallaba [más] porque la máquina esta alguien nomás tenía esa máquina, y se las prestaba a las gentes. En veces estaa ocupada, pus, desgranaba uno sin ella, con la mano.

Tamién [la mujer dispuntaba]. Cortar cuando está el maiz grande, que quede la pastura esa. La dejan pa los animales. Yo tengo una cicatriz aquí [en la mano] onde me di con la hoz. La primera vez que jui yo, diuna vez me corté. (Risas). Pero no, aá [en el rancho] se curaba uno solo.

Tamién el frijol, lo aigriaban el frijol [y el trigo]. El trigo sí, lo amontonaban en unas pilas grandotas, redonda la pila, y loo traiban tantos caballos y andaban sueltos. Nojotras, yo y Adelita [su hermana], nos subíanos en los caballos y les dábanos güelta hasta que se quedaba la pila bien lisita. Loo venía el aire, en la era, que teníamos nosotros, estaba en una loma aá arriba. Y cuando venía el viento en la tarde,

We Girls Helped a Lot in the Fields
Vicentita Chávez

In Guadalupe you got up almost as soon as the sun came out, when it started getting light, you see, because you started hoeing very early. You got up and then when it started getting hot, you went home to rest, until the heat of the day had passed, and then there you were back again in the afternoon.

And then we used to put out a cantaloupe as a finish line, that we were going to reach that night. That was the mark of how far we were going to hoe. (Laughter). We used a cantaloupe or a watermelon.

And then the corn, it was gathered and piled up in huge piles, and then at night all the neighbors got together and there you were husking corn. After it was husked, I and—you didn't know the Bacas, Evardito Baca and all of them—this Pora would strip the corn from the cob using these machines they had. You would put in the corn cob, one by one, or two by two. We used to fill up I don't know how many sacks of corn.

You also removed the corn from the cob by hand when there was no other way, because the machine I'm speaking about belonged to someone else, and he loaned it to people. Sometimes it was loaned out, so you had to strip the corn from the cob without it, by hand.

The woman also helped in cutting the cornstalks. You had to cut the cornstalks when the corn was ripe and dry, and what remained was fodder for the animals. The farmers left it there for the animals. I have a scar here on my hand where I cut myself with the sickle. The very first time I went to cut cornstalks, I cut myself. (Laughter). But no, on the ranch you treated your own wounds.

As for pinto beans, you had to toss the beans, as well as the wheat, up in the air to remove the chaff. The wheat, well, they'd pile it up in these huge, round piles, and then you'd get a number of horses to go round and round, loose. We, my sister Adelita and I, would get on the horses and go round and round until the piles of wheat were smooth, leveled to the ground. Then the wind would come to the threshing

decía mi papá, "Ya va venir el viento. Vamos a aigrar el trigo," y ai estaba uno aigrando el trigo. Con un bote de bandeja, tamién con unas tablas, lo agarraba uno y loo bajaba asina cuando venía el viento. Cuando iba el viento se llevaba la paja. Se quedaba el trigo. Tenían carpas pa que cayera el trigo. Lo echábanos en sacos, y loo lo traiban aquí en Alburquerque y lo cambiaban por harina.

¡Oh sí! Nojotras ayudamos muncho en la siembra. De todos modos le hacía uno. Trabajaba uno muncho allá [en Guadalupe].

field that we had; it was on top of a hill. And when the wind came up in the afternoon or evening, my dad would say, "The wind's coming. Let's 'air' the wheat [toss it up in the air]," and so you tossed the wheat up in the air. You'd do that with a can that you used as a tray; you'd also use wooden paddles. You'd toss the wheat in the air when the wind came. When the wind came, the wheat chaff blew away. The only thing left was the wheat. The farmers had canvases and that's where the wheat would drop. We would put it into sacks, and then they brought it to Albuquerque and exchanged it for flour.

Oh yes! We girls helped a lot in the fields. You helped in any way possible. You used to work very hard in Guadalupe.

La cosecha
Eremita García-Griego de Lucero

Pa la cosecha iban apartando todos los sacos, los sacos que estaban amarraos. Los desataban y los iban preparando pa echar el maiz o frijol, lo que cosechaban. Los sacos de guangoche, que eran los que se usaban, si estaban rotos, se iban remendando. Y las mujeres detenían los sacos, y el marido iba llenando con botes de diez libras, botes de cinco libras, pepenando la cosecha y echándola en sacos. La mujer siempre le tenía el saco abierto pa que entrara la cosecha adentro de los sacos.

[Trillar] el frijol. La palabra trillando. Traiban en veces cabras o en veces traiban caballos. Por eso tenían lo que llamaban la era. Los caballos, tres o cuatro, pisotiaban el frijol, especialmente el frijol. Entonces se apartaba la hoja, estaba seca, del frijol, y luego con la mano se iba apartando too hasta que se limpiaba. Se echaban en unas cajas, en unos cajones hechos al propio con un alambre, pa que se juera saliendo too el polvo, el tamo que le llamaban, hasta que quedaba el frijol bien limpio. Y de ai se iba echando en los sacos, en veces pa vender o para el uso.

Ayudaban a limpiar, a quitar el tamo y el polvo que había quedao cuando se apartaba la hoja seca del frijol. Todo esto lo hacían las mujeres: trillar, limpiar, y todo eso era con de pura mano.

Harvest Time
Eremita García-Griego de Lucero

When it came to harvest time, they would set aside the sacks, all of the sacks that were tied up in bunches. They would untie them and then get each one ready to fill up with corn or beans, whatever was being harvested. Gunnysacks, which is what was being used, if they were torn, would be sewn up one by one. The women would hold the sacks, and the husband would fill them up using ten-pound cans, five-pound cans, with the crops. They would put the corn or beans in sacks. The woman always held the sack open so the crops could be poured into the sacks.

Threshing pinto beans. The word is threshing. At times they would bring goats; other times they brought horses. That's why they had what is called a threshing field. The horses, three or four of them, would walk on the beans, especially the beans. Then the leaves, which were dry, would separate from the beans, and then everything else was done by hand until the beans were clean. The beans were poured into boxes, into special wooden boxes with wire on them so that the dust, that is, the small pieces of chaff, as it was called, could escape, until the beans were clean. From there they were thrown into sacks, sometimes to sell or for domestic use.

The women would help clean, to remove the chaff and the dust that had settled when the dry leaves were separated from the beans. The women did all of this: threshing, cleaning. And all of that solely by hand.

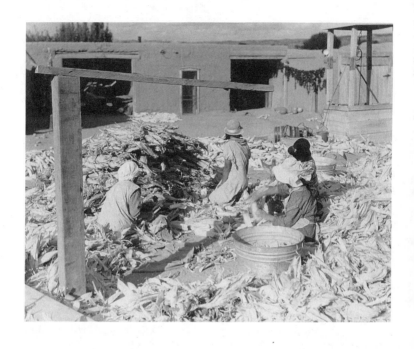

Women husking corn, ca. 1935. T. Harmon Parkhurst, courtesy of Museum of New Mexico, neg. no. 5172.

Teníamos que arrancar el maiz
Macedonia Molina

Pues yo después de que sembrábanos y todo eso, cuando ya se hacía el maiz y todo, teníamos que arrancar. Yo era de ésas tamién. Teníamos que arrancar el maiz de la carne y apilalo—hacerlo pilitas—y luego agarrar carreras y más carreras, y luego vinir en un carro de bestias y echalo en el carro y carrialo par unas cocheras grandotas que tenían. Tenían diferentes maizes. Tenían un maiz que le llamaban maiz avelicio, colorado. Y lo[o] tenían otro que le llamaban, yo no me acuerdo cómo le [llamaban], gringo quizás. Era amarillo, y otro maiz, el maiz azul, pa la harina azul.

We Had to Pick Corn
Macedona Molina

Well, after we planted and all of that, when the corn was ripe and everything, we had to pick corn. I was one of those who did that. We had to remove the corn from the cornstalks and pile it up—make small piles—and then take each row of corn one at a time, and then go in a horse wagon and toss it into the horse wagon and haul the corn to these huge sheds they had. There were different kinds of corn. They had this red corn called *avelicio*. And then there was another one called—I don't recall what it was called. It had an Anglo name, I guess. It was yellow, and then there was another corn, blue corn, used for blue-corn flour.

Todo eso lo apartábanos, una pila par un lao y otra pal otro hasta que acabábamos de char eso. Antonces nos poníanos a deshojar el maiz. Deshojábamos primero una pila de maiz colorado, y luego después el otro, y así. Cuando ya acabábamos lo poníamos par otra cochera. Apilábamos todo este maiz par otra cochera. Pues así tenían como cajones hechos pa echar el maiz ai.

Y lo[o] tenían unas pilas grandotas de desgranar maiz. Teníamos que echale maiz a la máquina y estaba desgranando uno el maiz y caindo en los sacos. Y otro cosiendo los sacos. Y siempre apilándolos pallá, pa una orilla, y apartaban las clases de maiz y todo. Cuando ya acabábanos de todo esto salían a caballo [los hombres] a sus órdenes. Yo no sé ónde lo venderían.

Bueno, el maiz azul lo llevaban pa onde había [un molino], porque el *grandpa* tenía un molino ai en Santa Clara. Él molía su *own* trigo y todo eso. Él lo molía. Oh, y tamién esto, se me olvidó dicirle. Pa Semana Santa enraizamos el trigo pa la panocha. Lo enraizábamos. Lo echábanos en sacos, lo húmido, y lo poníamos en un lao de la estufa, arriba de un cajoncito, y le teníamos que estar rociando con agua. Cuando ya comenzaba a salirse la raiz, ya estaba listo pa molelo pa la panocha. Y lo[o] lo sacábamos y lo destendíamos ajuera que se secara bien, bien con el sol. Cuando ya se secaba entonces comenzábamos a moler. Y apartábamos todo el salvao pa la torta. Ése era pa la torta, pal güevo, y la harina era pa la panocha. Todo ese trabajo hacíamos.

We would separate all of these, a separate pile for each one, one to one side and the other to the other, until we finished. Then we got down to husking the corn. First we'd husk a pile of red corn, and then the next kind, and so forth. Whenever we were through, we'd put it in a shed. That's where we'd pile the corn. That's where we had like wooden boxes to throw the corn into.

Then we ended up with huge piles of corn that we had to strip from the corncob. We had to feed corn into the grinding machine, and there you were stripping corn and it'd be dropping into gunnysacks. Others would be sewing the sacks. Still others would be piling them up to one side, while at the same time separating the different kinds of corn. By the time we finished all of this, the men would leave on horseback to go deliver whatever corn had been ordered. I don't know where they sold it.

Now, the blue corn they took to where there was a flour mill, because grandpa had a flour mill there in Santa Clara. He ground his own wheat and all of that. He ground it. Oh, and by the way, I forgot to tell you. For Holy Week we used to let wheat sprout for *panocha*. We'd let it sprout. We'd put wheat in damp sacks next to the stove, on top of a little wooden box, and we had to keep sprinkling the wheat with water. By the time it started to sprout, it was ready to be ground for the pudding. Then we'd spread it outside so that it'd dry real well, real well in the sun. When it was dry, we'd start grinding it. We'd also separate the bran for fritters. That was reserved for egg fritters, and the flour was for the pudding. We did all that kind of work.

7

Courtship, Marriage, and Children

In this chapter women enlighten us with stories regarding courtship, marriage, and children. Their candid testimony takes us inside a world with dimensions perhaps unfamiliar to some of us. Within the confined human environment of the Río Puerco valley, however circumscribed or diffuse it may have been, young women had to conform to certain social norms and precepts imposed, albeit not always adhered to, by their elders.

There is a dramatic difference beween the vibrant traditions and customs in vogue among Hispanos of the Río Puerco valley fifty to eighty years ago and the meager survivals among contemporary Hispanos of northern New Mexico today. When a young man and woman were to get married, certain rituals came into play. Courtship, for example, at times amounted to a kind of hide-and-seek game between parents and their sons and daughters.

The opportunities for a boy and girl to get acquainted were few and far between. Dating as we know it today was discouraged and even prohibited. What made matters worse was the fact that many youths lived in villages widely separated from one another. Young people were not only dissuaded from congregating in groups, but their chances of meeting privately were limited as well. On Sundays after mass, some of young men and women would exchange signals of sorts and sneak away

on horseback to meet at some clandestine place; but even these moments were brief. Once in a while on *días de fiesta*, holidays, such as Saint Anne's Day, reserved strictly for the women, boys would ride horseback with the girls, but not within view of their parents. She would ride in the saddle, while he sat behind her with his arms around her waist. Besides mass, other gathering places were community functions such as dances, weddings, or religious wakes, *velorios*. My maternal grandmother used to say, "If you want to marry a nice girl, go to church" ("Si quieres casarte con una buena muchacha, ve a misa").

Macedonia Molina, in "Con los ojos ya era uno novio" ("By Sheer Eye Contact, You Were Engaged") relates a tongue-in-cheek account of how girls attending religious wakes went to the *escusao* (outhouse), pretending to have a stomachache, just so they could exchange a few words with the boy of their choice. These brief encounters invariably amounted to dating or even engagement.

Marriages were also arranged between principal families, with the prospective bride having little to say about her marriage, often to a total stranger. As Eremita García-Griego de Lucero attests, it "was not even known that a certain boy liked a certain girl well enough for her to be asked to be his wife," until his parents showed up at her front door to ask for her hand in marriage. On rare occasions the decision was the girl's, with her father's blessings. "The mother," according to García-Griego de Lucero, "didn't have any say in the matter."

An impending marriage was characterized by a chain of formal and informal events. These included the *pedimento* (which has the same root as the verb *pedir*, to ask) and the *prendorio* (from the same root as *prender*, "to hitch up"), among others. The pedimento required the boy's parents to ask for the girl's hand in marriage; this could be done in person (the informal approach) if the families knew each other, or through correspondence. If a written communication was in order, a letter of acceptance or rejection to the boy's parents was drafted by a local scribe, an *escribano*, in case the parents could not read or write. The scribe then proceeded to mail or hand-carry the fateful letter. In the event the girl's parents rejected the marriage proposal, the boy got "squashed" or "pumpkined out." "They gave him pumpkins" ("le dieron calabazas"), people would say (there is a story in New Mexican folklore about a young man who was shunned by the girl's parents, but her mother felt

so sorry for him that she left a few pumpkins outside the door so that he would not go home empty-handed). Squashed and demoralized, the boy headed home with his tail between his legs ("con la cola entre las piernas"), riddled with shame and embarrassment. This was also humiliating for the boy's parents. The news of being snubbed reverberated throughout the community in short order; thus it produced a perfect topic for *mitote*, or gossip, for some time to come.

In case the girl's parents were unsure about a prospective son-in-law, they were often willing to give him the benefit of the doubt. This meant inviting him to the girl's home so he could prove his prowess as a worker in her father's presence. Throughout this entire ordeal, the father was usually circumspect and reserved. It was the boy's challenge to tear down the barriers of silence and convince the girl's father that he was worthy of his daughter's hand. If the boy made a favorable impression— that is, he could hitch up the horses, till the soil, or chop wood—he was then allowed to marry the daughter.

A prendorio, or betrothal party, followed thereafter, with a wedding date in sight. Following nuptial vows, the young couple would move in with the boy's family, so the father would not lose a helping hand. The newlyweds started planning a family, hoping their children would embrace and eventually carry on the traditions they themselves had been loyal to.

Parents on both sides expected the newlyweds to become parents so they could boast about a new granddaughter or grandson. Since family planning did not exist in those days, if a child was not born during the first year of marriage, speculation arose that either he was impotent (*un mulo*), or she was barren (*seca*, dry), so it was best to put those potential rumors to rest as soon as possible.

Every community had a *partera* (midwife)—the doctor in residence, the pediatrician, and general physician, all wrapped up into one—who cared for the expectant mother. After the baby was born, as we see in Pina Lucero's "¿Qué vas por la partera?", the new mother had to adhere to a strict set of dietary rules and certain rituals common throughout the Río Puerco valley. For instance she was compelled to eat lamb and forbidden to go outside the house for forty days after giving birth.

Macedonia Molina's "Yo tenía que cortarle el ombliguito" informs us that not all midwives were women. Her own grandfather was a *partero*, a

rare breed in any community. It was also not common to allow children to be present when a child was born. Nevertheless Molina's "midhusband" grandfather sought her assistance. Her account of how petrified she was at cutting the baby's umbilical cord evokes sympathy both for her and the newborn.

As they were growing up, little girls and boys in the Río Puerco valley immersed themselves in a world of fantasy and made or invented their own toys. Frances Lovato, in "Hacíanos muñecas" ("We Made Dolls"), and Eremita García-Griego de Lucero in "Teníanos munchos juguetes" ("We Had a Lot of Toys"), guide us through a playful world of make-believe. We clearly can already begin to observe a keen separation of the male and female worlds.

In this chapter we go from courtship and marriage to children and toys. Customs and practices, each one interrelated to tradition and affecting women in particular, are vividly articulated by them. Their testimony underscores their experiences and the world they inhabited, as they look back across time and space. But there is Inesita Márez-Tafoya, who, in "Una muchacha soltera" ("A Single Girl"), also criticizes today's youth for their footloose and fancy-free behavior. The social norms the Hispanas of the Río Puerco valley strove to uphold so unflinchingly, in concert with their husbands, today are crumbling before their eyes, in the midst of a modern technological and urban society.

María Catalina Griego y Sánchez, 1993.

¿Qué andaban mordiéndoles las orejas?

María Catalina Griego y Sánchez

En papá Teodoro y mamá Emilia nos llevaban al baile, pero ella tenía reglas. Teníanos que hacer muncho negocio antes de ir al baile. Nos ponían a deshojar maiz y a ponelo en una plataforma onde se secara. Las hojas las apartábanos. Me acuerdo que Eremita [su hermana] dicía, hasta lloraba, "Ya pa cuando vamos pal baile estamos todas negritas como una tinta, y las manos toas rajadas." (Risas).

Y luego cuando íbanos ir al baile nos dicía mi mamá Emilia, "Si yo no quiero que bailen con cierto muchacho, yo las pelizco y ustedes digan,

What Were You Doing, Chewing on Their Ears?

María Catalina Griego y Sánchez

Father Teodoro and Mother Emilia [grandparents] would take us to the dances, but she had her rules. We had to do a lot of chores before going to the dance. They made us shuck corn and then put it on a platform to dry. The leaves, we'd toss them to one side. I remember that Eremita [her sister], crying, would say: "By the time we're ready for the dance, we'll be all black like ink—and our hands all cracked." (Laughter).

And then when we were about to leave for the dance, my Mother

no, que no van a bailar." Y dije yo entre mí, "A mí no me va a pelizcar naiden." "Yo no quiero que le vayan andar hablando a todos los muchachos."

Güeno, cuando llegábanos al baile, en la sala, yo sabía que me iban a pelizcar. Antonces les dijía a las muchachas que estaban en seguida de mí que se abrieran, que se jueran abriendo hasta que estaba lejos de mamá Emilia. Eremita no se movía. Se estaba en un lao de mi mamá Emilia. Era muy obediente. Yo quizás era un poco más salida, más traviesa.

Güeno, otro día que nos levantábanos dijía amá Emilia, "¿Qué no les dije que no quería que jueran a bailar con los que no quería?" Eremita nomás me vía. "¡Curre! Mamá se nos va enojar muncho," me dijía Eremita. Y me dice mi mamá Emilia, "¿Qué no te dije que no jueras a bailar con ciertos muchachos?" Y loo le dije, "Pus, mamá, pus ellos vinieron. Tuvieron la gracia de preguntarme si quería bailar con ellos. No les podía dijir que no." "¿Y qué andaban machucándoles, mordiéndoles las orejas?" "No, mamá. ¡Yo andaba mascando chíquete!" (Risas). Porque dijía que estaba platicando muncho con el bailador. "No mamá. Yo estaba mascando chíquete." Allá salía yo de esa problema.

Emilia would say to us: "If I don't want you to dance with a certain boy, I'll pinch you and you say that you can't dance." And I said to myself: "Nobody's going to pinch me." "I don't want you to go around talking to all the boys."

Okay, by the time we got to the dance, to the dance hall, I knew that I was going to get pinched. So then I would tell the girls who were seated right next to me to spread out, to spread out until I was far from Mother Emilia. Eremita wouldn't move. She'd stay right next to Mother Emilia. She was very obedient. I guess I was a bit more daring, more of a cutup.

Okay, the next day when we were getting up, Mother Emilia would say to us: "Didn't I tell you not to go dance with those boys if I didn't want you to?" All Eremita could do was to look at me. "Run! Mother's going to really get mad at us," she'd say to me. And Mother Emilia says to me: "Didn't I tell you not to go dance with some of the boys?" Then I said to her: "Well, Mom, they're the ones who came to me. They had the decency to ask me if I wanted to dance with them. I couldn't turn them down." "And what were you doing chewing, biting their ears?" "No, Mom, I was chewing gum!" (Laughter). She'd say that because I was talking a lot with my partner. "No, Mom. I was chewing gum." That's how I got out of that predicament.

Emilia Gonzales. Courtesy Emilia Gonzales.

Una muchacha soltera
Inesita Márez-Tafoya

Allá [en Guadalupe] no había onde uno ir a divertirse. No había *show*; no había nada más que fiestas o bailes. Ai no andaban como ahora, que las traen [los muchachos a las muchachas] todas hechas pilas en los carros. (Risas).

Y ahora si le tocaba una mala suerte a una muchacha soltera, y tuviera *baby*, era un escándalo. ¡Era un escándalo! Pa los pobres padres, era vergüenza. Y casi no dejaban ni salir a la muchacha ni a la puerta, porque tenía vergüenza. No como ahora. Ahora no hay vergüenza, ni el respeto, ni miedo. ¡No hay nada! Ahora está terrible; está terrible. Y

A Single Girl
Inesita Márez-Tafoya

In Guadalupe there was no place to go have fun. There were no movie houses. There wasn't anything but fiestas and dances. You didn't have any of this business like now, where the boys haul around the girls all piled up on top of one another in the cars. (Laughter).

And now if it so happened that a single girl ran into some bad luck and had a baby, it was a scandal. It was a scandal! For the poor parents, it was a disgrace. And they rarely allowed the girl to leave the house, not even to stand at the doorway, because she was ashamed. Not like

antes no, antes aquella muchacha no la dejaban sus padres salir. Aí la tenían, hasta que el niño nacía. Y ai se quedaba la pobre, avergonzada, con vergüenzas.

Munchas se casaron después. Si les tocaba una güena suerte se casaban. Se casaban . . . ¡Qué bárbaro! Allá [en Guadalupe] siempre había más respeto en la gente de antes que la de ora, lo mismo el hombre pa la mujer que la mujer para el hombre.

Pues te diré que yo nunca tuve batalla con mi familia. Hasta orita, ahora mismo les digo yo que en el tiempo de que tuve yo a mis hijos creciendo, lo mismo las hijas [no tuve batalla]. Yo nunca ni mi esposo anduvimos con batallas de sacalos de una cárcel o de que anduvieran robando, que anduvieran en la marijuana, que anduvieran en esto o en lotro. Gracias a Dios. Yo le doy munchas gracias al Señor que nunca nos pasó andar en vergüenzas por nada. ¡Nunca! Y hasta ahora mesmo—ya ora todos tienen familia, lo mesmo los hombres que las mujeres—nunca me ha tocado de andar allá trompezando, buscando dinero pa pagar fianzas y esto y lotro.

Una muchacha soltera

now. Now there's no shame, nor lack of respect, or fear. There's nothing! Now it's terrible; it's terrible. And back then, no. Back then the parents didn't let the girl go out. They kept her there, locked up until the baby was born. And there she stayed, poor thing, embarrassed, full of shame.

Many of them were able to get married afterwards. If they were lucky, they got married. They got married . . . Good grief! In Guadalupe there was always more respect then among the people than you find in those of today, as true for the man toward the woman as for the woman toward the man.

Well, I'll tell you, I never had any problems with my family. Even now, even at this very moment, I can say that while my children were growing up, including the daughters, I had no trouble with them. Neither my husband nor I ever had to go bail them out of jail either because they were caught stealing, smoking pot, or were involved in one thing or another. Thank God. I thank the Lord that we never got caught in embarrassing situations or anything. Never! And to this day—now they all have their own families, the boys as well as the girls—I've never had to go around tripping over myself in search of money to bail them out for one thing or another.

Con los ojos ya era uno novio
Macedonia Molina

Pues yo creo que tenía de ser muy dificultao si a uno le gustaba el muchacho [y a él] no le gustaba uno, pus, ¿qué iba hacerle? Y munchas veces sí, yo creo que con los ojos ya era uno novio.

Y luego, pues, cuando había velorios, antonces era cuando ya hablábamos. Cuando había velorios [era] que le daba un dolor de estómago a las muchachas. "Vamos pal escusao." Y nos dicían, "Vienen pronto." Nos daban tantos minutos nomás pa ir pal escusao. Si no viníamos pronto, salían a cuidarnos, y allá a palabras asina nomás los muchachos. Cuando estaban en el rezo ellos nos vían cuando salíamos pal escusao. Allá nos hablábanos y ya éranos novios. De allá los [nos] hablaban [las mamás] y ya estuvo porque salían a corretiarnos pa manecernos pronto pa dentro pal rezo.

Ora en el rezo fue el encuentro de nosotras pa los novios, porque cuando íbamos a un baile, si andábanos platicando muncho, nos sacaban del baile. No nos dejaban platicar muncho con un muchacho. Nomás los [nos] vían que estábanos platicando muncho y riéndonos, nos sacaban del baile.

[Para casarse], pues, tenían que ir el papá y la mamá del muchacho a pidir a la muchacha. Por eso le llamaban calabazas más antes si no querían casarse. ¿Cómo iban adivinar? No sabían de cierto si la muchacha quería casarse o no. Ya ora no, ya están seguros. Pero antes no. Iban a tiento. Si le daban calabazas pus dicían, "Le dio calabazas," y si quería casarse, se casaron.

A veces los padres no dejaban a uno casarse. Pidían respuesta, no, que lo[o] esperara uno, dos meses antes de casarse. Lo[o] esperaban y ellos [los padres de la novia] les daban la respuesta, y lo[o] algunos sí dijían que tenían que trae al novio pa que trabajara a ver si era güen trabajador. Si no era güen trabajador, no dejan a la muchacha casarse con él.

Como yo, no estaban entonces muy estritos. Yo no tenía padre, como quien dice. Andaba volando en puerta en puerta. [Mi] tío fue

By Sheer Eye Contact, You Were Engaged

Macedonia Molina

I believe it was very difficult if you liked the boy, but if he didn't like you, what were you to do? And often, yes, I believe that by sheer eye contact, you were engaged.

And then whenever there were wakes for the deceased, that's when we spoke to one another. It was during these wakes that the girls got stomachaches. "We're going to the bathroom." And they [the mothers] would say to us, "Get back quickly." They gave us only so many minutes to go to the bathroom. If didn't return quickly, they'd come after us, so we were barely able to exchange a few words with the boys. When they were praying, they'd see us leave for the bathroom. That's where we talked, and before you knew it we were engaged. Meantime, there were the mothers calling us, and before you knew it they were after us to get back inside to pray.

I'm telling you, it was during these praying sessions that we girls found boyfriends, because when we went to a dance, if we talked a lot, they'd take us home. They wouldn't let us talk much to a boy. As soon as they happened to see us talking a lot and laughing, they took us home.

In order to get married, well, the boy's parents had to go ask for the girl's hand in marriage. That's why back then they called it "pumpkins" if the girl's parents didn't want her to get married. How could they guess? They didn't know if the girl wanted to get married or not. That's not true today. Everybody is in agreement. But back then, no. They played it by ear. If the boy was rejected, then people would say, "She gave him pumpkins," and if the girl wanted to get married, that was it.

At times the parents didn't let you get married. They would ask for a response, right? So the parents would ask the girl to wait a month or two before getting married. Then the boy's parents would wait and they [her parents] would give the response. Yes, there were some girls' parents who said that they had to take the fiancé so that he could

muy duro conmigo. Nunca me dejaba agarrar unas cartas de novios ni nada. Él tenía rentao su cajón en la estafeta, *so* yo no tenía una chanza. Nomás garraba una carta, ¡oh, era más lo que me investigaba!

Ai en Seboyeta [conocí a mi esposo]. Los [nos] vinimos yo y mi tío, un hermano de en papá, y los [nos] vinimos de Prescott, que me tuvo que sacar pulida del tío. No me dejaba venir. Yo me quería venir ya porque estaba pasando munchos trabajos con la tía, y luego de ai él me trajo, mi tío Severo. Es de la edá mía. Y llegamos a Seboyeta.

Eran las fiestas de Seboyeta. Me dice, "Amos a las fiestas a Seboyeta." "Oh, no me dejan," le dije. "Vamos," me dijo. "Yo te saco el tíquete," y me vine. Pues ai en Seboyeta ai estaban los de Márquez. Pues ai nos encontramos yo y Pablo [su esposo]. Ya nos conocíamos. Nos capiábamos así porque él iba muncho a las fiestas a Gualupe. Y luego ai nos encontramos esa noche y siguimos bailando, que ya pasamos toda la fiesta juntos. Y loo ya con el tiempo yo volví otra vez de güelta pa Gualupe con mi prima hermana. Y allá me casé.

Con los ojos ya era uno novio

work, to see if he was a good worker. If he wasn't a good worker, they wouldn't let the girl marry him.

Like with me, they weren't very strict. I guess you might say I didn't really have a father. I bounced from one home to another. My uncle was very hard on me. He never let me go out; he never let me receive letters from boyfriends or anything. He had a mailbox at the post office, so I didn't have a chance. No sooner did I get a letter, then he started in questioning me!

I met my husband there in Seboyeta. My uncle, a brother of my father, and I left Prescott. Why, he even had to take me out secretly. They wouldn't let me come. I already wanted to leave, because I was having trouble with my aunt, and after that my uncle Severo brought me. He's my age. So, we got to Seboyeta.

The fiestas were going on at Seboyeta. He says to me, "Let's go to the fiestas in Seboyeta." "Oh, they won't let me go," I said to him. "Let's go," he said. "I'll buy you the ticket," and I left. Well, in Seboyeta there were those guys from Márquez. It was in Seboyeta that my husband, Pablo, and I met. We already knew each other. We used to wave at each other a lot, because he used to go to the fiestas in Guadalupe. Then we got together that night and just kept dancing, and ended up spending the whole fiesta together. After a time I went back again to Guadalupe with my cousin. And that's where I got married.

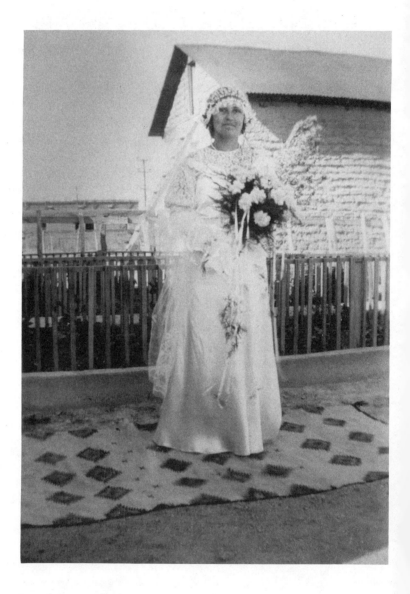

Agapita López-García, 1935.

Ése jue el noviazgo de mí y de Juan
Susanita Ramírez de Armijo

Yo diré que yo me conocí de Juan [su esposo] porque, como quien dice, él me crió. Él era mayor que yo doce años. Y él dice que él me crió porque para la inflencia tenía yo—la inflencia jue el diez y ocho—dos años, tres años por lo menos. Yo nací en el diez y seis.

Como dije, él me crió. ¿Y cómo me conocí yo con Juan? Te diré yo que me hice novia de él, jue en un baile. Era pal día de San Juan. Esta prima mía, ésta que te digo yo que era muy amante de andar, [como] los hombres—pus ella andaba ondequiera. Y juimos pa San Juan. Nos despacharon solas, que juéramos a ver ónde corrían caballos. La corrida

That Was Juan and My Courtship
Susanita Ramírez de Armijo

I'll say that I became acquainted with Juan [her husband] because, as you might say, he raised me. He was twelve years older than me. And he says that he raised me, because at the time of the influenza—the influenza was in 1918—I was two or three years old, at least. I was born in 1916.

As I said, he raised me. And how did I get to meet Juan? The way I became his girlfriend was at a dance. It was for Saint John's Day [June 24]. This cousin of mine, the one I told you about who was very fond of running around, like men—why she went all over, and we went to-

de gallos que le dijían. Nos despacharon solas mi *daddy* y mi mamá a nosotras. Tenía un bogue de aquellos que usaban antes con aquellos techitos. Y juimos. Y cuando viníamos de allá pacá, ya tenía unos pulsos muy bonitos porque estaban cerca los navajoses. Y me dijo [mi prima]:

—¿Cuánto me apuestas que esta noche a que Juan me hace el propósito de que me case con él?

—Güeno, como quieras—le dije. —Yo no tengo interés de él. Yo lo conozco—le dije—por mi vecino y me trata muy bien, pero si quieres vamos apostando. Tú tus pulsos, yo los míos. Si gano yo, me quedo con tus pulsos, y si ganas tú, te quedas con Juan.

Güeno, nos llevó mi *daddy* y mi mamá al baile. Era en la noche. Güeno, pus cuando se comenzó el baile allá, pus tenía don Juan Córdova refrescos para vender allí en la sala. Tenía *ice cream*. Luego me dice Juan:

—¿Qué no quieres ir a comprarte una *ice cream*?

Vendían de esa, aquella *ice cream* que hacían en aquellos botes.

—Güeno—le dije. —¡Vamos!

Y ya me vido mi mamá y a mi mamá no le cayó muy bien. Yo sé que no le cayó muy bien que me envitara, porque a ellos no les gustaba eso. Pus ya cuando vine yo de allá, vine yo y me senté juntra a mi mamá y le dije que si quería *ice cream*, y comió mi mamá de la que Juan me compró.

Güeno, era la primer pieza, y, como me dijo Lola, "Si baile él primero contigo la primer pieza, es que vas a ganar tú; y si soy yo, gano yo." Güeno, ésa era la apuesta.

—Güeno—le dije.

Bailó él primero conmigo, y siguimos bailando y a ella no la bailó. Y ella se enojó. Aá pa la acabada del baile, ya Juan quizás andaba poquito en copa, yo no sé. Jue y la sacó a bailar y ella lo desaigró. Le dijo que no. Ella no quería bailar. Se vino Juan y me sacó a mí después y bailé hasta que se acabó el baile y de ai quedé novia de Juan. Yo anduve con Juan *maybe* tres meses. Me casé en setiembre. Y ése jue el noviazgo de mí y de Juan.

Ése jue el noviazgo de mí y de Juan

gether to Saint John's Day. They sent us alone, to watch the horse races. The rooster races, as they were called. My daddy and my mom sent us alone. He had one of those buggies that were popular back then, with a little sun roof. So we went. And when we were on the way back, I already had some very beautiful bracelets, because the Navajos were close by. And my cousin said to me:

"How much do you want to bet that tonight Juan will propose to me?"

"Fine with me; whatever you say," I said to her. "I'm not interested in him. I know him," I answered, "only as a neighbor, and he treats me very well, but if you want to, let's bet. You bet your bracelets, I'll bet you mine. If I win, I'll keep your bracelets. If you win, you can have Juan."

Well then, my daddy and my mom took us to the dance. It was at night. Okay, by the time the dance started over there [in Guadalupe], Don Juan Córdova had refreshments for sale there in the dance hall. He had ice cream. Then Juan said to me:

"Don't you want to go get an ice cream?"

They were selling that ice cream that they made in those tin cans.

"Fine." I said to him. "Let's go!"

And about that time, my mom saw me and she didn't like the idea very well. The idea of him inviting me didn't sit very well with her, because my parents didn't like that sort of thing. Well, by the time I got back, I sat down next to my mom, and I asked her if she wanted some ice cream, and so she ate some of what Juan had bought me.

Okay, the first dance began, and, as Lola told me, "If he dances first with you, then you're going to win; and if it's me, I'll win." Okay, that was the bet.

"Okay," I said to her. He danced first with me, and we kept on dancing, but he wouldn't dance with her. So she got mad. Just as the dance was about to end, I guess Juan was a bit tipsy, I don't know, he went to ask her to dance and she slighted him. She refused. She didn't want to dance. Juan then came and took me out to dance, and I danced with him until the dance was over. From that moment on I was Juan's girlfriend. I went with Juan maybe three months. I got married in September. And that was Juan and my courtship.

Voy a tener un niño

Eremita García-Griego de Lucero

Eso ["the birds and the bees"] cuasi después de que una hija era casada, antonces era cuando la mamá hablaba a tocante de eso. De tener un niño, eso todo venía, todo esto venía muncho después de que estaba la hija casada. Tamién tenía la confianza de preguntar, por ejemplo, "Yo no sé si yo estaré como enbarazada, como que si voy a tener un niño," cuando ya pasaba un tiempo, cinco meses, seis meses de una muchacha haberse casao.

Tamién tenía muncha confianza en la suegra, porque siempre le llamaba de mamá, pero se volvía negocio de mujer.

Los hombres no usaban nada de eso. Cuando ellos daban su opinión, era cuando una muchacha, una nuera, una hija iba tener un niño. Antonces sí se juntaban hasta los tíos, tías, todos, abuelitos. Se juntaban todos a dar un opinión, porque en ese tiempo los dotores [las parteras] venían a la casa. Ésa tamién era una cosa de mujer, que había mujeres que les llaman parteras, que les llamamos *midwives*. Antonces sí daban muncha opinión el papá, el papá del niño, los agüelitos, los suegros, a ver si ese nacimiento venía bien, cómo estaba la mamá, si la mamá no necesitaba de ir, de levantarse a un espital.

Porque munchos niños fueron nacidos afuera de la Plaza, y en la casa. Yo tuve a toda mi familia en la casa, sin dotores, menos los últimos; antonces fui a un espital. Antonces se unía toda la familia. Los hombres siempre era costumbre de estarse en la cocina cuando un niño estaba naciendo porque estaban siempre queriendo saber cómo estaba la mamá haciendo, a ver si no se enfermaba muy mal, en qué podrían

I'm Going to Have a Baby

Eremita García-Griego de Lucero

All that business of the "birds and the bees," it was almost always after a daughter was married; it was only then that the mother even spoke about that sort of thing. The matter of having a child, all that came, all that came much later, after the daughter had been married. At that time she also had the confidence to ask, for example, "I don't know if I'm pregnant. It seems as if I'm going to have a baby," but only after quite a bit of time had elapsed, like five or six months after a girl had been married.

She also had a lot of confidence in her mother-in-law, because she was always called "Mom," but there again, all of this became a matter for the women.

The men didn't talk about those matters at all. When they gave their opinion was when a girl, a daughter-in-law, a daughter was going to have a baby. It was at that time that even the uncles, aunts, everyone, including the grandparents, got together. They all gathered to render an opinion, because in those days the doctors [midwives] would come to the house. That was also a matter for women, because it was the women who were midwives. They were called midwives. At that time the father, the father-to-be, the grandparents, the in-laws, all expressed their opinion as to whether the impending birth was coming along fine or not, whether the mother-to-be was all right, or whether she should be taken to a hospital.

Many children were born away from Albuquerque, at home. All of my children were born at home, without doctors, except for the last ones; then I went to a hospital. Back then the whole family would rally around. It was customary for the men to gather in the kitchen whenever a child was going to be born, because they always wanted to know how the mother was doing, whether she was doing worse, whether they could help in any way, such as picking her up and taking her—if

ayudar, como ora llevar y levantar a la enferma—si estaba muy enferma teniendo a su niño—a levantala a un dotor más competente.

Cuando la partera entraba con una muchacha que iba a tener un niño, entraban en veces si había tías tamién. Siempre se juntaban hasta de a cinco mujeres cuando la partera entraba a su cuarto atender a la que iba tener su niño.

she was having a hard time with the delivery—to a more competent doctor [in more recent times].

When the midwife went into the room where a girl was going to have a baby, at times there were aunts who entered also. There were always up to five women whenever the midwife went in to assist the one who was going to have a baby.

¿Qué vas por la partera?

Pina Lucero

Parteras habían en esos años, munchas. Y aquí van por la partera. Güeno, había casos que si estaba cerca [la partera] pus ya estaba lista. Ya nomás sabía cuando iban a ir por ella. Llegó haber veces que tenían que salir a la medianoche por ella, pero en un carro de bestias ai iban por ella. Por eso dijían el dicho, "¿Qué vas por la partera?" (Risas). "¿Qué vas por la partera?," dijían cuando iba uno apurao.

Cuarenta días [tenía que estarse en casa la mamá después de nacer el niño]. No tenías que quitarte el paño. Era un paño que usaba uno, blanco en la cabeza, pero no te daban carne. Tenía que ser carne de borreguito [no de hembra] que comías. Tenías que comer atole y güevos cocidos nomás. No te dejaban comer como ora, munchas cosas. Casi la mujer se la pasaba con el puro atole. Y gallina tenía que ser hecha con arroz, como un caldito, y es todo. No sé qué idea sería pero de la cama no te dejaban levantarte hasta los ocho días [de nacer el niño]. A los ocho días te levantabas. Tú no te lavabas la cabeza hasta los quince días. Y hasta los cuarenta días no te salías de la casa a pasiarte ni que te viera naiden. (Risas).

Y luego en la gente católica, a los cuarenta días salía, iba mi mamá allá onde está la iglesia de San Luis, ¿no? De ai iba de rodillas hasta donde estaba el Oratorio. Ése era la gracia que daban porque había pasao todo bien, con el parto, lo que era el parto. De rodillas, ¡fíjate tú!

Are You Going After the Midwife?

Pina Lucero

Back in those days there were lots of midwives. And here they go after the midwife. Well, there were cases where if the midwife was close by, why she was probably ready, she already had an idea when they were going to come after her. There were times when they had to go after her in the middle of the night, but by horse wagon, that's how. That's why there was a folk saying, "Are you going after the midwife?" (Laughter). "Are you going after the midwife?," they'd say when you were in a hurry.

The mother had to stay at home for forty days after the baby was born. You couldn't take off the kerchief. It was a white kerchief that you wore on your head, and they didn't give you beef. You had to eat lamb [not from a female]. You could only eat blue-corn gruel and hard-boiled eggs. You weren't allowed to eat like now, all kinds of things. The woman practically survived on nothing but blue-corn gruel. And the chicken had to be fixed with rice, like a broth, and that's it.

I don't know what the idea was, but they wouldn't let you out of bed until eight days after the child was born. Once the eight days were up, you would get up. You wouldn't wash your hair until fifteen days were up. And you wouldn't leave the house to take a stroll or let anyone see you until forty days had passed. (Laughter).

And among the Catholic people, after forty days, my mom would go over to San Luis, where the church was, right? From there she would go on her knees to where the Oratory was. That was the gratitude people showed because everything had turned out all right with the childbirth. On her knees, just imagine!

Yo tenía que cortarle el ombliguito
Macedonia Molina

Mi tío Celso estaba afuera todo el tiempo. Yo no sé ónde trabajaría. Quizás de *cowboys* y ganaos y yo no sé en qué. Y luego de ai cuando ella [su tía] estaba pa esperar niño, él estaa afuera.

El cuento es que nomás estaba yo y la agüelita en la casa y ella [su tía]. Y loo yo durmía con ella. Ya quizás el último mes que le iba a ofrecer a ella, me despachaba el *granpa* que juera durmir con ella. Me dicía ella que juera a dicile al *granpa* que ya estaba en *labor* quizás, y aquí yo voy corriendo y le dijía a mi *granpa*, "Dice mi tía que vaya pallá, ya." Se vinía él. Él era el partero de ella; él era el que la partiaba.

Yo nomás oí un grito. ¡Ajuera! Yo no me estaba. Yo salí a juir. Me gritaba él en la puerta, "¡Ven acá! ¡Ayúdame!" Nada. Pero hasta eso hice, mire. Cuando entraba de ajuera y había tenido su niño, yo tenía que cortarle el ombliguito al muchito. Y lo[o] con dolor, sabes, yo no podía cortárselo. Se me hacía que lo iba a, güeno, me hacía que lo cortaba. Temblando. Y loo se lo cortaba y lo[o] tenía que marrárselo con de ese cordón amarillo que vinían en los saquitos de punche. Con ése les amarraban el ombliguito. Me dijía él, "¡Apriétaselo bien! ¡Hazle un ñudo firme!"

Había veces cuando iban por una mujer pa que viniera a acabarla arreglar. Garraban el caballo y aquí van por la mujer pa que viniera a acabar de arreglar a la que había sanao. Cuando ella vinía ya se le estaba saliendo el cordón, pus no se lo marraba bien. Me daba lástima amarrarle.

I Had to Cut the Baby's Umbilical Cord

Macedonia Molina

My uncle Celso was away most of the time. I don't know where he worked. I guess he worked as a cowboy, taking care of animals and what have you. And then when she [her aunt] was expecting a baby, he was gone.

The fact is that only my grandma and I were at home, along with my aunt. I used to sleep with her. About a month before she was going to have the baby, my grandpa would send me over to sleep with my aunt. She'd tell me to go tell grandpa that she was maybe already having labor pains, so here I'd take off running and I'd say to my grandpa, "My aunt says for you to go over there, now." He'd come. He was her "midwife"; he was the one who delivered the baby.

I only heard a scream. Off I went! I didn't stay. I took off running. He was standing at the door hollering, "Come here! Help me!" I didn't want to go. But look, I even did that. When I came in from outside and she had her baby, I had to cut the little baby's umbilical cord. And then since the baby was in pain, you see, I had a hard time cutting it. I thought, well, I thought I was going to cut him accidentally. I was shaking. After I cut it, I had to bind it up with one of those yellow strings that came in the little sacks of tobacco. That's what people tied babies' umbilical cords with. My grandpa was saying to me, "Tie it tight! Make a knot!"

There were times when they'd go after a lady so she'd come and finish the job. They'd grab a horse and here they go after a lady so she'd come and finish tending to the woman who had just had a baby. By the time she arrived, the string on the umbilical cord was already coming loose, because I hadn't been able to tie it tight. I felt sorry for the baby, having to tie it so tight.

Hacíanos muñecas

Frances Lovato

Hacíanos muñecas tamién. *We made our own* muñecas. Usábanos unas medias que le dicían, de popotío. Ya fueran *brown or beige*, y loo yo usaba *high-top shoes* con de esas medias popotío, y trenzas. Y agarraba yo manta o lo que me daban, y loo les hacíanos la cabecita de media negra y loo palos *across here* [en el pecho]. Y pa patas tamién le hacíanos un *boarding* y loo las patitas.

Yo fui muy *close to my brother*, el mayor. Él me hacía—hacíanos con las cajas de sardina, adobes. ¡De veras! Las abujeraba. Pus tamién llevaba sardinas y mucha comida [su papá]. Carne de bote y todo. Hacíanos los adobes y loo *behind the barn* ai me hizo [su hermano] una casita. Loo con yeso la pintó blanca. Y me hacía mis camitas de madera. Yo tenía mis muñequitas y luego me hacía las *little beds*. Y luego en ese tiempo compraban trastes, *little china dishes*.

Él hacía los caballos de *coke bottles*. Y les hacía las guarniciones. Muy curioso, y hacía su carrito él y me pasiaba mis muñecas. Tenía mi papá un corral onde echan la pastura a los animales, en la caballeriza que le dicían. Como una *trough* grandota. Ai ponía yo mis juguetes.

Yo era muy marota. ¡*I was a tomboy*! (Risas).

We Made Dolls

Frances Lovato

We used to make dolls also. We made our own dolls. We'd make some stockings from a Mormon tea plant, they might be brown or beige, and then I would use high-top shoes with those stockings made from this plant,and braids. I would grab a blanket or whatever they gave me to cover the dolls, and then we'd make their little heads from a black sock and some sticks across here, across the chest. And then for the legs we'd make like boards; that's how we made them.

I was very close to my brother, the eldest. He'd make me—we made adobes by using sardine tin cans. Really! He'd punch holes in them. Why my father used to buy sardines and a lot of other food. Canned meat and everything. We'd make adobes, and then behind the barn my brother made me a little house. Then he whitewashed it with gypsum. He'd also make me little beds out of wood. I had my little dolls, so he made me little beds for me. Back then we also used to buy dishes, little china dishes.

My brother made horses from coke bottles. He'd make their harnesses too. It was very funny. And he made his own little wagon and took my dolls for a ride in it. My father had a corral where he used to feed the animals, in the barn, as it was called. It was like a huge trough. That's where I'd store my toys.

I was a real tomboy. I *was* a tomboy! (Laughter).

Teníanos munchos juguetes
Eremita García-Griego de Lucero

Jugaban muncho los chiquitos afuera, juguetes diferentes a ora. Porque antonces el papá no era el estilo de que mercaba juguetes en las tiendas, de a munchos, como se merca ahora. Tenían sus juguetes todo el tiempo. Y para las muchachitas era el juguete, que le llamaban *hopscotch*. Ése siempre se usaba la palabra en inglés. Pa los muchachitos siempre tenían su sombrero de vaquero, sus chaparreritas, y sus botitas y siempre jugaban con cabrestos, como modo de querer hacer unos vaqueros cuando ellos iban a crecer.

Las muchachitas jugaban *jacks*. Pero jugábamos muncho tamién casitas. Hacíamos comiditas, que agarrábanos de la cocina de la mamá. Hacíamos pedacitos de tortilla y pretendíanos que en esta olla había una clase de comida y lotra, lotra. Antonces jugábamos como si fuéramos, como si fuéramos mujeres grandes. Las chiquititas usaban el zapato del *high heel* con el tacón alto, de las mamases, pa jugar y asina nos entreteníanos, pero cuasi era el pensamiento como de, de aprender hacer las cosas bien hechas de la mujer, como la comida, y de tener casa pa cuando creciéramos. Yo creo que ése era el modo de jugar casitas.

Teníanos munchos juguetes que le llamamos muñecas. Yo creo que por eso de la época de nosotros ya cuando se casaban yo creo que por eso tenían muncha esperencia en criar a sus babitos. Porque ponían pañal a las muñequitas, hacíanos los tuniquitos, los vestiditos, pa las muñequitas, y en eso era lo que se entretenían las mujeres, las chiquitas.

We Had a Lot of Toys
Eremita García-Griego de Lucero

The children used to play a lot outside with toys, different from today's toys. Back then the father was not in the habit of buying toys in the stores by the bunches, as is done now. They had their toys all the time. And for the girls the game was hopscotch. The word in English was always used for that game. For the small boys they always had their cowboy hats, their chaps, and their boots, and they always played with ropes, as if showing that they wanted to grow up to be cowboys.

The girls played jacks. But we also played house (*casitas*) a lot. We'd make our little meals, our food, which we took from Mom's kitchen. We would cut up little pieces of tortilla and we would pretend that in this pan there was a certain kind of food and in another, another. At that time we used to play as though we were, as though we were grown-up women. The little girls would wear high heels belonging to their mothers, and that's how we entertained ourselves, but the thought was sort of to learn how to do women's chores well, such as preparing food, and how to maintain a house by the time we grew up. I believe that that's the way to play house.

We had a lot of toys, including dolls. I believe that with our generation, by the time we got married we had a lot of experience in raising babies, because we learned how to put diapers on a doll, how to sew little dresses, little suits for the dolls. And that's how the ladies, the little girls, entertained themselves.

8

Husband and Wife:
A Case of Mutual Respect

The mutual respect that prevailed among men and women in general, but especially between wife and husband, is something that women of the Río Puerco valley treasured. Many allude to and underscore the fundamental importance of regard between spouses in both nurturing and maintaining good marital relationships. It also led to a harmonious environment in which to raise a family. Respect was the overriding element of concern for the children's sake as well as that of the family, both at home and in public; a positive image in the village was of paramount importance to a person's self-dignity.

Respect was reciprocal between wife and husband; each knew and understood the boundaries of authority and responsibility. For example, since former Río Puerco residents lived under a patriarchal system, the woman purportedly assumed a role subservient to the man. While this was true in theory—and men did their utmost either by design or through tacit indifference to reinforce and perpetuate this belief—the Hispana was no pushover.

True, the man tended to assert his manly role in public, something the woman accepted and permitted him to do, but he could ill afford

to overstep his bounds. Nevertheless, a man's social behavior was not something he always kept in check. At times he drank too much at fiestas or dances and acted obnoxiously, thereby embarrassing his wife and family, but she simply sat stoically through the whole episode. It was not common, however, for the husband to be disrespectful toward his wife at social events. To begin with, people from the community, who would be familiar with the family, attended; and secondly, his parents and in-laws, all of whom acted as watchdogs, would often be present as well. He was aware also that he would be reprimanded once he got home, both by his wife and possibly by his own parents, even though he was married and presumably an independent adult.

At home after such an incident, the husband either turned meek and subdued or got angry. It was not so much his guilt that was at issue; rather, it was the humiliation heaped upon him. If provoked he often lashed out using *palabrotas* (foul words). Some husbands were certainly no saints. In spite of his outbursts, the wife had the upper hand. It was her domain (*querencia*). Contrary to what many of us have been led to believe, in their homes women had a lot more say than they have ever been credited with—but men have done little to acknowledge this reality. On the other hand, women have refused to project a more accurate image of themselves, because they never deemed it necessary. They have simply allowed men "to have their cake and eat it too," as long as their self-avowed machismo did not encroach upon women's own immediate dominion and duties.

I know. I saw my mother and my paternal grandmother in action, both of whom were strong but gentle women, not likely to bend, twist, or be intimidated. Their words were few and far between, so when my mother spoke, my father listened. The same thing was true of my grandmother. And they were much like other women in the Río Puerco valley, who epitomized a strong feminine character and personality.

Pina Lucero, in "La mujer trataba al hombre muy bien," sets the tone for the general relationship between wife and husband and for the stories that follow. But married life was hardly a utopia; they all endured their share of problems and disagreements. Macedonia Molina reminded me of this reality when she said: "Pues algunas veces los vía yo que estaban [el esposo y la esposa] poco como, poco mal . . ." ("Well, at

times I'd see them [husband and wife] like, like things weren't going well . . .").

Domestic violence is a case in point. Wife beaters were known in some villages. One could hear women mutter from time to time, in a contemptuous tone, "Ese sinvergüenza le pega a su mujer" ("That scoundrel beats his wife"). At least one woman outside Guadalupe, in Santa Clara, was known for beating her husband whenever he got drunk. This situation, however, was treated more humorously in the community. The man, in a scornful sort of way, was looked upon as a wimp.

Despite misunderstandings and arguments, there is no more sincere manifestation of a woman's compassion and worry for the well-being of her husband than that expressed in Frances Lovato's account of "Yo vi a mis padres que se querían" ("I Saw That My Parents Loved Each Other"). The tender story of her mother getting up at the unthinkable hour of three o'clock in the morning to go take hot coffee to her husband, who was irrigating the fields, depicts a gesture of love and concern for her husband's safety that was not atypical among rural Hispanas. Moreover, the affection between spouses, as we learn in Eremita García-Griego de Lucero's "Eran muy güenos esposos" ("They Were Very Good Husbands"), either in public or at home, was not shown by kissing, hugging, or opening doors. They had their own body language, and terms such as "hija," similar to "my dear," "my love," and so forth were common.

Time and again I heard words from women like Adelita Gonzales testifying to the genuine rapport that existed between wife and husband. "Muy bien nos tratábanos" ("we got along very well"), she says, as if to emphasize the perfect partnership arrangement between them. The main thing, according to her, was "never, never to be scornful of one another," above and beyond all else, in public. To do so would be to violate their own rules of the game. My parents used to say, "You must not go around airing your dirty laundry in public" ("no hay que andar lavando y tendiendo la roña en público").

The husband also was not what we would classify as "the boss." While "he was the one who held," as Eremita García-Griego de Lucero called it, "the reins" (la rienda), and was more of a leader (because someone had to be the spokesperson or decision maker), in her estimation, the husband was hardly deserving of being labeled "the macho man."

"El hombre era el respetivo, guía de todos nosotros, y támién la mujer" ("The man [husband] was the one respected, the guide for all of us, as was the woman [wife])." These poignant and laudatory words from Inesita Márez-Tafoya capture the essence and spirit of the overall relationship that existed between husband and wife in the Río Puerco valley.

Pina Lucero, 1992.

La mujer trataba al hombre muy bien

Pina Lucero

¡Ay! No sé cómo dijir yo. Pus, yo nunca llegué a ver mal. Yo no sé, no sé. Las trataban bien [los maridos a las esposas], pero que él mandaba, nomás. Nomás él dijía. Él daba la palabra. Lo que él dijía eso se tenía que hacer.

Güeno, en mi casa no, no llegué a ver, no llegué a ver [mal] yo asina; ni aí que me acuerde. Yo no llegué a ver a nadien maltratar. Ohhh sí se enbolaba el hombre. Se enbolaban muncho todos los hombres. Se

The Wife Treated the Husband Very Well

Pina Lucero

Oh boy! I don't know how to say it. Well, I never saw anything bad. I don't know, I just don't know. The husbands treated the wives well, but the only thing is that he was the boss. He had the last word. He gave the word. Whatever he said went.

Okay, in my house I never saw, I never saw anything bad; nor where I lived, that I can remember. I never saw anyone being mistreated. Ohhh of course the man did get drunk. The men got drunk a lot. They got

enbolaban, pero yo no me acuerdo que llegaban maltrantando [a la mujer].

Oh, la mujer trataba al hombre muy bien porque le tenía todo ya listo cuando viniera: comida, cama y todo, en lo que vide yo. Yo no sé qué en otros casos.

Se encargaba de todo [el marido]. Sí, la mujer tenía el poder en la casa pero lo de la casa, sí. Pero ella no podía hacer decisiones grandes como el hombre. Casi más el hombre decidía. Había munchos casos que no.

Sí, pasaba [uno] trabajos duros. Lo que se me hacía triste que no tenía uno en qué salir lejos, en qué andar, que estaba nomás ai. Pero, *as far as* triste, en ese lugar [el Río Puerco] no se me hace que era triste pa mí porque me crié ai y tavía me gusta muncho. Nomás que eran unos trabajos bárbaros que pasaba uno a pie pa todo, aí. Nomás que eran *munchos* trabajos que pasábanos.

Si hubiera tenido yo las cosas que tiene uno ora, pa corretiar, porque tenía uno que ir a trae agua, tenía uno que ir a trae leña, y salir a comprar cosas y no había el modo. No había dinero; no había. Ése es todo lo que se me hace a mí que está duro, y por eso tavía tengo el costumbre de que si agarro una cosa la guardo por, por años, porque se me hace que ya no va venir patrás, como no las tenía antes. (Risas).

¡Tan bonito que era allá [en el Río Puerco]! Siempre y tavía pa mí es alegre. Pero nomás lo que le digo, era más duro.

Si hubiera tenido lo que tengo ahora, el modo de andar, pa salir, porque la gente estaba muy atrasada y no tenía la manera de salir.

drunk, but I don't recall that they went home and mistreated their wives.

Oh, the wife treated the husband very well, because when he got home she already had everything ready for him: supper, bed, and everything, from what I saw. I don't know about other cases.

The husband was in charge of everything. Yes, the wife had the power at home, at home, yes. But she couldn't make important decisions like the husband. The husband almost always made the decisions. There were [however] many cases in which he didn't.

Yes, you went through some rough times. What I thought was very hard is the fact that you didn't have a way to get away very far, a way to travel, you were just there. But, as far as being a lonely place, for me I don't believe that place [the Río Puerco] was lonely, because I was raised there and I still like it a lot. The only thing is that we suffered through some very bad times going everywhere on foot. That's the only thing; we went through *a lot* of rough times.

If I had the things then that one has today for getting around, because you had to go after water, you had to go fetch wood and purchase different things, and there was no way to do it. There was no money; there just wasn't. That's what I think is still difficult, and that's why, if I'm given something, I still have the habit of keeping it for years, because I get the feeling that it's not going to come back again, especially since I didn't have it before. (Laughter).

It was so nice over there [on the Río Puerco]! It was always—and still is—a happy place. The only thing, as I said, is that it was very hard.

I wish I'd had what I have now, such as transportation, for traveling, because the people were very poor and they didn't have the means for getting around.

Frances Lovato, 1995.

Yo vi a mis padres que se querían
Frances Lovato

Yo vi a mis padres que se querían. Se preocupaba uno por el otro. Mi papá se preocupaba mucho por mi mamá y mi mamá por [él], simplemente cuando sembraba de noche. Mi papá sembraba trigo, y había unos canales allí cerca onde regaba mi papá. Podían ser las tres de la mañana y estaba mi mamá que, "Con cuidao." Le iba llevar café. Le llevaba café a esa hora porque estaba regando. "Ay," dicía, "le va dar un dolor a tu papá, y se cae en la cequia." Y me despertaba a mí y yo iba con ella a llevarle café en la madrugada, *three o'clock*, porque ella se preocupaba que se juera caer y todo.

I Saw That My Parents Loved Each Other
Frances Lovato

I saw that my parents loved each other. Each worried about the other. My dad worried a lot about my mother and my mother worried about him, especially when he planted at night. My father planted wheat, and there were some canals close by where my father irrigated. It could have been three o'clock in the morning, and there'd be mom saying, "Be careful." She'd go take coffee to him. She'd take coffee to him at that hour because he was irrigating. "Oh, my gosh," she'd say, "your dad's going to be struck with some pain and fall into the ditch." So she'd wake me up and I'd go with her to take him coffee in the wee

Oh, eso sí me acuerdo que hacíanos nosotras. Le ayudábanos a mi papá con el trigo. Y loo el trigo me acuerdo que lo traían a un molino que tenía el Mercantile [en Bernalillo]. Tenía mi papá un cajón de madera grandote y lo llenaban de trigo. Vinían y cambiaban costales de trigo por harina. Y como secaban carne, tenían muncha carne seca.

Pus mi *daddy*, como él es que se vinía a llevar el mandado, nos llevaba la ropa, de todo, de todo. ¡Y vieras que tenía tan güen gusto! Nos llevaba a la medida. Quizás nos midía porque nos llevaba [a la medida]. A mi mamá le compraba muy bonita ropa y a nosotros [la plebe]. Nos vistía pobremente, tú sabes, pero *well dressed*.

Pus tú sabes. La gente entre las familias, todo el pueblo se quería muncho. Eran sinceros. Se querían. ¿Me entiendes? No como ora. Se visitaban y loo si algo le pasaba a uno, todos sintían aquello. Era muy sincera la gente. Por eso nos decíamos tíos y tías y primos y no somos nada. Pero así nos enseñaron, ¿ves? Hasta la fecha, todavía todos son tíos y tías y en verdad, *they were nothing. They were just neighbors.* Pero antes era más respeto. Era muncho respeto. Los papases tenían *a lot of respect.* Todo eso.

Yo vi a mis padres que se querían

hours of the morning, at three o'clock, because she was worried that he'd fall or something.

Oh, yeah, that's something I do remember doing. We'd help my dad with the wheat. Then I also recall that we'd bring the wheat to a mill that Bernalillo Mercantile had [in Bernalillo]. My dad had a huge wooden box and we'd fill it up with wheat. People would come and exchange sacks full of wheat for flour. And since they dried meat, they also had a lot of jerky to trade.

Well, my daddy, since he's the one who went after whatever he was asked to bring back, brought us clothing and everything, all kinds of things. And you should've seen! Why he had such good taste. He'd bring us back the right size. I guess he measured us for sizes, because he'd bring us the exact sizes. He'd buy very pretty clothes for my mother and for us also. He dressed us modestly, you understand, but he dressed us well.

Well, you know how it is. People in their families, all of the people liked each other very much. They were sincere. They liked each other. They would visit one another and then if something happened to one of them, they all felt the pain. People were very sincere. That's why we referred to each other as uncles and aunts and cousins, when we weren't even related. But that's the way we were brought up, you see? To this day everyone is still an uncle or an aunt, but in reality, they were nothing. They were just neighbors. But back then there was a lot of respect and all of that.

Eran muy güenos esposos
Eremita García-Griego de Lucero

Eran muy güenos esposos. Eran muy humildes con la mujer. Pero no con afecto de un beso, con afecto de abrazo. No. [Casi] siempre usaban la esposa y el esposo por su nombre, por sus nombres. Tenían [tamién] unas palabras muy bonitas pa usar a la esposa. Entraba el esposo, el marido, y le decía a su esposa, cuasi usaban muncho para la esposa, la palabra "hija." Y le decían a la esposa, "Hija, ¿ya está la cena lista?" O llegaban y le decían a la esposa, "Hija, ¡cómo vengo cansao! Hija, ¿me ayudas a quitarme una bota? ¿Me ayudas a quitarme la otra bota o las dos botas?"

Y comenzaban [a platicar]. Siempre tenían conversación entre uno y el otro. Y la esposa ya tenía muncho que platicale al esposo. Por ejemplo, si se había tardao un día entero de ir a salir afuera, o ir a la Plaza [Alburquerque] a trae provisión que le llamaban antonces. Ora le llamamos *groceries*. Tenían muncho que platicarse cuando se juntaban. Le decía la esposa, "Mi hijito se cayó hoy, y lo curé de una rodilla." Y iba el esposo a ver qué, cómo grave era, o qué había pasao. Y platicaban muncho de la familia—qué había hecho cuando el papá andaba afuera, qué había hecho la familia y qué habían jugao.

El esposo trabajaba algo duro pero siempre tenían muncha comida la familia y la esposa y tenían ropa tamién. Compraba muncha ropa; le mercaba el esposo. Venía a la casa con vestidos bien bonitos, con medias de seda, con zapatos. Sabía qué número usaba su esposa de ropa y tamién salían juntos de compras, pero ellos [los maridos] eran los que mandaban.

They Were Very Good Husbands
Eremita García-Griego de Lucero

They were very good husbands. They were very humble
with the women. But as I said a little while ago, not with affection, like
a kiss or an embrace. No. The husband and wife almost always referred
to each other by their first name. The husbands also had very pretty
words that they used with their wives. The husband would come in
and he'd say to his wife—something they used in place of *wife*—the
word *hija*, a term of endearment for "dear." So they'd say to their wife,
"Dear, is supper ready?" Or they'd get home and they'd say, "Dear, I'm
sure tired! Dear, would you help me take off this boot? Would you help
me take off this boot or both of them?"

And they would begin a conversation. There was always a conversa-
tion between the two. And the wife would also have a lot to tell him.
For example, if had he taken a whole day to leave the ranch or to head
for town [Albuquerque] to buy provisions, as food was called back
then. Now we call it groceries. They had a lot to share with one an-
other when they got together. The wife would say to the husband,
"Our little boy fell down today, and I had to nurse his knee." Then the
husband would go and see what was what, how serious it was, or just
what had happened. And they talked a lot about the family—what the
family had done while the father was away, and what games they had
played.

The husband worked pretty hard, but the family and the wife always
had plenty of food and clothing as well. He bought a lot of clothes; the
husband bought them for her. He would show up at home with very
pretty suits, silk stockings, and shoes. He knew what size clothing his
wife wore, and they also went shopping together, but they [the hus-
bands] were the bosses.

Yo estaba pensando como en el trato de esposa y esposo. Como ora. Ora hay estilo que la mujer dice—nunca yo había oído decir, desde que yo era *teenager*, le dice ora la esposa al marido, "I'll be back honey!" pero no se pregunta ni par ónde va, ni cuándo va venir la esposa. Y tiene su carro, su autómovil, y el esposo no le dice, "¿Par ónde vas o cuándo vienes?" Pero ese estilo antonces no era asina.

I was thinking more about the treatment of husband and wife. Like now, for example, the wife says—I had never since I was a teenager heard a wife say to her husband, "I'll be back honey," but now the man doesn't even ask where she's going, or when the wife is returning. And she even has her own car, her own automobile, and the husband doesn't even say, "Where are you going and when are you coming back?" But that wasn't the way it was back then.

La mala rienda pa mí jue mi suegra
Susanita Ramírez de Armijo

Pos a mí, diré que a mí me trató mi esposo bien. Yo no tengo que decir que él me tratara a mí mal, o que a mí me maltratara o que yo dijiera que yo quería tener lo que él no tenía tampoco. Sabía que él era pobre. Me crié a lo pobre porque mi *daddy* jue un pobre. Me crié a lo pobre.

El hombre dijía que tenía que hacer esto, pero, como me dijo mi *daddy* cuando me iba a casar, porque yo jui muy consentida de mi *daddy*. "Mira mi jita," me dijía. "Te vas a casar, porque cuando uno se casa es muy diferente. Pero el día que te cases le vas a dijir a tu marido, 'Vamos a llevar las riendas iguales.'" Y eso jue. Si él iba hacer una cosa me pidía permiso, y yo daba permiso pa él y asina nos llevamos.

La que jue, que jue diré, mala rienda pa mi jue mi suegra. Ella quería tenerme, quizás como la criaron a ella, debajo sus leyes, que las nueras tenían que hacer lo que la suegra les dijía, y yo nunca me dejé. Y por eso mi suegra, Dios que la perdone, dijía que yo no me dejaba manijar.

The Bad News for Me
Was My Mother-in-Law

Susanita Ramírez de Armijo

As for me, I'll say one thing. My husband treated me very well. I can't say that he treated me badly, or that he mistreated me; and I didn't demand from him what he couldn't afford. I knew that he was poor. I was raised poor, because my daddy was poor. I was raised poor.

The husband used to say that he had to do this and that, but, as my daddy said to me when I was going to get married, because I was very spoiled by my daddy, "Listen here my little daughter," he'd say to me. "You're going to get married, but when somebody gets married, it's a lot different. The day you get married, you're going to tell your husband, 'We're going to hold the reins equally.'" And that's the way it was. If he was going to do something, he'd ask me permission, and I'd say yes, and that's how we got along.

The one who, the one who was bad news for me was my mother-in-law. She wanted to have me under her control, I guess, perhaps the way they raised her, because according to her the daughters-in-law were supposed to do what the mother-in-law told them, but I never fell for that. That's why my mother-in-law, may God forgive her, used to say that I didn't let myself be dominated.

9

The Comadres' Get-Togethers

Unless women resided in the placita proper of one of the villages of the Río Puerco valley (see map 1), such as Guadalupe, where I grew up, they had few opportunities for getting together in the evening, because many of them lived far apart from each other. Even those whose homes were in the placita did not congregate much in the daytime, except when comadres went to borrow baking powder or to fetch a bucket of water from the local artesian well. It was on these brief occasions that they caught up on the latest news or gossip; exchanging information was common and one of the ways of whiling time away. Visiting, most of it of short duration, took place throughout the week (weekends were for more formal visitors); during the winter months, women were pretty much confined to their homes.

The summer was the most propitious time for women in placitas to assemble in the evenings. This was their version of the "girls' night out," especially if their husbands were away herding cattle. Men, after all, invariably had an opportunity to chat about a variety of topics with their compadres around the evening campfires. Their exchanges, unlike those of women, were looked upon as *pláticas*, chats or informal conversations, presumably more dignified than the stereotypic *mitote* or *chisme* (gossip) generally attributed to women.

Gossip as such, or mitote, as it was called, has always been a cultural

trait among Hispanos; those of the Río Puerco valley were no exception. The word *gossip* evokes an immediate and negative reaction, as does *mitote*, but in a Hispanic community, it also conjured up the latest word-of-mouth news, pleasant or otherwise, whether based on fact or fiction. Newsworthy items were often limited to the respective villages or to households in the outlying areas and brought "to town" by the mail carrier who delivered the mail along the Río Puerco. He was the primary source of news—or gossip.

The question is, what did women talk about when they met as a group? The stories that follow speak to this query in a sincere and candid fashion. What women said or did not say may surprise us. Certain subjects such as sex were deemed too personal and taboo, not only between mother and daughter, but among older women as well.

One favorite topic was the husbands, but women never talked about intimate moments between husband and wife. By and large, if women mentioned their husbands, they did so only in relationship to their work or the family, nothing more, nothing less. I was assured of this even by women I know well, such as Catalina Griego-Sánchez and Eremita García-Griego de Lucero, both of whom are quite open-minded and liberal in their views. As García-Griego de Lucero said to me: "No había un afecto afuera" ("There was no outward show of affection") toward the husband.

Yet they were quite forthright and to the point about what they discussed. For instance, Macedonia Molina's story on "Se juntaban las comadres" ("The Comadres Got Together") is a moving episode about a girl whose physical evidence of pregnancy disappeared from one day to the next. With total disregard for the baby's fate and the girl's psychological and physical well-being, the family's code of honor had to be kept intact—her insensitive and doggedly strict father saw to that. His fanatical and intolerant attitude defied all human decency, while evidently justifying in his own mind the drastic actions he undertook.

But not all comadre sessions were as distressful. Many gatherings, as women drank coffee, ate bizcochitos, smoked, mended their clothes, or made a new outfit for the Santo Niño de Atocha at the local church, produced moments of levity, such as we see in "Chistiando" ("Joking Around"), by Mary Jaramillo Gabaldón. It was customary to discuss such topics as witches, the evil eye (*el mal ojo*), or to exchange riddles (*adivinan-*

zas), one of the most popular and entertaining aspects of the Hispanic folklore of New Mexico. Here is the Spanish version (the English appears in the translation of her account) of a riddle that Mary Jaramillo Gabaldón shared with me:

> *En medio de la gloria estoy,*
> *en misa no puedo estar.*
> *De la ostia soy la primera,*
> *y de Dios el tercer lugar.*

Other riddles contained a double entendre and therefore could be interpreted on two levels: one, the so-called innocent version; and the other, suggestive of certain risqué elements. Here in Spanish is an example of a riddle with a double meaning that no doubt evoked laughter among the women; at the same time, it erases any notion of innocence or naiveté they may unknowingly tend to project:

> *En el suelo con desvelo,*
> *en la cama con más ganas,*
> *se junta pelo con pelo,*
> *y pelado queda adentro.*

Nothing in the Hispanic folklore of New Mexico has ever surpassed the *dichos* (folk sayings) in popularity, however, even to this day. They are culturally charged expressions and philosophical gems that represent the wisdom of our forefathers and foremothers, as well as the sagacity of our elders of today. Mary Jaramillo Gabaldón shares a few of the dichos with us that women would exchange with one another. They are didactic in essence and carry the kind of guidance we expected our abuelitos to share with us as we sought their advice.

Because of certain taboos, women did not readily divulge personal information even to each other; nor did they resort to gossip mongering as such. Instead they talked about typical things such as foods, baptisms, who wore what color clothing to the wedding, and so forth. At times the comadres' and neighbors' (*vecinas*) rendezvous even included planning a procession through the cornfields praying for rain, or playing

games like *pon y saca*, a kind of gambling game, with match sticks. All in all, as Eremita García-Griego de Lucero put it, the get-togethers were "pláticas muy bonitas," "very nice chats," although women were quite ornery and capable of holding their own when it came to mitote. They were not, by any stretch of the imagination, holier than thou; nor did they attempt to project such an image.

Se juntaban las comadres
Macedonia Molina

Pues casi todo el tiempo estuvimos [ella y su abuelito] en el rancho. No estuvimos cerca de vecindajes ni nada, pero el tiempo de la escuela, los [nos] cambiábamos pa la Placita. Aá teníamos una casa en la Placita onde estaba la escuela, pa estar cerquita pa ir a la escuela. Los hombres estaban en el rancho.

Pues entonces se juntaban las comadres. Se juntaban a platicar y nojotros [la plebe] queríamos escuchar, *so* nos encerrábamos pa un cuarto, como le digo. Nomás ojos nos hacían. Y había veces que nos escabullíamos pa bajo de la mesa. Quizás [para escuchar] lo que platicaban. Pues yo no me acuerdo. Yo creo que negocios de ellas, usté sabe. Los problemas de ellos, lo que pasaba con los maridos y así.

Yo no tuve nunca congregación con la mamá y las hijas. Pa lo que víamos, muchachos con muchachas, nos platicábamos nomás. Nos platicábamos una a la otra, que si estábamos con un muchacho algo nos iba a pasar. Una a la otra los [nos] consejábamos, ¿no?

Pasaba muncho. Yo no sé si será verdá o no será verdá. Esta prima hermana mía se enfermó, y dicen pues toda la gente que iba a los rezos—porque él [el papá] jue muy católico—pues ya ella, se conoce una mujer cuando está en embarazo, ¿no? Iban a los rezos y todo y lo dice mi tía—ella vivía en un ladito—decía ella que esa mañana amaneció muy delgadita [su prima], y allá la traiba sembrando [el papá], que andaba sembrando cáindose. La traiba con l'arao, y reclamaba la gente que no se supo qué pasó con el niño.

The Comadres Got Together

Macedonia Molina

Well, most of the time we [she and her grandpa] were at the ranch alone. We weren't close to neighbors or anything, but by the time school started, we would move to the Placita. We had a house there at the Placita where the school was, so that I'd be close to school. The men were at the ranch.

Back then comadres got together. They'd get together to talk and we [kids] wanted to listen, so we used to go lock ourselves up in a room. All they had to do was to look at us and off we went. There were times when we'd sneak under the table. Maybe to listen to what they were talking about. I don't remember. I guess they talked about their own affairs, you know, such as couples' problems and what was happening with their husbands and things like that.

I never had any gatherings with any mother [she had no mother] and her daughters. As far as we could see, we only talked to each other, boys and girls. We girls talked to each other about, if we were alone with a boy, something could happen. We used to give each other advice, understand?

A lot went on. I don't know if it's true or not. This cousin of mine got pregnant, and they say that all the people who went to the rosaries—because the father was very religious—could tell that she in fact was pregnant, understand? Everybody would go to the rosaries and everything, and then my aunt says—she lived next door to my cousin— that one morning my cousin got up very thin and that her father had her out in the fields planting, and she kept falling down. He had her working the plow, and people claimed that they didn't know what happened to the baby.

Pláticas muy bonitas
Eremita García-Griego de Lucero

Cuando las mujeres se juntaban a platicar era como de cuasi platicaban muncho de comidas, cómo hacía cierta comida otra vecina, o otra mujer. En veces que hasta por qué los frijoles, cuándo acababan de ser cocidos y puestos en una mesa, por qué tenía diferencia un sabor a otro. Antonces platicaban de que munchas comidas entre más jervidas, eran más sabrosas y mejor sabor tenían.

Las mujeres platicaban muncho de quererse a juntar. En veces pensaban munchas veces tamién de comprale como regalos al marido, porque no era el estilo de hacer eso como se hace ora. Y querían, como hacer un afecto de amor al esposo porque en ese tiempo tamién toavía de mil novecientos treinta y seis, treinta y ocho, no platicaban una mujer o un hombre nada de amor. No se costumbraba de ver, como ora, de dar un beso la esposa al esposo. No había un afecto afuera. Parecía que todo era nomás trabajar, limpiar, y enseñar a la familia a trabajar.

Por cuasi no había afecto ni de la mamá, de dale un beso a un niño, si no era como nomás una responsabilidá pero en el corazón, dentro del corazón, de cada mamá y cada papá. Por eso eran como más, poquito más, retiraos de la familia, del hijo o de la hija, y siempre estaban cuidando a la hija y al hijo. Porque no estábanos al tanto abajo de leyes como estamos ora, que le llamamos polecías. Yo creo que en ese tiempo cuasi el papá y la mamá era la ley.

De maneras que las mujeres ya pensaban de hacer munchas cosas que hay ora. Como digo yo, una mujer, una tía, un tío mío, yo nunca los llegué a ver que le diera un beso un tío a una tía. Pero el afecto estaba dentro su corazón de ellas y platicaban muncho de querer comprar, como dar una sorpresa de cierto color de camisa, a cierto color de pantalón.

Y con eso era el afecto en igual de un beso porque no era el costumbre de ver a naiden hacer amor, como se mira ora, y sale hasta en los, ahora sale hasta en los cines, *movies*. Sale todo eso. En ese tiempo

Very Nice Chats
Eremita García-Griego de Lucero

Whenever women got together to talk, what they discussed mostly was foods, such as how did another neighbor or another woman prepare a certain food. At times they even discussed why the beans, after having been cooked and put on the table, why did some vary in taste from each other. Then they talked about the fact that many foods, the more you boiled them, the more delicious and better they tasted.

Women talked a lot about getting together. Many times they thought also of buying gifts for their husbands, because it was not fashionable to do that then as it is now. And they wanted to, like show some affection for their husband, because in those days, in nineteen thirty-six, thirty-eight, a woman or a man still didn't discuss anything about love. You weren't used to seeing, like now, a wife giving her husband a kiss. There was no outward show of affection. It seemed like everything was work, clean house, and teach the children how to work.

It was not even common for a mother to show affection by giving a child a kiss, unless it was just a responsibility, but it was in the heart, inside the heart of every mother and the father. That's why they were more, a little more, removed from the family, from the son or the daughter, and they were always watching over the daughter or the son, because they were not as conscious of being under the laws like now, that we end up by calling the police. I believe that back in those days the father and the mother sort of were the law.

So the women already were thinking of doing a lot of the things that we have today. As I say, a woman, an aunt, or an uncle of mine, I never saw an uncle kiss an aunt. But the affection was in the wives' hearts, and they spoke a lot about wanting to buy something, like surprising the husband with a certain color shirt, or a certain color pair of pants.

And the same thing was true regarding the affection of a kiss, because it was not customary to see anyone "making love," as you see nowadays, where it's even shown in the movies, in films. All that sort

toavía de mi época de mil novecientos treinta y seis, treinta y ocho, no era ése el estilo. Había muncho respeto.

[Las mujeres] sí platicaban. Se ponían a platicar. Como ora, si cierta señora habría salido de un rancho a la Plaza, platicaban hasta lo que había visto en un papel, periódico. Se iban patrás pal rancho, como munchas venían más seguido a la Plaza que otras, platicaban tamién de los estilos de ropa que habían entrao. Platicaban de colores y de modos que habían cambiao, estilos de ropa.

Tamién platicaban otras cosas: tragedias o cosas bonitas, casorios y todo, que había pasao en otras familias. Tamién platicaban porque no todas sabían todo lo que estaban pasando al mismo tiempo. Había casorios de parentela que no todos eran convidaos al casorio. Antonces se juntaban a platicar. "Yo fui a cierto casorio." Par otras parentelas, parientas, mujeres no habían ido al casorio. Antonces platicaban qué colores de ropa traiba la suegra, qué color de ropa traiba la comadre, la otra comadre, los suegros de la novia, cosas asina.

Eran pláticas muy bonitas tamién que tenían. Lo que tenían que leían muncho; eran muy religiosas. Lo que había muncho en estilo, en el rancho, era de rezar, lo que le llamamos ora el rosario, de la religión católica. Ese costumbre lo tenían y lo practicaban cuasi cada sábado, si era posible. En veces que la familia quería rezar el rosario, y usaban muncho en ese tiempo el santo, que le llamaban, Santo Niño, Jesús, María y José, en la religion católica. Rezaban muy seguido el rosario.

of stuff is shown. Back in those days, going back to nineteen hundred thirty-six, thirty-eight, that wasn't done. There was a lot of respect.

Women did talk. They did get together and talk. Like now, if a certain woman had left the ranch to go to Albuquerque, they would even speak about what she had read in the newspaper. When they returned to the ranch, since some of them came to Albuquerque more frequently than others, they spoke also about the latest styles in clothing that had come out. They spoke about the colors and styles that were in fashion in clothing.

They also discussed other things: tragedies, pleasant things, weddings, and everything that had occurred in other families. They would also get together to talk because not all of them knew everything that was happening elsewhere. There were relatives' weddings to which not everyone was invited, and so they got together to chat. "I went to so-and-so's wedding." With regard to other kinfolk, relatives, some women hadn't gone to the wedding. Then they would talk about what color clothes the mother-in-law wore, what color clothing this comadre or that one was wearing, what the bride's in-laws were wearing, and things like that.

And those were very nice chats that they had. Another thing was that they read a lot; they were very religious. What was very much a ritual on the ranch was praying, like what we now call the rosary within the Catholic religion. They had that ritual, and they practiced it almost every Saturday, if possible. At times the family would want to recite the rosary, and they prayed in those days to a certain saint, such as the Holy Child, Jesus, Mary, and Joseph, all in the Catholic religion. Women said the rosary very often.

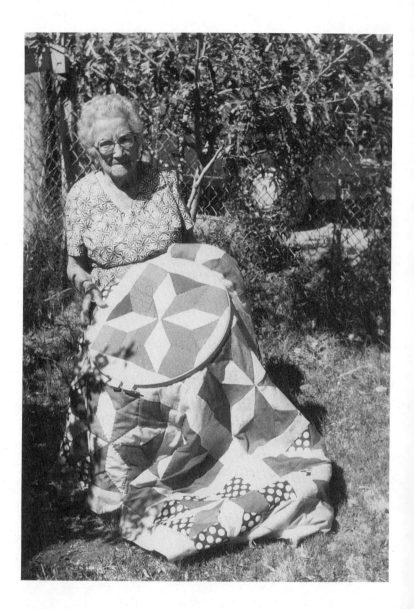

Mary Jaramillo Gabaldón, 1989.

Chistiando
Mary Jaramillo Gabaldón

¡Del hombre! (Risas). Hablaban [las mujeres] del marido, seguro. ¿De qué otra cosa? Chistiando. Se contaban munchos chistes, adivinanzas y todo eso. No me acuerdo muy bien. De algunas nomás. Aquí está una; a ver si la adivina usté:

En medio de la gloria estoy,
en misa no puedo estar.
De la ostia soy la primera,
y de Dios el tercer lugar.

Joking Around
Mary Jaramillo Gabaldón

About men! (Laughter). The women talked about their husbands, for sure. What else? They joked around. They also told each other lots of jokes, riddles, and that sort of thing. I don't remember very well. I only remember some riddles. Here's one; let's see if you can guess what it is:

I find myself in the middle of glory,
at mass I cannot be present.
Of the host I'm the first,
and of God the third place.

Es la O. La O, pus "en misa no puedo estar, en medio de la gloria estoy. En misa no puedo estar, de la ostia soy la primera, y de Dios en tercer lugar." Y en misa no puede estar. No está.

No me acuerdo otras adivinanzas. Ya está uno tan desmemoriao que ya . . . y otros dichos tamién:

>Haz bien y no acates a quién.

>Nadien le escupa a los cielos
>que a la cara no le caiga.

>Lo que des con tu mano derecha,
>no se lo hagas saber a la izquierda.

>El que recio va, pronto para.

Sí, platicaban y se riían unas a las otras, sí. ¡Y cómo ya se me olvidaron los dichos que tenían todos los viejitos! Al fin del todo tenían más educación los viejitos que la moderna [la juventud] de ora.

Y pa adivinalas [las adivinanzas], yo sé una pero pa dicila es poco fea, y pa adivinarla, pus no es. Yo no sé. Pus es la misma cosa que ésta que le voy a contar yo.

>En el suelo con desvelo,
>en la cama con más ganas,
>se junta pelo con pelo,
>y pelado queda adentro.

Es el ojo. Es el ojo, pus se junta aquí, ves, pelo con pelo, y el ojo se queda adentro. Pa decilo está feo, el que quiere agarralo por mal.

It's the letter O. The O [since it doesn't appear in the word *mass*, but it does appear in the word *glory*.] "I can't be in mass, of the host [*ostia*] I'm the first, and of God [*Dios*] the third place." And in mass it cannot be present. It isn't.

I don't remember any other riddles. By the time you get to be my age, you're so forgetful that . . . I do have some folk sayings:

> *Perform a good deed, regardless of who's in need.*

> *People who live in glass houses shouldn't throw stones. [No one spits into the air without it falling in their face]*

> *What one doesn't know, doesn't hurt. [Don't let your left hand know what your right hand's doing]*

> *The faster you go, the quicker you'll stop.*

Yes, women talked and laughed with one another, of course. Wow, how I've forgotten the folk sayings all the old-timers knew! After all is said and done, the old-timers had more education than today's generation.

When it comes to guessing what the answers are to riddles—I know one riddle, but telling it's a little dirty, and as for the answer, it's not. I don't know. Well, it's the same thing that I'm going to tell you.

> *On the floor anxiously,*
> *in bed with more desire,*
> *hair joining hair,*
> *and hairless it stays inside.*

It's the eye. It's the eye because it comes together like so, hair with hair, while the eye stays inside. When it comes to telling the riddle it's dirty, if someone wants to take it the wrong way.

Hablaban de las brujas

Pina Lucero

Hablaban de las brujas, porque en esos años, Dios mío, yo no sé dónde vían tanta bruja. "¿Vido comadre," dijía una, "que a ésta le había llorao un tecolote? ¡Era una bruja!" Y loo dijía, "¿Qué no le platicaron que estaba esa luz antenoche allá, y que esta luz la vieron allá?" ¡Ah cómo platicaban de eso! Yo me acuerdo cuando estaba mediana que las oía platicar a todas.

Mi bisagüelita me platicaba que ella tenía tres hijas, y que las tres hijas esas les habían hecho mal. Dicía ella que esta hija estaba casada y tuvo este *baby*. Cuando tuvo este *baby* pus quizás le habían hecho mal porque estaban enteresaas otras mujeres en el marido. Pus dice que cuando estaba muy mala, es que esta hija, es que toda la noche que estaba mirando luces. Es que dijía, "¡Quítenlas! Quítenlas de ai."

Yo me envelaba oyéndolas platicar todo. Y ora me pongo a pensar y me da como un escalofrío. En ese tiempo tamién pus le daba uno como—despúes cuando te acostaban, que como le daba miedo a uno, porque platicaban tantas cosas horrorosas.

Pero mi bisagüelita dicía que las tres hijas que tenía, yo no sé por qué tenían ese costumbre. Estaban todas enbrujadas quizás. En esos años, si se moría [una] de algo, era que estaan enbrujadas.

Women Talked about Witches
Pina Lucero

Women talked about witches, because back then, good gracious, I don't know where they saw so many witches. "Did you hear comadre," one comadre would say to another, "that an owl hooted at this woman? It was a witch!" And then she'd add, "Didn't anyone tell you that this light appeared over there the other night, and that someone saw it?" Oh but did they talk about that sort of thing! I remember hearing all the women talk about these things when I was small.

My great-grandmother used to tell me that she had three daughters, and that all three daughters had been inflicted with some evil spell. She used to say that this one daughter of hers was married and had a baby. When she had this baby, I guess someone cast an evil spell on her, because there were other women who were interested in her husband. Well, she says that when she [the daughter] was very sick, that she was seeing lights all night long. She's supposed to have said: "Take them away! Take them away from here!"

I became spellbound listening to them talk about all of this. And now I stop to think about it, and I get like goose bumps. Back then it also gave you—after they'd put you to bed, it'd like scare you, because they talked about such scary things.

But my great-grandmother used to tell me that the three daughters she had—I don't know why—had that habit [of seeing things]. They were all bewitched, I guess. Back in those days, if a woman died, it was because she was bewitched.

Mi agüelita nos enseñó a rezar

Frances Lovato

Pus a nosotros nos echaban ajuera [las mamás]. [No] como
hoy en día que están las criaturas ai metiéndose, oyendo lo que no
deben y todo. Su mamá de él [su esposo] iba y estaba, nosotros allá
andábanos en el llano hasta que no nos llamaban. Nomás nos hacían;
andábanos así. De por sí nos tenían a casi toda la familia enseñaos que
no teníanos que estar onde estaba la gente mayor escuchando o
metiendo en las conversaciones. ¡Nada!

Mi agüelita, lo que nos enseñó fue a rezar. Taba cieguita y fíjate que,
pus, ella tenía su cuartito. Me acuerdo que la tenían que atender,
porque estaba cieguita. Tenía su *kiva*, ves, que le dicían. Y me acuerdo
que en la tarde, que se llegaba la tarde, yo era la más alerta, me
apuraba a comer pa irme a dormir, [a ver] quién le ganaba a la cama pa
dormir con mi agüelita. Nos enseñaba a cantar, a rezar. Que me enseñó
"Las doce verdades del mundo." Todavía las sé, "Las doce verdades del
mundo," y los alavaos. Ésos sí se me han olvidado. Y lo[o] rezos se me
olvidaron. Nomás "Las doce verdades del mundo," y rezos que me
enseñó, que hasta mi tía Mariita cómo sabía de ésos. Quise ir a que me
los enseñara y nunca fui, los que me enseñó mi agüelita.

Nos dicía de la Llorona y de la Jorupa. (Risas). Le dicían la Jorupa. "Te
va llevar. Te va llevar la Jorupa." No me acuerdo [la historia], pero sí oía
yo que la Jorupa y la Llorona. Nos metían miedo con la Llorona. Ya en
la tarde nos dicían que ai andaba la Llorona. Ya no salíanos a jugar.

My Grandma Taught Us How to Pray

Frances Lovato

Well, the mothers used to toss us out. It's not like nowadays, where the children are there sticking their noses in, listening to what's none of their business and everything. If his mother [her husband's] came and was there, we'd be out on the plains messing around until they called us. It goes without saying that they had all of us in the family trained so that we weren't to be around listening or intruding in conversations where grown-ups were present. Not at all!

My grandma, one of the things she taught us was to pray. She was blind and had her own little room. I remember that they had to take care of her because she was blind. She had her own kiva [room], as they called it. And I recall that in the evening, when the evening came, since I was more on my toes, I hurried and ate so I could go to sleep, to see who would get to bed first to sleep with grandma. She taught us how to sing, to pray. She taught me "The Twelve Truths of the World." I still know them, and hymns of praise. Those I've forgotten. And then I've also forgotten prayers. I only recall "The Twelve Truths of the World" and some prayers she taught me. Why, even my aunt Mariita knew a bunch of them. I wanted to go have her teach them to me, the ones that my grandma taught me, but I never did.

She talked to us about the Wailing Woman and the Jorupa. (Laughter). They called her the Jorupa. "She's going to take you with her. The Jorupa is going to take you." I don't recall the story, but I did hear about the Jorupa and the Wailing Woman. They'd scare us with the Wailing Woman. By evening they would tell us that the Wailing Woman was around. From then on we wouldn't go outside to play.

Glossary

Guide
adj. = adjective
adv. = adverb
Angl. = Anglicism
dim. = diminutive
fem. = feminine
mas. = masculine
n. = noun
p.p. = past participle
v. = verb

Regional	Standard
A	
aá	allá
abuja(s)	aguja(s)
abujeraba	agujeraba
acabábanos	acabábamos
acarriaba	acarreaba
acarriábanos	acarreábamos
acarriar	acarrear
a case de	en casa de
acostábanos	acostábamos
adentro de	dentro de
adivinalas	adivinarlas
adormía	adormecía
afijaban	fijaban
afuera	en público
agarrábanos	agarrábamos
agarralo	agarrarlo
agüelita(o)	abuelita(o)
aí	ahí

aigraban	aireaban
aigralo	airearlo
aigrando	aireando
aigrar	airear
aigre	aire
ajuera	afuera
ajuero(s)	agujero(s)
alavaos	alabados
alisábanos	alisábamos
alivioso	aliviador (n.)
almorzábanos	desayunábamos
almuadas	almohadas
almuerzo (n.)	desayuno (n.)
amá	mamá
amarraos	amarrados
amos	vamos
andábanos	andábamos
andames (endames)	andamios
antonces	entonces
apá	papá
apartábanos	apartábamos
apilalo	apilarlo
apurao(s)	apurado(s)
arao(s)	arado(s)
arededor	alrededor
asegún	según
asina	así
asolaba	ponía suela
atrasaa	atrasada
autómovil	carro; coche
ayudábanos	ayudábamos
ayudale(s)	ayudarle(s)
B	
babitos (Angl.)	niños
bajábanos	bajábamos
barillas	barrillas

bisagüela(s)	bisabuela(s)
blanquillos	huevos
boquesitos	manojos
bordaos (p.p.)	bordados
bote(s)	lata(s)
bragueta	abertura delantera del calzón
buslaban	burlaban

C

caiba	caía
caida	caída
caindo	cayendo
cáindose	cayéndose
calor (fem.)	calor (mas.)
camalta(s)	cama(s)
cambiao	cambiado
cansao	cansado
capiábamos	capeábamos (saludábamos)
cargábanos	cargábamos
carriábanos	acarreábamos
carrialo	acarrearlo
carriar	acarrear
casao	casado
case (n.)	casa
cequia(s)	acequia(s)
chábanos	echábamos
char	echar
chíquete	goma; chicle
chistiando	chisteando
chupador(a)	fumador(a)
cimento	cemento
cirgüela	ciruela
clas	clase
clavábanos	clavábamos
cocíanos	cocíamos
cocinábanos	cocinábamos
colorao	colorado

coloriaban	coloreaban
comenzábanos	comenzábamos
comprale	comprarle
contoy	con todo y
convidaos (p.p.)	convidados
corretiar	corretear
corretiarnos	corretearnos
coselos	coserlos
costales	sacos
costumbre (mas.)	costumbre (fem.)
costuriar	coser
croche	croché
cuasi	casi
cuidao	cuidado
curre	corre; anda
custoriaban	cosían
custoriábanos	cosíamos

D

dale	darle
darniarlas	zurcirlas
de ajueras	rotas
decíanos	decíamos
decilo	decirlo
dejalo	dejarlo
delantar(es)	delantal(es)
desaigró	desairó
desbaratábanos	desbaratábamos
desbaratalos(as)	desbaratarlos(as)
descalabrao	descalabrado
desgranábanos	desgranábamos
desgranalo	desgranarlo
deshojao	deshojado
deslonjar	quitar la lonja
desmemoriao	desmemoriado
desnatala	desnatarla

despuntábanos	despuntábamos
destapalas	destaparlas
destenderla	extenderla
destendía(n)	extendía(n)
destendíanos	extendíamos
destendiendo	extendiendo
devasanas	damasanas
dicía(n)	decía(n)
dicíanos	decíamos
dicila	decirla
dicile	decirle
dicir	decir
dicirle	decirle
dificultao	dificultoso
dijían	decían
dijiera(n)	dijera(n)
dijir	decir
dijunto	difunto
dirritía	derritía
dispensita	despensita
diuna	de una
diuna vez	en seguida; pronto
dotores	doctores
duces	dulces
durmía	dormía
durmir	dormir

E

echábanos	echábamos
echale	echarle
echalo	echarlo
edá	edad
embordes	bordes
enbarazada	embarazada
enbolaba(n)	embolaba(n)
enbordábanos	bordábamos

enbrujadas	embrujadas
encalábanos	encalábamos
enchasones	hinchazones
endames	andamios
en de que	desde que
enpacaba(n)	empacaba(n)
enpacar	empacar
enpaco (v.)	empaco
en papá	mi papá
enpapelaba(n)	empapelaba(n)
enpapelábanos	empapelábamos
enpapelada	empapelada
enpapelando	empapelando
enpapelaron	empapelaron
enponjaba(s)	esponjaba(s)
enseñaos	enseñados
entarime	suelo de madera
enteresaas	interesadas
entrale	entrarle
entrao	entrado
entreteníanos	entreteníamos
envelaba	envolvía
envitara	invitara
envolvíanos	envolvíamos
éranos	éramos
escusao	escusado
espauda (Angl.)	"baking powder"
esperencia	experiencia
espital	hospital
estaan	estaban
estáanos	estábamos
estábanos	estábamos
estale	estarle
estao	estado
estrito(a)	estricto(a)
evideros	venideros
exaitamente	exactamente

F

feo	sucio; asqueroso
feyas	feas
fiero	feo
flamantita	bien nueva; nuevecita
friía(n)	freía(n)
friías	freías

G

galletas	"biscuits"
ganao (p.p.)	ganado
garraba(n)	agarraba(n)
golver	volver
golvía(n)	volvía(n)
golvíanos	volvíamos
greve (Angl.)	"gravy"; salsa
Gualupe	Guadalupe
guardala	guardarla
güelta	vuelta
güen(o)	buen(o)
güérfana	huérfana
güevo(s)	huevo(s)
guisábanos	guisábamos
gustao	gustado

H

habíanos	habíamos
hablábanos	hablábamos
hacelo	hacerlo
hacíanos	hacíamos
hallábanos	hallábamos
hirvíamos	hervíamos
hogao	hogado
huerfanato	orfanato

I

íbanos	íbamos

inflencia	influenza
izque	es que

J

jalala	jalarla
jallaba(n)	hallaba(n)
jallar	hallar
jerbía	hervía
jerbir	hervir
jervida	hervida
jirbía(n)	hervía(n)
jirbiendo	hirviendo
jirvía(n)	hervía(n)
jirviendo	hirviendo
jirvir	hervir
jita	hijita
joyo	hoyo
jue	fue
juera (v.)	fuera (v.)
juera (adv.)	afuera (adv.)
juéramos	fuéramos
juera(n)	fuera(n)
juéranos	fuéramos
juere	fuere
jueron	fueron
jugao	jugado
jui	fui
juimos	fuimos
juir	huir
juntábanos	juntábamos
juntra	junto a; cerca de

K

L

l'agua	el agua
lao(s)	lado(s)

latías	latillas
lavábanos	lavábamos
lavalos	lavarlos
lego	luego
levantábanos	levantábamos
levantala	levantarla
lo	luego
logo	luego
lonche (Angl.)	almuerzo
londre (Angl.)	"laundry"; ropa
loo	luego
los	nos
lotro(a)	e(la) otro(a)

LL

llamale	llamarle
llegábanos	llegábamos
llegates	llegaste
llenábanos	llenábamos
llevábanos	llevábamos
llorao	llorado

M

macarrones	pasta
machucábanos	machacábamos
magazín	revista
magazines	revistas
maiz	maíz
maizes	maízes
mama	mamá
mamases	mamás
manias	mañías
manijaba(n)	manejaba(n)
manijar	manejar
marraba	amarraba
marrárselo	amarrárselo
matalo	matarlo

Glossary

meda	a cierta distancia
mediodía (fem.)	mediodía (mas.)
melao	melado
meniábanos	meneábamos
meniabas	meneabas
merca (v.)	compra
mercaba	compraba
merqué	compré
mesmo	mismo
metíanos	metíamos
midía	medía
midila	medirla
molelo	molerlo
monos	muñecos
muchito	muchachito
muncha(o)	mucha(o)
munchas(os)	muchas(os)

N

naguas	enaguas
nadien	nadie
naiden	nadie
Natividá	Natividad
necitábanos	necesitábamos
nojotras(os)	nosotras(os)
nuevas (n.)	noticias

Ñ

ñudo	nudo

O

ojalí	ojalá
ojelata	hojalata
ojelatitas	hojalatitas
onde	donde
ónde	dónde
ondequiera	dondequiera

opinión (mas.)	opinión (fem.)
ora	ahora
orita	ahorita
ostia	hostia
otubre	octubre

P

pa	para
paá	para allá
pacá	para acá
pa case	para casa
pader	pared
paderes	paredes
pal	para el
pallá	para allá
panqueques (Angl.)	"pancakes"; tortitas
pantaletas	bragas; "panties"
papases	papás
paquel	para aquel
par	para
parriba	para arriba
partiaba	apartaba; separaba
partíanos	partíamos
pasábanos	pasábamos
pasao	pasado
pasiaba	paseaba
pasiarte	pasearte
patrás	para atrás
pegábanos	pegábamos
pelizcar	pellizcar
pesao	pesado
pidía(n)	pedía(n)
pidir	pedir
pilábanos	apilábamos
pintábanos	pintábamos
piquinic (Angl.)	"picnic"
pintala	pintarla

pisotiaban	pisoteaban
planchábanos	planchábamos
planchala	plancharla
platicale	platicarle
plebe	chicos; jóvenes
podíanos	podíamos
polecías	policías
poliada(s)	poleada(s)
ponela	ponerla
poneles	ponerles
ponelo	ponerlo
poníanos	poníamos
popotío	popotillo
pos	pues
preparao	preparado
pretendíanos	pretendíamos
problema (fem.)	problema (mas.)
pulla	púa
pulsos	pulseras
pus	pues

Q

quebrábanos	quebrábramos
quedábanos	quedábamos
quedao	quedado
quitábanos	quitábamos
quitala	quitarla
quitale	quitarle
quitao	quitado

R

rabones (adj.)	cortos
raice	raíz
raiz	raíz
rayao(s)	rayado(s)
refriía	refreía
regala	regarla

regüelta	revuelta
rentao	rentado; alquilado
repelamos	raspamos
responsabilidá	responsabilidad
retirao(s)	retirado(s)
riían	reían
rondanilla (dim.)	rondana
rula (Angl.)	regla

RR

S

sacábanos	sacábamos
sacalo(s)	sacarlo(s)
safrán	azafrán
sagraos	sagrados
salao	salado
salíanos	salíamos
salvao	salvado
sampábanos	metíamos
secábanos	secábamos
sembrábanos	sembrábamos
setiembre	septiembre
shortes (Angl.)	ropa interior (de abajo)
siguía	seguía
siguido	seguido
siguimos	seguimos
siguir	seguir
sintían	sentían
siñalaban	señalaban
sirvía(n)	servían
sombriar	sombrear

T

taavía	todavía
taba	estaba
tamién	también

tapala	taparla
tardábanos	tardábamos
tardao	tardado
tare	tan
tavía	todavía
tendelos	tenderlos
tendíanos	tendíamos
tenelo(a)	tenerlo(a)
teníanos	teníamos
tíquete (Angl.)	billete
tirantes (adj.)	estirados
tirantiábanos	estirábamos
toavía	todavía
too	todo
torkey (Angl.)	pavo; cócono; guajolote
trae	traer
traela	traerla
traiba(n)	traía(n)
tráibanos	traíamos
Trinidá	Trinidad
tualla(s)	toalla(s)
túnicos	vestidos

U

usábanos	usábamos
usala	usarla
usté	usted

V

variábanos	variábamos
variala	variarla
verdá	verdad
vía(n)	veía(n)
víamos	veíamos
vide	vi
vido	vio
vinía(n)	venía(n)

viníamos	veníamos
viníanos	veníamos
vinir	venir
vistía(n)	vestía(n)
voltiaban	volteaban
voltiar	voltear
volvela	volverla
volvíanos	volvíamos

W

X

Y

yerba(s)	hierba(s)

Z

zalellita	zaleíta
zanjas	surcos
zotea	azotea

Interviewees/Entrevistadas

Elfides Apodaca-Baca
 Date of Birth: March 27, 1921
 Place of Birth: Guadalupe, NM
 Date of Interview: May 29, 1992
 Place of Interview: Albuquerque, NM

Vicentita Chávez
 Date of Birth: May 5, 1913
 Place of Birth: Guadalupe, NM
 Date of Interview: March 25, 1989
 Place of Interview: Albuquerque (Atrisco), NM

Dorela Chávez Romero
 Date of Birth: March 8, 1913
 Place of Birth: Márquez, NM
 Date of Interview: July 17, 1990
 Place of Interview: Los Lunas, NM

Eremita García-Griego de Lucero
 Date of Birth: May 24, 1925
 Place of Birth: Casa Salazar, NM
 Date of Interview: August 25, 1990
 Place of Interview: Los Ranchos de Albuquerque, NM

Adelita Gonzales*
 Date of Birth: June 11, 1909
 Place of Birth: Guadalupe, NM
 Date of Interview: March 6, 1989
 Place of Interview: Albuquerque (Atrisco), NM

María Catalina Griego y Sánchez
>Date of Birth: January 28, 1927
>Place of Birth: Albuquerque, NM
>Date of Interview: March 18, 1992
>Place of Interview: Albuquerque, NM

*Mary Jaramillo Gabaldón**
>Date of Birth: November 8, 1906
>Place of Birth: Casa Salazar, NM
>Date of Interview: April 12, 1989
>Place of Interview: Bernalillo, NM

Pina Lovato Lucero
>Date of Birth: July 2, 1927
>Place of Birth: San Luis, NM
>Date of Interview: December 28, 1992
>Place of Interview: Albuquerque, NM

Inesita Márez-Tafoya
>Date of Birth: April 2, 1912
>Place of Birth: Guadalupe, NM
>Date of Interview: September 1, 1990
>Place of Interview: Cubero, NM

María Macedonia Martínez de Molina
>Date of Birth: December 17, 1921
>Place of Birth: Guadalupe, NM
>Date of Interview: March 8, 1990
>Place of Interview: Albuquerque (Atrisco), NM

Frances Mirabal Lovato
>Date of Birth: October 12, 1921
>Place of Birth: San Luis, NM
>Date of Interview: May 9, 1992
>Place of Interview: Albuquerque, NM

Susanita Ramírez de Armijo

Date of Birth: December 5, 1916
Place of Birth: Guadalupe, NM
Date of Interview: March 7, 1989
Place of Interview: Albuquerque (Old Town), NM

*Deceased